# THE ART OF FILM

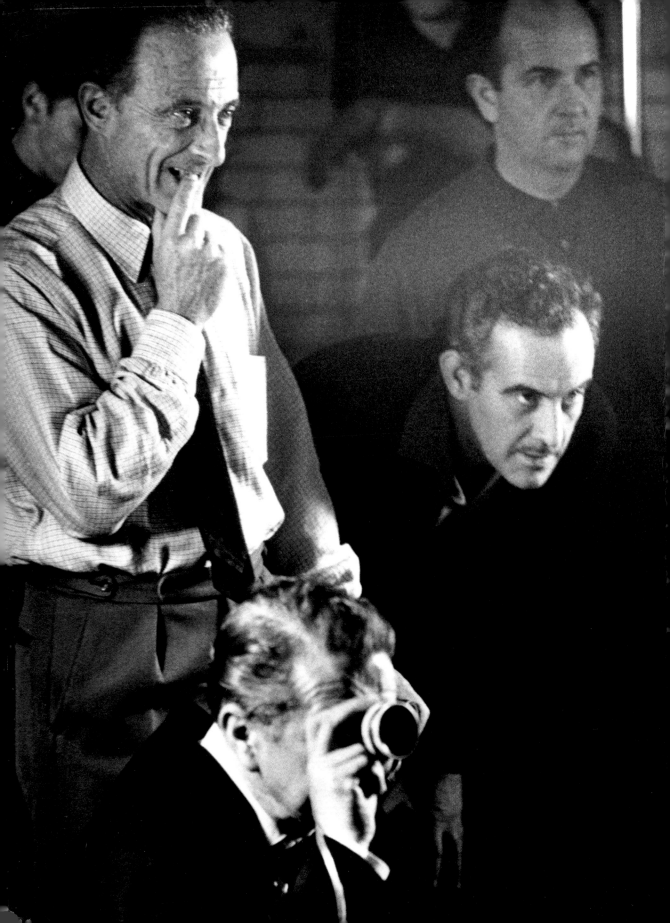

# THE ART OF FILM

## JOHN BOX AND PRODUCTION DESIGN

**Ian Christie**

**WALLFLOWER**
LONDON and NEW YORK

First published in Great Britain in 2009 by
Wallflower Press
6 Market Place, London W1W 8AF
www.wallflowerpress.co.uk

Published with the generous assistance of The David Lean Foundation.

A catalogue record for this book is available from the British Library

ISBN 978-1905674-94-7

Frontispiece: John Box (at right) with Fred Zinnemann and cinematographer Ted Moore during the
production of *A Man for All Seasons* (1966)

Designed and produced by Tom Cabot/ketchup
Printed in the UK by Scotprint, Haddington, Scotland

# Contents

This book is dedicated to
the (often) unsung heroes and heroines of
the Art Department
and to the memory of John Box
(1920–2005)

# Introduction

What is production design? Too often, it is equated with spectacular sets and the sketches that suggest they have sprung from a single imagination. In this sense, it might be considered a form of fantastic architecture, conceived to have the maximum impact on screen. But many filmmakers, and almost all production designers, would reject this image – just as film editors would reject the idea of virtuoso cutting as the essence of editing and cinematographers the lure of the 'great shot'. Designers, like their colleagues, usually prefer the idea of interpreting the script and the director's vision; of creating spaces and images that are not so much memorable for their own sake, but because they embody what the film is about.

This was certainly the design philosophy of John Box. For all his four Oscars and four BAFTA awards, capped by a special BAFTA Life Achievement award in 1991, he believed strongly that film designers should serve the film, rather than creating the spectacular set-piece or enhancing personal reputation. This conviction dated back to the early years of his training as an architect at the Northern Polytechnic on Holloway Road in London. The maxim that 'nothing should be arbitrary or self-advertising' remained his guiding rule.

His career followed an unexpected arc. Coming into film design in the late 1940s, he benefited from the craft training and strict discipline of the studio art department, working under such veterans as Alex Vetchinsky and Carmen Dillon. Breaking free from this tradition at the point where it was in decline, he gained invaluable experience working on location with Warwick Productions, which equipped him with the logistical skills that enabled him to tackle such challenges as *The Inn of the Sixth Happiness* and *Our Man in Havana*. With these as calling cards, he was ready to seize the opportunity that arose when John Bryan withdrew from *Lawrence of Arabia*.

After the eventual triumph of *Lawrence*, he had become a key member of Lean's 'dedicated maniacs', and was, from all accounts, rather more than a production designer

in helping Lean achieve his vision. Significantly, Lean asked him to remain on staff during the editing of *Doctor Zhivago*, which further enhanced his experience beyond the art department. However, parting company with Lean for the troubled *Ryan's Daughter* gave him the chance to design two of the most impressive studio-based English historical films of the 1960s, *A Man for All Seasons* and *Oliver!*, and also to try his luck as a producer.

When the experience of producing proved unsatisfying, the opportunity arose to work with Lean again, this time on *The Bounty*. But the doubts he voiced about this project became public and apparently helped to sink it, so there seemed little chance that the two would ever collaborate or even speak to each other again. Instead, John embarked on a series of challenging productions that drew on his particular skills in location-based filming, seamlessly blended with studio work. After creating the flamboyant settings for Hollywood legend George Cukor's *Travels with My Aunt*, he worked with three rising and very different young North American directors: Norman Jewison on *Rollerball*, William Friedkin on *Sorcerer* and Michael Mann on *The Keep*. None of the resulting films had the same critical or box-office success of his work with Lean and Reed, but all have since developed some degree of cult following for the visual boldness that John helped to realise.

Then, unexpectedly, the call came from Lean and the two veterans were reunited for *A Passage to India*, a film that incurred considerable condescension for seeming outdated in the mid-1980s, but which has since grown steadily in critical standing. Both men hoped to continue their partnership for one final project, Conrad's great indictment of imperialism, *Nostromo*, but Lean's health and a changing production climate prevented this. There were, inevitably, other missed opportunities in John's career, which he was reluctant to discuss and probably glad to have escaped. In 1962, there had been the possibility of *Cleopatra*, which was partly shot in the same Spanish locations that had been used for *Lawrence*, and later to design *Greystoke*, which Robert Towne hoped to direct from his own script.

In the event, a decade after *A Passage to India*, his final engagements provided a bittersweet contrast. Having greatly enjoyed the experience of supporting Caroline Thompson's directing debut with the modest *Black Beauty*, he found himself at the mercy of the ill-conceived *First Knight*. Despite his efforts to flesh out Jerry Zucker's anachronistic vision of Arthur and his feuding knights, and the opportunity to incorporate early computer-generated effects, he found himself blamed for the film's excesses. Yet even here, especially away from the chocolate-box Camelot, there are images to admire.

As John's near-contemporary Ken Adam observed: 'a designer needs luck as well as talent'.[1] It was Adam's luck to be taken on for the first Bond film, *Dr No*, at the same time that John was working on *Lawrence of Arabia*. Both of these landmark films would

---

1    Adam quoted in Peter Ettedgui, *Production Design and Art Direction*, RotoVision, 1999, p. 26.

indelibly mark their designers' careers. Yet by comparison with Adam, even within the limited literature of film design, there has been surprisingly little recognition of John Box's achievement.[2] In keeping with his wishes, this book aims less to praise him – although it can hardly avoid that – than to pass on what he hoped would be the lessons of a lifetime and provide inspiration for the future generations of young filmmakers.

## Acknowledgements

I first met John Box in 2000 through an invitation to chair a presentation he gave in Canterbury, as part of the Kent International Film Festival. I later had the privilege of introducing him to audiences on several more occasions, while carrying out interviews for this book. John had already written about his early life and accumulated notes on his experiences of working with the great filmmakers. Above all, he hoped that an eventual book would reveal something of his 'vocabulary of life' and contain useful accounts of problems solved. Sadly, the book was far from complete when John died in 2005. Several of his former colleagues have been particularly helpful by agreeing to be interviewed about their experiences of working with him. I am especially grateful to Omar Sharif, Terence Marsh and Phyllis Dalton for sharing their memories. John's daughter, Susan, and her husband Martin Gandar, have been unfailingly helpful with illustrations and information, and Catherine Surowiec provided advice and encouragement throughout the book's long gestation, while Patsy Nightingale enthusiastically organised expeditions to inspect some of John's more exotic locations. Since David Lean was so central to John's career, I am inevitably indebted to Adrian Turner's and Kevin Brownlow's heroic and scrupulous published work on Lean. Gina Fegan first introduced me to John and facilitated our early interviews, helped by my daughter Beatrice Christie (now an art director herself). However, my main thanks are to The David Lean Foundation for generously supporting the publication of this book, to Yoram Allon for taking it on, to Philippa Hudson for copy-editing against the clock and to Tom Cabot for much more than elegant design – in the Box spirit.

---

2   There is no mention of John Box in Leon Barsacq's standard history, *Caligari's Cabinet and Other Grand Illusions*, New American Library, 1976, in Charles and Mirella Affron's *Sets in Motion: Art Direction and Film Narrative*, Rutgers University Press, 1995, or in Ettedgui's anthology.

# The Magician at Work

## Filmmakers on John Box

### David Lean

The painted path to the well [in *Lawrence*] and the black tongues of pebble pointing towards the approaching figure was a created pattern, a design, which was part of the drama. Not an affectation. No one noticed it, but I'm quite sure it helped contribute to the impact of the sequence.

After the shot, Lean said to John, 'You'll never do a better bit of designing in films, ever!'[3]

### Terence Marsh

One of the great things about John was that he was never afraid to take responsibility. And in our business, time and money are so precious that decisions can cost a lot of money – or save it. Many production people would say: it's someone else's decision. But John would say, 'I'm telling you it can be done and I'll back that decision', and consequently he sort of ran [*Lawrence of Arabia*]. Sam [Spiegel] kept hands off and the production manager John Palmer had so much day-to-day administration, so John would say, 'This is what we'll do: we'll build the train, we'll lay the tracks on the sand dunes at Almeria, and we'll get a quantity surveyor down to say what we need …' And during the time we're doing this, he's building something else.

There was a lot of pressure, and you've got to be able to delegate, because you can't do everything yourself on big movies. I could never really let go the reins the way John did. Once you had done something for him and it worked, he trusted you. I enjoyed working with him, and he was very sought-after, so you could be sure of working on the best movies.[4]

---

3    Kevin Brownlow, *David Lean: A Biography*, Richard Cohen Books, 1996, p. 437.
4    From interviews with Terence Marsh, who worked with John Box from *Lawrence* to *Oliver!*, before becoming a successful production designer in his own right.

## Steven Spielberg

I guess [David Lean] really never transported us anywhere more exotic than through the brilliant eyes of John Box, his genius production designer, in *Doctor Zhivago*.[5]

## Fred Zinnemann

Because of the tiny budget [on *A Man for All Seasons*], we had to be enormously careful about building sets and making costumes. Fortunately, one of the great production designers, John Box, was with us. Using three enormous flats raised in perspective, he built a replica of the palace at Hampton Court for £5,000. When comparing photographs of the movie set and the real thing, no one could tell the difference.[6]

## Michael Mann

My second film, *The Keep*, was about the pathology of Fascism, set in Romania early in World War Two, and I was lucky to have John Box as my production designer. Although we did our research on traditional Romanian architecture, we had to create spaces that would work directly on the audience, making them feel certain things. John helped us find the Welsh slate quarries as a weird background and framing for the spaces we went on to create in the studio. He set me on the road towards originating and manufacturing a film, starting from a blank sheet of paper. Working with him, I began to discover the language of constructing things, instead of selecting from what was already there, as I had in *Thief*.

I knew I was home with him very early on when he asked me to look at something by Piranesi and a painting by Cezanne – two images that couldn't have been further apart – and suggested that we could combine them. We were really building an expressionistic world that had to avoid the clichés of Fascist architecture, but had to create for the audience an intense anti-Fascist dream. With the façade of the castle, the doorway, the ramp and the walls, John was able to conjure up the spaces of that dream.

Of course I admired John's great work with David Lean, which was always based on a firm design principle. The important thing is that it had a concept that precedes going to work – which is the essence of design for me. Forming that concept was something John and I shared on *The Keep*, which is why I loved working with him, especially at that early stage in my filmmaking career.

---

5    Speaking in a BBC documentary on David Lean, presented by Jonathan Ross, tx 2 April 2009.
6    Fred Zinnemann, *An Autobiography*, Bloomsbury, p. 199.

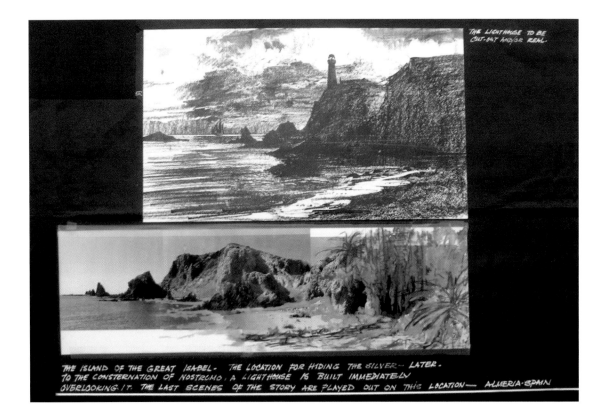

THE LIGHTHOUSE TO BE CUT-OUT AND/OR REAL.

THE ISLAND OF THE GREAT ISABEL. THE LOCATION FOR HIDING THE SILVER — LATER. TO THE CONSTERNATION OF NOSTROMO, A LIGHTHOUSE IS BUILT IMMEDIATELY OVERLOOKING IT. THE LAST SCENES OF THE STORY ARE PLAYED OUT ON THIS LOCATION — ALMERIA·SPAIN

Location and construction options for *Nostromo*, as laid out by John, after the production was replanned to be based in Spain.

## Shama Habibullah

My greatest joy on [*A Passage to India*] was to encounter John Box and to have access to the art department. To look at what they were doing was a privilege. It was something I don't suppose I'll ever see again in my life. It was so incredibly organised. I've seen art departments … but this was absolutely organised … John Box suddenly had everything he ever wanted around him. He had one wall which was just photographs of the colours of India. People would feel themselves into the areas they were in.[7]

7    Quoted in Brownlow, *Lean*, pp. 664–5. Shama Habibullah was production manager on both *Gandhi* and *A Passage to India*.

# Prelude

A Vocabulary of Life

My first memory is of a monkey leaping into my pram and grabbing something I was eating – with a soundtrack of screams and yells.

John Box

John Box often talked about how his early experience had given him a 'vocabulary of life' – a phrase he never explained, but which seems to have encompassed what he could draw upon in making films that dealt with life-changing themes. He was certainly lucky to have worked on more films of real quality and ambition than many of his contemporaries in British cinema. But this was also due to more than luck. Directors soon realised that he brought not only skills and vision to each project, but also invaluable qualities of resourcefulness and 'character', which could make the vital difference between triumph and disaster. Little wonder, perhaps, considering his colonial childhood and the experience of commanding a tank squadron in his early twenties during some of the Second World War's fiercest battles. For nearly forty years, from dressing Wales to look like China in *The Inn of the Sixth Happiness*, to his epic work for Lean on *Lawrence of Arabia* and *Doctor Zhivago*, and in his final atmospheric designs for *Black Beauty* and *First Knight* in the mid-1990s, he could draw on an incredibly rich vocabulary of experience.

That experience had begun in Sri Lanka, then known as Ceylon, where his father had been posted soon after the end of the First World War. Serving in the Royal Engineers during the war, Allan Box met his future bride on a hospital train, where she was looking after a wounded officer as a Queen Alexandra army nurse, and they married in August 1917. Faced with the post-war depression, Allan Box decided that the Colonial Service offered better prospects than trying to find a job in Britain to support his new family. Less than a year old, in 1920, John found himself part of a pattern of colonial life that

The Box family would spend Christmas in Ceylon's capital, Kandy, visiting the famous Temple of the Tooth and the Peradeniya botanical gardens.

John Box (centre) with his brother David and mother, Bertha.

now seems more like fiction than reality. After being terrified by monkeys and snakes while still in his pram, the future conjuror of fortifications and whole cities was able to travel around with his father, watching him inspect bridges and waterways, while living amid the tropical splendour of Sri Lanka. One of their bungalows overlooked a waterfall that would later feature in *The Bridge on the River Kwai* – a strange premonition of how important John's relationship with David Lean would become. A brother, David, was born in 1922 and at Christmas, the Box family would go to Ceylon's capital, Kandy, with its spectacular Buddhist Temple of the Tooth, and visit the famous Peradeniya Botanical Gardens, through which ran the river that stood in as the Kwai for filming.

In spite of his exotic surroundings, young John was to experience the rituals of middle-class boyhood and at the age of eight started prep school in one of the high hill stations. Haddon Hill School aimed to offer a facsimile of English school life, with a neo-gothic chapel, a lake stocked with trout, and initiation into cricket, rugby and golf. John developed a passion for cricket, to which he would later add boxing, but what left a lasting impression were the long voyages to and from England. 'It was the start of an adventure as you sailed out of Colombo into the Arabian Sea, then into the Gulf of Aden and to Port Sudan, with all its new sounds and sights.' After the Suez Canal, the route passed the still-erupting volcanoes of Stromboli and Vesuvius, then rounded Gibraltar before entering the English Channel and steaming

up the Thames to berth at Tilbury. This last part of the journey 'more often than not took place in thick fog, with ships' fog horns baying all around', sounding to John and David like 'ships' cows moaning about the awful weather'.

Back in England, staying with their grandmother in the mining town of Maryport in Cumberland during what was now the Depression, John and his brother suddenly lost their mother, Bertha, in 1933. She had never fully recovered from the rigours of nursing during the First World War, and may have found it hard to move from the heat of Ceylon to northern England. Ruefully, he later remembered that he and his brother had tried to persuade her to come with them to the cinema that day in April, but she had not felt well. When they returned, she was obviously ill and their grandmother was distraught. John ran to fetch their aunt, calling out for a doctor as he dashed through the streets, but no help was forthcoming. By the time he returned, she was dead and the blinds were already drawn according to the local custom. John was considered too young to attend the funeral, but watched the cortège from a distance – and later remembered his childhood emotions when working on the funeral sequence that opens *Doctor Zhivago*.

John Box with his mother shortly before her early death.

The boys were now sent to a prep school in Wetheral, near Carlisle, where they had their first taste of English boarding-school life, including cold showers. John also began to discover historic England for himself, learning to fly-fish and walking part of Hadrian's Wall. He was encouraged to draw and paint and had the satisfaction of selling a painting to the mother of one of his fellow pupils. Violet Loraine had been a famous music-hall star during the First World War, best known for her rendition of the song 'If You Were the Only Girl in the World' with George Robey. She had married into the Joicey family of mine-owners – and, probably unknown to John, was about to make her screen debut in *Britannia of Billingsgate* (1933), alongside the young John Mills and Kay Hammond.

John Box with his father, Allan Box.

After prep school, with their father still in Ceylon, John and his brother came under the wing of an aunt and uncle in north London, and were enrolled as boarders at Highgate School. There was little encouragement of art, but John excelled in boxing and became goalkeeper for the school's first soccer team. After passing his matriculation, there was the prospect of a university scholarship to study literature and history, or a career in the Metropolitan Police on the strength of his sporting achievements. But his heart was set on architecture and, since money was scarce, he enrolled in 1936 at the 'down to earth' Northern Polytechnic School of Architecture on Holloway Road. The college had been founded in the 1896 as part of a national scheme to 'to promote the industrial skill, general knowledge, health and well-being of young

Modernist design, influenced by Le Corbusier and the Bauhaus, in the futuristic climax of Korda's *Things to Come* (1936).

men and women [and provide] … the means of acquiring a sound General, Scientific, Technical and Commercial Education at small cost'.[1] After the existing polytechnics were rationalised in 1913, the Northern specialised in sciences and building, before adding rubber technology, radio and architecture to its subject range in the 1920s, with the latter recognised by the Royal Institute of British Architects in 1925.

Compared with Ceylon, and the rarefied yet spartan atmosphere of his schools, this felt like the real world – lodging with his relatives and travelling every day 'on a clanking tram through the streets of north London'. John remembered the School principal's speech to new students, which included the observation that doctors could bury their mistakes, while architects could not. Although modern architecture was attracting attention in 'advanced' circles, through the example of Le Corbusier in France and the Bauhaus school in Germany, this was to be a training in the Classical tradition. Two firm principles, however, stuck in John's mind: one, that nothing must be arbitrary; and two, that no design should be self-advertising. Such maxims would have appealed equally to Bauhaus designers, many of whom, such as Walter Gropius and László Moholy-Nagy, had fled Germany and were living in London at this time. John would certainly have seen the impact of Modernism on Alexander Korda's futuristic epic *Things to Come*, filmed at the new Denham Studios and released in 1936. He would not yet have known

---

1    Northern Polytechnic foundation papers, accessed online at: http://www.aim25.ac.uk/cats/49/5478.htm.

how Vincent Korda, Alexander's brother and the film's designer, had taken contributions by such artists as the one-time Cubist Fernand Léger and László Moholy-Nagy, and moulded them into a synthetic vision of the future, with a prophetic message about the terrors of any future war.

Nor would he have known that another refugee from Germany, the art historian Nikolaus Pevsner, was conducting a survey of the state of industrial design in Britain and concluded in his 1937 report that '90% of British industrial art is devoid of any aesthetic merit', followed by the pessimistic assertion that this was unlikely to be reduced below 80% even by publicity and education.[2] For Pevsner, it was an unwelcome paradox that only absolutist states seemed to be able to produce the concentrated education that would restore art to a central place in society and enable it to join forces with industry. Later, in his famous BBC radio lectures on *The Englishness of English Art* (1956), he would undertake a crusade to persuade the English that they should value their own distinctive contributions to art and design – rather than merely feel inferior to other cultures. In fact, he would have endorsed the philosophy that John was absorbing on Holloway Road:

> Everything around us; architecture in all its forms; transport, whether it be aeroplane, car or ship; all aspects of industrial design, right down to the everyday objects we use – all of these have to be drawn before they become reality. God help us if we are bad draughts-men. On the other hand, good line-makers can create an atmosphere of exhilaration, as happened during the Italian Renaissance.

Although Pevsner had little appreciation of cinema, the tradition he traced in his book *Pioneers of Modern Design*, which located the English arts and crafts movement at the root of 'modern design', was the same tradition that shaped John Box.[3] His work in cinema would require him to imitate many design styles, but it was always underpinned by the disciplines of draughtsmanship and craft skill, and by a philosophy that stressed integration and economy of means.

John's progress towards becoming an architect, together with the mediocre state of British industrial art, was rudely interrupted by the outbreak of war in 1939. Like many of his contemporaries, John was attracted to the Royal Air Force, but having been an army cadet at school was told that he would eventually be called up for the army. His un-cle's family had moved to Guildford when the air raids on London started and he joined

---

2    See Ian Christie, 'What Counts as Art in England: How Pevsner's Minor Canon Became Major', in Peter Draper, ed., *Reassessing Nikolaus Pevsner*, Ashgate, 2004, p. 151.

3    Nikolaus Pevsner, *Pioneers of Modern Design*, Penguin, 1960. This was first published as *Pioneers of the Modern Movement* in 1936, and a second edition was sponsored by the Museum of Modern Art in New York in 1949, before the influential 1960s edition.

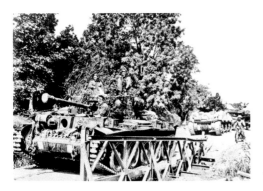

Cromwell tank from 1st Royal Tank Regiment crossing the Orne bridge in Normandy.

them while awaiting his call-up. Trains carrying wounded servicemen would pass through Guildford and he offered his help with their care, remembering how his mother had nursed the wounded during the First World War. He also explored the local countryside during the evenings and at night, discovering the start of the old Pilgrim's Way that led towards Canterbury – the same route that Michael Powell and Emeric Pressburger would celebrate in their 1944 film *A Canterbury Tale* with something of the same sense of reverence that John had felt.[4]

This interlude, which included several tentative romantic relationships, came to an end when John was commissioned into the Hampshire Regiment based on the Isle of Wight. He soon found himself defending the British coast with, as he recalled, 'great confidence but very limited resources'. Tired of inactivity, he transferred to the Royal Armoured Corps and began training in tanks. His sentimental education also continued and at the age of twenty-four he married Barbara, then serving in the WRNS, against his family's wishes. Almost immediately, however, after a 'foggy honeymoon', their paths diverged: Barbara joining Churchill's staff as a cipher officer and John embarking with his tank regiment for the Normandy beaches in June 1944. He was soon involved in the protracted Battle for Caen, during one phase of which the Allied 11th Armoured Division lost 400 tanks and over 5,000 troops in the face of ferocious German resistance by a well-entrenched panzer division.

Wounded during the battle, John was initially treated in a hospital at Bayeux, which he recalled as a 'nightmare'. A French student nurse recorded her memory of the scene at the hospital:

> … we found a disaster. For the past three days, nobody had changed bandages. The smell was horrible. A large number of wounded had arrived from Caen. Some were also sick, and needed sulfamide, others were dehydrated to the point of death, having been given nothing … There were so many things to do. Sometimes we couldn't stand washing bandages while soldiers were dying, but it was a necessary task.[5]

John recovered in time to rejoin his unit as they advanced into France, reaching Paris in August and experiencing the madness of the Liberation. But they were soon

---

4   On the Pilgrim's Way and *A Canterbury Tale*, see Ian Christie, '"History Is Now and England": *A Canterbury Tale* and Its Contexts', in Christie and Andrew Moor, eds, *The Cinema of Michael Powell: International Perspectives on an English Filmmaker*, BFI Publishing, 2005, pp. 82–4.

5   Odette Bonfardion's account of the aftermath of the Battle for Caen is translated at: http://www.pbase.com/bonfas/dday.

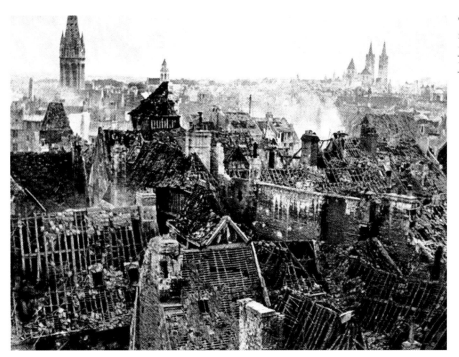

Caen in ruins after the ferocious tank battle of June 1944, in which John Box was wounded.

on the move again, into Belgium and Holland, for what was the last great engagement of the war, the Battle of the Bulge. Hitler planned a counterattack on the advancing Allied forces in the Ardennes, a strategy that achieved its intended surprise impact on 16 December, inflicting heavy casualties on the Americans. John remembered the eerie contrast between the fairyland appearance of the Ardennes forest at Christmas and the carnage of the battle, remarking only that he had 'never liked barbecues since'. The Allied drive towards Germany continued, crossing the former Maginot and Siegfried lines, with the Battle of Reichwald Forest in February forming a prelude to crossing the Rhine. During this battle, John's squadron lost sixteen of its eighteen tanks. After the German surrender on 4 May, John's brigade became part of the military government of Germany and he was given command of a regiment: 'very strange for an ex-student of architecture still in his early twenties'. He visited Berlin, where 'the sight of the destruction, physical and moral, had a devastating effect – I took nothing for granted from that moment on'.

John was now an acting Major, promised a career in the army if he stayed, but he had had enough of killing and asked for demobilisation. As he waited for a boat at Calais on 26 July, news of the general election came through: 'Churchill was out and it was to be a Labour government – the end of the war and now hopes for a future based on peace.' On leave in London in August, he saw the headline 'Atom Bomb dropped on Japan' and felt deep relief that the war was finally over, especially since his regiment was to have been part of the invasion of Japan.

Returning to architecture school was inevitably an anticlimax; and being reunited with his wife Barbara in a small flat in London soon revealed that they had little in common. An amicable divorce followed, and John set about completing his qualifications as quickly as possible in order to pursue his growing passion for cinema. One year would be enough to complete his technical examinations, and the final thesis could be written while, he hoped, working in a film studio. 'It might not be a great art form,' he thought, 'but it was a powerful way of communicating with people throughout the world. I felt that my previous life, from growing up in the tropics, through fighting in and surviving a world war, had been laced with sufficient drama to give me an understanding of what life was about.' Architectural training offered a way to enter the design departments of filmmaking.

# Chapter 1

## First Steps

How to get into films? The same question has puzzled many would-be filmmakers for nearly a century, and John's prospects in 1947, after completing his architectural studies, were no better than most. He had no inside contacts through family or friends, except an uncle who worked in a Bond Street clothing shop where the designer Elizabeth Haffenden sometimes bought items. Haffenden (1906–76) had worked in costume design since the 1930s, before becoming head of wardrobe for Gainsborough Pictures in the 1940s, when this studio developed a reputation for popular romantic melodramas such as *Love Story* (1944), *Madonna of the Seven Moons* (1945) and *Caravan* (1946), many featuring extravagant historical costumes. She would later win an Academy Award for the costumes on one of John's great successes, *A Man for All Seasons*, and in 1947 she helped start his career by providing an introduction to a Gainsborough colleague and one of Britain's leading art directors, John Bryan.

Elizabeth Haffenden (left) with Joan Bridge, who originally worked for Technicolor and later became Haffenden's partner in design.

Born into a theatrical family, Bryan (1911–69) was apprenticed to the scenic artists who worked for his producer father. He then transferred to another firm of scenic painters and made his first contact with cinema through Laurence Irving, who had already graduated from illustration and theatre design into films, working in Hollywood on Douglas Fairbanks's lavishly detailed *The Iron Mask* and Fairbanks and Pickford's *The Taming of the Shrew* (both 1929). Back in Britain, Irving combined design for the stage and for film, and Bryan became his assistant before going to work on Alexander Korda's epic production of *Things to Come* in 1935. This adaptation of a prophetic novel by H. G. Wells, which predicted the catastrophic effects of a future world war and the eventual birth of a new civilisation, was produced in parallel with the construction of Korda's new Denham Studios in 1935–6. Appropriately, both the layout of the studio and the direction of its debut film were handled by Hollywood art directors, the former by Jack Okey and the latter by William Cameron Menzies. Both also grew beyond their original conception. The studio had seven separate stages, a processing laboratory, a power station, projection theatres and a restaurant, not to mention star dressing rooms, as well as the various technical departments divided between a central manor house and cottages dotted around the 165 acres of the estate. Little wonder that it soon proved too vast for Korda and was only rescued by the intervention of J. Arthur Rank.Indeed, its scale almost overwhelmed the young John Box on his first visit to see Bryan.

Since the sprawling epic that *Things to Come* became was directed rather than designed by Menzies, the coordination of its complex design fell to Vincent Korda, Alexander's brother and head of the art department at Denham, who also became John Bryan's second mentor in cinema. A painter by training and inclination, Vincent brought a sophisticated range of stylistic references into British art direction, combined with the

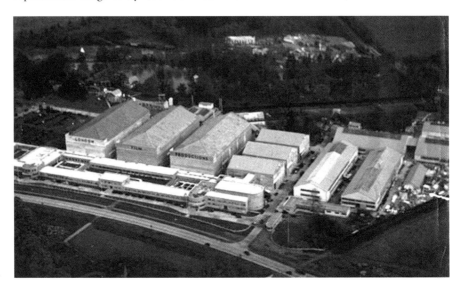

Denham Studies, built by Korda in the mid-1930s, although later operated by Rank.

ability to drive ambitious projects forward. Although he could not overcome the didactic stiffness of *Things to Come*, he was responsible for the impressive spectacle of its scenes of devastation by aerial bombardment, which was followed by the rebirth of civilisation under an enlightened dictatorship, proclaimed by streamlined futuristic architecture that drew on Cubist and Modernist styles. Vincent's gifts were even more apparent when he managed to unify triumphantly the patchwork elements of Korda's Technicolor fantasy *The Thief of Bagdad*, begun at Denham in 1939 and completed in Hollywood in 1940. Meanwhile, John Bryan developed his own reputation working on three prestigious literary adaptations, *Pygmalion* (1938), *Major Barbara* (1941) and *Caesar and Cleopatra* (1945), all from plays by George Bernard Shaw, and on a range of other wartime productions, including the Gainsborough period pieces *Fanny by Gaslight* (1944) and *The Wicked Lady* (1945).

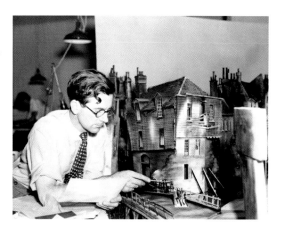

John Bryan working on a set model for Lean's *Oliver Twist* (1948), which established a style for 'Dickensian London' that balanced architectural authenticity with a dark Romanticism.

At the point when John came to see him at Denham, Bryan was in the midst of working on what is now regarded as one of his greatest achievements, *Great Expectations* (1946), the first of two Dickens adaptations he designed for David Lean. 'It was a very important day in my professional life', John later wrote. 'John [Bryan] was very gracious and spent much time explaining his and David's intentions in transforming Dickens's great novel for the screen. Now there was no going back, as far as I was concerned: I wanted to be part of that world.' Bryan could not offer the young man any immediate work, but sent him to see Edward Carrick, another leading designer, who was then supervising art director at Pinewood Studios. Carrick, in turn, advised him to write to four other art directors, and after an agonising silence, John received an appointment to meet one of them: Vetchinsky.

Once again, he was impressed by the immensity of Denham, with its massive stages and long corridors, and the complexity of the studio's many departments. Who was this exotically named figure, he wondered, as he arrived clutching his portfolio of architectural drawings. Perhaps a sensitive, sharp-featured Polish aesthete? He asked directions from a big, lumbering man, who told him where to go. As he waited, the same man burst in, dishevelled and sweating in the heat, and demanded abruptly, in a London accent, 'Who are you? What do you want?' 'I'm here to see Mr Vetchinsky,' John explained, whereupon the man said, 'I'm Vetchinsky, come in here.' In the neighbouring room, Vetchinsky proceeded to fill a basin full of cold water and pour it over himself, and over some of John's precious drawings. Still dripping, he snarled, 'You any good?' When John replied that he thought he was and offered to show his drawings, Vetchinsky snapped, 'No – start on Monday'.

John's first taskmaster and mentor, the versatile art director Alex Vetchinsky, pictured while working on Powell and Pressburger's *Ill Met By Moonlight*.

This may not have been the Vetchinsky that John had imagined, but he had at least got a start and turned up on Monday, neatly dressed and wearing a tie, as studio etiquette demanded from all but Vetchinsky. One of John's near contemporaries, Elliott Scott, the future designer of *Indiana Jones and the Temple of Doom* (1984) and of *Who Killed Roger Rabbit?* (1988), used to appear absentmindedly wearing two ties. By this time, Alex Vetchinsky (1904–80), invariably known by his surname alone, was one of the longest-serving production designers in British film, his career only matched by that of Alfred Junge, who had come to Britain from Germany in 1928.[1] As a stalwart of Gainsborough Studios for much of his early career, Vetchinsky received little personal recognition, while reliably producing 'the country mansions, Swiss finishing schools, Riviera casinos, London Art Deco nightclubs, trans-Atlantic liners and innumerable trains and stations demanded by the standard Gainsborough films'.[2] Having a personal style would have seemed a luxury, although Vetchinsky could rise to the occasion when teamed with a strong director, as in his lighthouse design for Michael Powell's *The Phantom Light* (1935), or the train for Hitchcock's *The Lady Vanishes* (1938), and most recently for the psychological thriller *The October Man* (1947), directed by Roy Ward Baker at Denham.

Now he would give John his first assignment: to design the forward deck of a battleship and fit it into a studio stage. John was visibly nonplussed, which prompted Vetchinsky to sneer: 'You're a smart ass, aren't you, and you think you know everything?' John stammered that he thought he'd be able to draw anything required. 'They never taught you about false perspective, did they, smart ass? We'll teach you.' So, after commanding a tank regiment and qualifying as an architect, John began his career in film as a junior draughtsman learning on the job, with additional responsibility for making the tea.

The art department at that time was organised on a drawing-office basis, with personnel contributing to all the studio's projects, as required. All agree that it provided a remarkable training. Terence Marsh, who would work closely with Box for ten years as art director on *Lawrence of Arabia*, *Dr Zhivago* and *Oliver!*, recalled the value of this apprenticeship as he experienced it ten years later. He had trained as a painter rather

---

1  Junge (1886–1964) had worked in theatre before entering the Ufa studios in the early 1920s and working on such notable films as *Waxworks* (Paul Leni, 1924) and E. A. Dupont's *Varieté* (1925), which latter brought him international fame and led to him following Dupont to Britain in 1928, where he remained for most of the rest of his career. Junge was supervising art director for MGM Britain in the 1930s, and worked closely with Powell and Pressburger from 1939–47. Together with Vincent Korda, he is widely considered the major influence on British production design of the 1930s and 1940s.

2  Brian Baxter, 'Alex Vetchinsky', in *Film Reference*, at http://www.filmreference.com/Writers-and-Production-Artists-Ta-Vi/Vetchinsky-Alex.html.

than an architect, but at Pinewood, where he spent six years, 'they had a department for everything – matte painting, scenic artists, special effects – and you were given a grounding in all of these'.

> You could actually go there and see how they did it. And you were given tests: an art director would say, 'here's a still they took on location: we're going to do a blue-screen shot using that as a plate. Work out how high the camera is and what the angle of tilt is.' And you had to do that on the drawing board, by geometry, and they would say, 'no you got it wrong!' Or they would give you a plan and elevation, and ask you to make a projection: 'there's a 35mm camera over there – draw me a picture of what it's going to look like'. And by projecting everything geometrically, you can do that. Now they can do a walk-through on a computer – and if you said 'do a projection', they'd wonder what you're talking about. But the grounding was so good that when you left Pinewood you could tackle almost anything.

For all Vetchinsky's gluttony and distressing personal habits – said to include using a bacon rasher as a bookmark – both Box and Marsh would learn from him the virtues of economy, producing just enough for the demands of the scene. John was once berated for labouring on a skirting that no one would ever see; while Marsh recalled Vetchinsky's skill in creating 'the most wonderful effects with just a black backcloth, a bit of light and some fog, a sound effect, a glistening floor'.

John soon began to distinguish himself among the art department staff at Denham, and achieved his first credit for 'sets' on a thriller, *Escape*, directed by Joseph Mankiewicz from a play by John Galsworthy in 1948, with Vetchinsky as art director. *Escape* starred Rex Harrison, who had been a leading man in British films for fifteen years, but had just played his first lead in Hollywood in *Anna and the King of Siam* (1946), the original version of *The King and I*. Made for Twentieth Century-Fox's British subsidiary Fox British, *Escape* was in many ways typical of a crisis period in British cinema, whose long-term implications would result in filmmakers such as John Box and Terence Marsh working for most of their careers for US-based companies.

American studios had begun to produce films through British subsidiaries in the early 1930s, after the British government required exhibitors and distributors to observe a minimum quota of local films in order to protect the fragile British industry. Immediately after the Second World War, Britain's economic situation became critical, as wartime support from America was withdrawn. In an attempt to ward off a balance of payments crisis in 1947, the government imposed a drastic 75 per cent customs tax on all imported films, which struck at the £17 million being earned yearly by American films in their largest export market. Hollywood retaliated with an immediate boycott, withholding all new films from British cinemas, which were forced to rerun old titles. Britain's two leading producers, Rank and Korda, announced that they would fill the gap

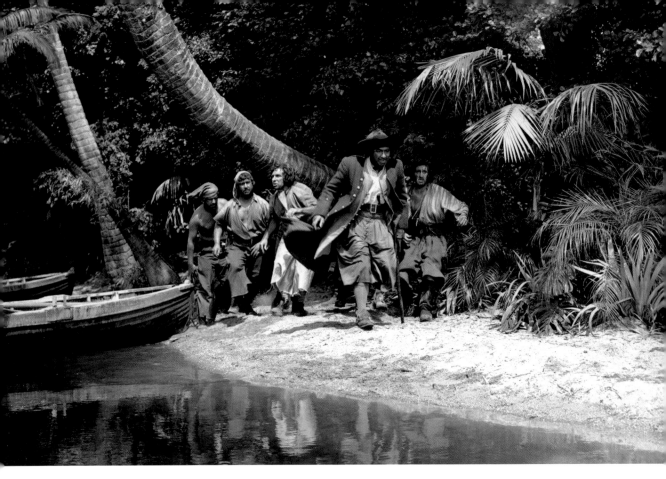

Disney branched out into live action with *Treasure Island* (1950), made in Britain partly to use frozen assets, and giving John his first taste of fabricating exotic settings. Robert Newton swaggered unforgettably as Long John Silver.

by dramatically expanding their production schedules. But when peace was brokered eight months after the boycott began, domestic productions faced even stiffer competition than before, with a backlog of prime American releases swamping the cinemas.

The longer-term consequences of the crisis, however, would help those starting out in cinema, such as John. A tax on box-office earnings, nicknamed the Eady Levy, would be paid to successful British producers to reward films that proved popular. And the immediate settlement with Hollywood required that earnings that could not be exported should be spent in Britain. One of the companies affected, Disney, took the opportunity to venture into live-action filmmaking for the first time with a new version of Robert Louis Stevenson's adventure classic *Treasure Island* (1950). Directed by the special-effects expert Byron Haskin, this was filmed partly on location in Cornwall, but mainly at Denham, where sand and palm trees were brought in to create the required tropical settings. John found himself working for the irascible art director Tom Morahan, 'brilliant but fearsome', and famed for his violent reactions. John remembered him coming into the art department one day, his hands streaming with blood, after he'd torn down wire-mesh trees on the set that weren't to his liking.

> He had a particular way of working. He'd do a sketch, very detailed and precise, and you had to make a plan for the set from this that would exactly reproduce his sketch, and

he would check the set against his sketch through a viewfinder. I was given a difficult assignment, Bristol harbour, and it was so complicated that I had to change some details of Tom's sketch to make it work. When I showed it to him his first reaction was, 'This is great, the best yet.' Then he looked at his original sketch and came at me, shouting 'You bastard, you've cheated me: that's not my sketch, it's your version.'

John had been a boxer and stood his ground: 'Yes it is, but you've got virtually what you sketched, and it's practical.' Morahan lowered his fist and they both laughed.

Working at Pinewood during the lean years that followed the Anglo-American 'film war', with Rank nursing heavy losses, John met another art director who would leave a lasting impression. Carmen Dillon (1908–95) was famously the only female production designer in British cinema, which meant that she had to work harder than most to impose her authority and maintain the respect of all-male crews. One of three talented sisters – Una Dillon was responsible for launching Dillon's bookshop in partnership with the University of London – Carmen had been educated at a convent before qualifying as an architect and starting to work at Wembley Studios in 1934. By the time John began working as her assistant in 1950, she was famous for her involvement with Laurence Olivier's films, *Henry the Fift* and especially *Hamlet*, for which she had shared the Academy Award for art direction in 1948. John was immediately impressed by her breadth of knowledge and brisk professionalism; and Terence Marsh, who worked with her later, remembers her kindness to young staff such as John and him.

Carmen Dillon had worked on Olivier's innovative *Henry the Fift* and designed his *Hamlet*, and set a high standard for John, and later Terence Marsh, when they worked with her.

One of Dillon's closest working relationships was with Anthony Asquith, an exotic figure among English directors and a son of the Liberal prime minister Harold Asquith. 'Puffin' Asquith, as he was universally known, was famously eccentric and closely involved in the creation of the Film Society in London in the 1920s, where a wide range of international films attracted the intelligentsia. His own first films at the end of the silent period were the experimental features *Shooting Stars* (1927) and *A Cottage on Dartmoor* (1929). During the war, he directed some distinctive propaganda films, including *Freedom Radio* (1940), *The Demi-Paradise* (1943) and *The Way to the Stars* (1945), all designed by Dillon. John worked as a draughtsman on two of Asquith's highly acclaimed literary adaptations, *The Browning Version* (1951) and *The Importance of Being Earnest* (1952). Encouraged by Dillon to come onto the floor during shooting, he never forgot watching Asquith at work with the leading stage actors who appeared in Wilde's classic farce. After a run-through of one scene, with Edith Evans, Asquith congratulated the actors profusely, before asking them to help him reduce the running time, as an oblique way of securing a better rhythm for the scene. Less, John was learning, could often be best, both in design and direction.

After his early experimental films and imaginative propaganda work during the war, Anthony Asquith had turned to prestige literary adaptations by the time John could observe him at work in the 1950s.

By 1952, John was one of many young filmmakers impatient to escape the moribund climate of the Rank Organisation, which had retrenched after the 1948–9 crisis, with

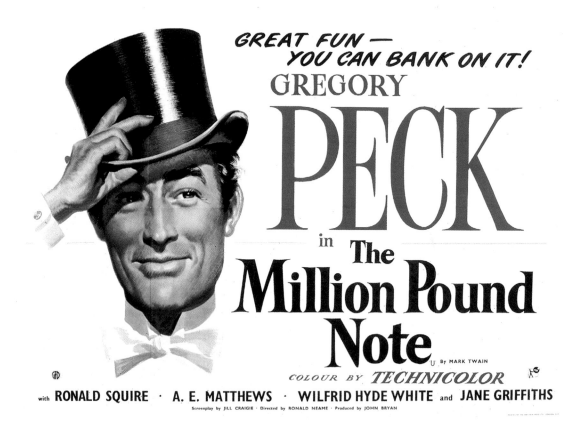

GREAT FUN —
YOU CAN BANK ON IT!
GREGORY
PECK
in The
Million Pound
Note
U By MARK TWAIN
COLOUR BY TECHNICOLOR

with RONALD SQUIRE · A. E. MATTHEWS · WILFRID HYDE WHITE and JANE GRIFFITHS
Screenplay by JILL CRAIGIE · Directed by RONALD NEAME · Produced by JOHN BRYAN

John shared his first art director credit on *The Million Pound Note* (1954), a period comedy made by former Cineguild colleagues Ronald Neame and John Bryan, with the added attraction of a Hollywood star.

the creative units that once gathered under the Independent Producers umbrella now dispersed. *Malta Story* (1953) was one of the first of a wave of Second World War films that would dominate British production in the mid-1950s, and it gave him the chance to travel to the island for location shooting. John's main memory of the film was his intense embarrassment when the director, Brian Desmond Hurst, well known to be gay, described him to a room full of naval personnel as 'the best fuck on Malta'. John protested his innocence, but it was his introduction to the intense and often bizarre dynamics, personal as well as logistical, of working on location.

Back at Pinewood, John Bryan and Ronald Neame, formerly of Cineguild, were starting to carve out their own careers with a series of light comedies. After a delightful Arnold Bennett adaptation, *The Card* (1952), they took a vintage Mark Twain story about a bet to see if the possession of a million pound note will guarantee a life of luxury on trust. *The Million Pound Note* (1954), set in Victorian London, became John's debut as art director, a credit he shared with another relative beginner, Jack Maxted. Twenty years later, they would share an Academy Award for the design and settings of *Nicholas and Alexandra*.

# Chapter 2

## A Wider Canvas

Working under Carmen Dillon at Pinewood had given John an excellent training and the confidence to work independently. But traditional British producers had suffered badly in the late 1940s and settled into an unadventurous routine consisting mainly of low-budget comedies and thrillers. However, fresh opportunities were beginning to appear and John got his chance with a new company, Warwick Films, formed in London by two ambitious American independents. Irving Allen and Albert 'Cubby' Broccoli knew that the major Hollywood studios had revenues earned in Britain that they could not send back to the United States under post-war British and American financial regulations. They also knew that American film personnel could reap tax benefits from working abroad, while there was a pool of experienced technicians in Britain eager to spread their wings on more exciting films. A deal with Columbia to release their films and the underpinning of Britain's recently introduced Eady Levy completed Warwick's new business model, and Alan Ladd became their first star.[1] Ladd's third Warwick film, *The Black Knight* (1954), directed by the Hollywood veteran Tay Garnett, provided John's introduction to working in the new world of transatlantic independents.

The story is set at the time of King Arthur, with Alan Ladd playing a blacksmith's apprentice who wins his spurs as a knight through daring deeds and plays a part in defending Britain against an improbable Saracen invasion. John was to be assistant art director to his old mentor Vetchinsky, and would supervise the English settings at Pinewood while Vetchinsky oversaw the work in Spain, Madrid and around various castles in Segovia and Ávila. The ironies of the situation were to prove numerous. Not only would John's

---

1 The Eady Levy, named after the civil servant who devised it as a means of supporting domestic production, was a tax on all box-office receipts distributed to qualifying British films in proportion to their earnings. It started in 1950 on a non-statutory basis, and continued until 1985.

Patricia Medina with
the image-conscious
Alan Ladd in Warwick's
*The Black Knight*.

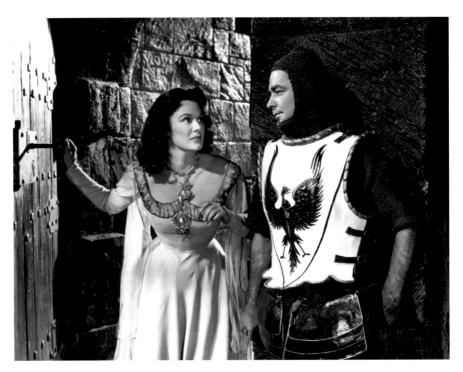

final film, forty years later, be another Arthurian fantasy, but also a senior colleague's illness would push him into assuming a new level of responsibility, as it would again on *Lawrence of Arabia*. Vetchinsky was noted for his gluttony, and when he fell seriously ill after eating shellfish, John took over supervision of the whole production.

This gave him his first substantial experience of working abroad, especially in the country that would be the scene of some of his greatest achievements, with tasks that included creating a mock-up of Stonehenge in Madrid's Casa de Campo park, and also filming Spanish castles. It also provided an introduction to the art department's eternal task of mediating between authenticity and expediency, forever at the mercy of producers and stars. The suggestion that Spanish castles might not be stylistically right was met by Irwin Allen's barking retort, 'A castle is a castle, wherever it is and whatever it looks like.' Alan Ladd, who was then a major star, also had strong views. He explained that the film had a message for contemporary America, where 'every boy aspired to reach the heights and become president of a major corporation'. To get this message across, he wanted the art department to pay special attention to the Black Knight's helmet, and model it on the front of a Cadillac. John caught the eye of the costume designer, Beatrice Dawson, as they stifled their smiles. His eye was also caught by one of 'Bumble' Dawson's assistants, Doris Lee, who had the temerity to speak up at a production meeting and criticise a feeble line in the script. A romance followed and they married in 1953.

John's work on *The Black Knight* secured him a three-year contract with Warwick and promotion to art director on *A Prize of Gold*, shot at the end of 1954 under the direction of another experienced Hollywood professional, Mark Robson. Robson had worked on Orson Welles's spectacular debut, *Citizen Kane* (1941), and started his own directing career under Val Lewton, producer of some of Hollywood's most stylish and suggestive horror movies of the 1940s, including Robson's *Isle of the Dead* (1945). *A Prize of Gold*, starring Richard Widmark as a US sergeant tempted to steal bullion on behalf of a refugee, played by Mai Zetterling, was set in Germany after the war, with filming at Tempelhof Airport, which had recently been the focus of the Berlin Airlift. John appreciated 'a good script' and got on well with Robson, which would lead to him being entrusted with the greater logistical challenge of *The Inn of the Sixth Happiness* four years later.

Warwick had launched with a film about a daring parachute brigade exploit, *The Red Beret* (1953), and as interest in the Second World War continued to grow, they would contribute to the cluster of films made in the mid-1950s that recalled wartime heroism. *The Cockleshell Heroes* (1955) recreated, with some fictional licence, Operation Frankton, a near-suicidal mission carried out in December 1942 by a small squad of Royal Marine commandos who were brought by submarine to the mouth of the Gironde in western France, to canoe sixty miles up river and attach limpet mines to German

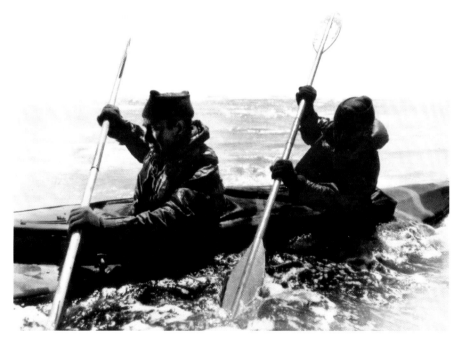

*The Cockleshell Heroes* (1955) teamed John with José Ferrer, directing for the first time as well as starring, and involved re-creating a daring World War Two mission, not in its original French location but in Portugal.

25

warships moored at Bordeaux. Only two of the twelve survived, one being their leader, Major Hasler, played by José Ferrer, who was also directing for the first time, with John as art director. Ferrer, John remembered, 'knew very little about directing, but I was able to help him a bit, even though I was still learning to use locations'.

Filming where the operation had taken place was impossible, so the unit went to Portugal, to shoot on the River Tagus, using the outskirts of Lisbon as Bordeaux. The producer, Phil Samuel, had been a production manager and was overseeing frantic preparations to film on a sandbank as the tide came in. To John's astonishment, he remained stark naked throughout the whole episode. Producers were clearly a law unto themselves. *The Cockleshell Heroes* opened to considerable acclaim, joining the popular success of *The Dam Busters* (1955), *Reach for the Sky* (1956) and, in a more muted vein of wartime celebration, the Powell–Pressburger pair, *The Battle of the River Plate* (1956) and *Ill Met by Moonlight* (1957).

John would serve as art director on two minor Warwick productions directed by John Gilling, *The Gamma People* (1956) and *High Flight* (1957), both of which reflected the Cold War climate of the decade. The first was set in an unnamed Eastern European country, where a scientist is experimenting on its population with gamma rays; while the second was partly filmed at Cranwell RAF station and stressed the tradition linking contemporary air defence with sacrifices during the war. Another background theme that runs through much British cinema of the period is the end of empire, with the debacle of the Anglo-French Suez operation of 1956 bringing this sharply into focus. There were inducements for British producers to film in Commonwealth countries, which encouraged Warwick to make two films in Kenya in 1956, *Safari* and *Odongo*, *Fire Down Below* (1957) in Trinidad and to plan *Zarak* for shooting in India in 1956.

In the event, economy dictated that *Zarak* was filmed in North Africa, in what was still Spanish Morocco, introducing John to another region he would come to know well, and to the pleasure of working with imaginative Spanish assistants. Like most Warwick productions, the film aimed to provide undemanding entertainment – in this case, John recalled, 'action, with lots of sex'. These were to be provided by the striking physiques of Victor Mature, fresh from his triumph in *The Robe* (1953), and the former Miss Sweden, Anita Ekberg, playing respectively Zarak, the son of an Afghan tribal ruler in the 1860s, and Salma, the youngest member of his father's harem. After Zarak is caught kissing Salma, he is nearly killed by his father, but escapes to become a reckless outlaw, hunted by the British Indian army.

The unit was based in what was then the capital, Tétouan, a historic city in the foothills of the Rif mountains that still bore the traces of its Andalusian founders. One important feature of the area was a thirty-foot ravine, used in the film to stage a fight on a suspension bridge, which required maximum teamwork by the whole crew to bring off successfully. John was beginning to evolve his philosophy of conceiving the whole

*Zarak* (1956) promised 'Pillage! Plunder! Passion!', with much of the last to be provided by a voluptuous Anita Ekberg. John particularly relished working with the legendary Hollywood stuntman Yakima Canutt.

world in which the film is set, planning it in terms of how the images would cut together and anticipating how sound could evoke what there might not be money or time to build. He learned much from the stunt supervisor on *Zarak*, the legendary Yakima Canutt, famous for his work on many great Westerns among more than two hundred films. John remembered him as 'a lovable and generous man, who had no hesitation in passing on all his expertise to the Spanish and English stuntmen'. And there was much for John to learn from this seasoned Hollywood professional, since 'laying out in sketch form and designing action sequences is also an important part of the work in an art department'.

Although Victor Mature was the established star, and was given an appropriate welcome by the local people, there was little doubt that much of the film's appeal would centre on the voluptuous charms of Ekberg. To research the atmosphere for the scene of her seductive dance, she and John visited a local dance hall, where the girls all had red hennaed hair and drank brandy disguised as cola. As the evening grew more hectic, John found his wallet had disappeared and a naked dancer was drawing him towards a back room, where two more dancers set upon him. Fortunately, his art director was on hand to mount a rescue and the film party beat their retreat. *Zarak* appeared with a lurid poster featuring the scantily clad Ekberg and promising 'Pillage! Plunder! Passion!' 'Probably the worst film I ever worked on', John admitted, but very good experience of coping

*Fire Down Below* (1957) took John to the West Indies for his penultimate adventure outing with Warwick, starring Rita Hayworth and Jack Lemmon, alongside Robert Mitchum.

with an exotic location. Another opportunistic Warwick production, *Fire Down Below*, directed by Robert Parrish, took John to Trinidad and Tobago locations for a seafaring adventure starring Robert Mitchum and Jack Lemmon, with Rita Hayworth as their mutual love interest. *No Time to Die* (1958) was to be his last job for Warwick, a Second World War battle drama filmed in Tripoli; and for John and the director Terence Young, who had both served in tanks, recreating the experience fictionally proved disconcerting. 'I discovered that it's better to show the opening and then the consequences, and not too much detail' – a lesson that would be applied just five years later in his return to the desert for *Lawrence of Arabia*. There was talk of John directing for Warwick, after his success in managing the visual spectacle of several films, but the company's good run was coming to an end, and its partners would soon go in different directions – Broccoli to form Eon and launch the Bond franchise, while Allen continued the Warwick formula with decreasing success throughout the 1960s.

### The Inn of the Sixth Happiness (1958)

One of the first offers John received after his Warwick prospects declined was from Mark Robson, who was preparing *The Inn of the Sixth Happiness* for Twentieth Century-Fox. Based on a popular book about the missionary Gladys Aylward, who had rescued a hundred children during the Japanese invasion of China in 1941, this posed the immediate

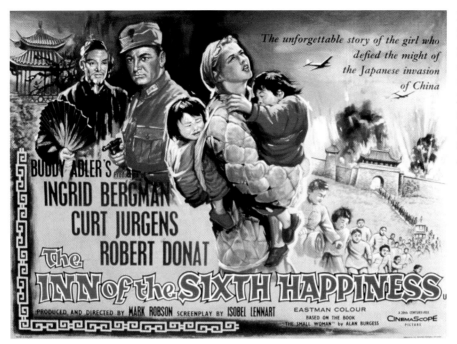

challenge of where to shoot. Filming on location in China was quickly ruled out, and a crisis meeting was called at Fox's European headquarters in Soho Square, London, with the company president Spyros Skouras present, and the inevitable question: 'Well John, what are we going to do?' John didn't have an immediate solution, but promised to come up with one. Thinking about the distinctive features of Chinese landscape, he suddenly realised that these could be found much closer to home, in the mountains and lakes of North Wales. 'Nothing says it's Wales, so if you put in Chinese details, with actors and extras in costume, it can easily become China.'

Having Snowdonia stand in for China was the first of a series of bold strokes of logistical imagination for which John would become famous. Once Robson and Fox were convinced, he set to work, sharing this daunting task with Geoffrey Drake, another of Carmen Dillon's protégés, alongside whom he had served as a draughtsman on *The Sword and the Rose* (1953). The practical problem of finding enough extras to create a convincing China was solved by raiding the Chinese restaurants of Liverpool and recruiting their staff. And the film's casting brought the exciting prospect of working with Ingrid Bergman, who had just won her second Academy Award for *Anastasia* (1956), and with the distinguished British actor Robert Donat, whose last role this would be. There were certainly some issues of authenticity in this story of the intrepid missionary, with a strapping Bergman bearing little resemblance to the tiny Gladys Aylward, and Donat's Mandarin seeming more like an English headmaster, not to mention the entirely

fictitious romantic storyline that introduced Curt Jurgens as Aylward's Eurasian suitor. But the film's physical setting raised no doubts, with Snowdonia providing a versatile backdrop for the story of Bergman's discovery of rural China and how she eventually led her children to safety from the invading Japanese army. *The Inn of the Sixth Happiness* became the biggest box-office success of any film John had so far worked on, and soon led to fresh offers.

## Our Man in Havana (1959)

John's next film would introduce him to the director he admired most next to David Lean. A former actor, Carol Reed had started directing in the mid-1930s, attracting attention in a number of genres before making the trio of films that confirmed him as second only to Hitchcock among British directors. *The Stars Look Down* (1939), *Night Train to Munich* (1940) and *Kipps* (1941) showed Reed's dramatic range and his skill with actors. But it was three post-war successes that revealed his psychological penetration and a growing concern with visual stylisation. *Odd Man Out* (1946) created an expressionistic nocturnal world for its gunman's final hours, and benefited from atmospheric settings by Ralph Brinton. *The Fallen Idol* (1948), about a lonely boy's misplaced faith in the butler who has befriended him, launched a lively partnership with Graham Greene, as well as establishing Reed's skill with child actors. Then in 1949, Greene and Reed created one of the most admired of all British films, *The Third Man*, with a gallery of memorable characters and the remarkable combination of Vincent Korda's sets, especially of the Viennese sewers, and Robert Krasker's angled, chiaroscuro camerawork.

Reed's films during the following decade were of varying quality, before he joined Greene again on a new project for Columbia. This was based on an earlier script idea about a bogus pre-war spy, which Greene had transformed into a sardonic 'entertainment' set in the picturesquely corrupt Cuba of the Batista regime. The central character, Jim Wormold (played by Alec Guinness), is an Englishman who, improbably, sells vacuum cleaners in Havana, while worrying about how he can afford to send his maturing, spoiled daughter to finishing school in Switzerland. The solution arrives in the form of an English spymaster (Noël Coward), who dragoons him into becoming a British agent, 'our man in Havana', and opens the way for Wormold to create an imaginary spy network, the surveillance of which will pay for his daughter's social ambitions.

With John engaged on the strength of *The Inn of the Sixth Happiness*, Columbia offered a choice: shoot in Cadiz in colour or in Havana in black and white? Reed still preferred black and white, believing that 'colour is just not real enough yet', despite his success with it for the garish world of the circus in *Trapeze*.[2] John, too, instinctively

---

2    Nicholas Wapshott, *The Man Between: A Biography of Carol Reed*, Chatto and Windus, 1990, p. 294.

preferred Havana, but after visiting the city with Reed in January, found himself unexpectedly disappointed by the reality of the location. Since Reed wanted to film as much as he could in the studio, preferring to have everything under complete control, the Havana phase of filming was devoted to capturing as much street atmosphere as possible and meeting many of the character types who figured in Greene's story. The CinemaScope format proved particularly good for the bustle of Havana's squares and streets, filled by the massive American cars that remain today as relics. However Reed's idea of having an amorous Cuban couple, first seen during the credits, continue to appear throughout later street scenes proved distracting and largely disappeared during editing.

Coincidentally, the film's atmosphere was already becoming history while the filmmakers were at work in Cuba. Fidel Castro's uprising against Fulgencio Batista had triumphed in the very week that Reed and John arrived in Havana, and they found themselves surrounded by both incoming revolutionaries and what would soon be departing gangsters, as the new regime moved fast to close down Havana's notorious casinos. Fortunately, Greene was *persona grata* with the Revolution, and his presence enabled the unit to recreate the florid decadence of the regime that had just been overthrown – to the confusion of many Cubans. Castro even visited the set, announcing 'you are free to make your film exactly as you please: those are my orders', although a government supervisor kept a close eye on the degree of decadence allowed in nightclub scenes.

Reed had wanted him to stay on to the end of the seven-week Havana shoot, but John knew how much work needed to be done back in the studio and left his assistant Syd Cain to oversee the final weeks on location. For the most important set, which combined Wormold's electrical appliance shop and the upstairs apartment where he lives with his daughter, and which will become the nerve-centre of his bogus spy network, John devised a connecting spiral staircase. He remembered waiting nervously for Reed's verdict, when the director, recently arrived back from Cuba, toured the set, leaving John with his wife Pempie. 'A lot of directors who aren't quite sure what they're going to shoot

The surreal image of a window display in Jim Wormold's Havana electrical appliance shop, created at Shepperton, which inspires his fictional reports of enemy activity in Cuba to British intelligence.

A spiral staircase economically links Wormold's shop with his upstairs apartment, both built at Shepperton. To help link the studio sets with street scenes shot in Havana, John mounted a mock-up tramcar, propelled to and fro by an elastic rope.

Wormold (Guinness) is first approached by Noël Coward's comic spymaster in what appears to be a real Havana bar, where he suggests they talk confidentially in the matched (studio-built) lavatory.

will make trouble over something you've done, to give them time to work out their problem.' But when Reed simply said 'excellent', their relationship was sealed.

Filming Cuba in black and white might have seemed perverse, but it suited John and Reed to play down local colour in order to focus on their tale of expatriate follies. Recurrent scenes set in the Wonder Bar on the corner of one of Havana's arcaded streets of *portales*, with Guinness and Burl Ives in the foreground and passers-by and traffic behind, are superb examples of keeping exotic background action firmly under control. The famous Malecón harbour-side drive provides a suitably opulent setting for Milly's convent school and for the police chief to sweep her off in his sports car. And the extravagant variety of Havana's Cristóbal Colón cemetery offers Burls Ives's compromised Dr Hasselbacher a suitable resting place. To enhance the authenticity of the studio-built shop, amid these distinctive exteriors, John mounted a Havana bus on stout elastic, so that it could be seen moving to and fro through the shop window. The comedy of Noël Coward as Guinness's 'controller' is heightened by scenes such as their first meeting in a bar's lavatory, and by a briefing set on an open beach where Coward conspiratorially closes the bamboo lattice door that Box had provided. As Wormold's

Shooting on the streets of Havana provided invaluable authenticity, but involved keeping the bustling background activity firmly under control in order to focus on the web of expatriate relationships, as between Wormold and Dr Hasselbacher (Burl Ives).

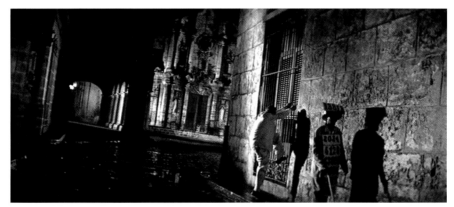

Havana's arcaded portales created the opportunity for several eerie night scenes, recalling the expressionistic nocturnal Vienna of Reed's *The Third Man*, as Wormold's innocent espionage fantasy embroils him in impending violence.

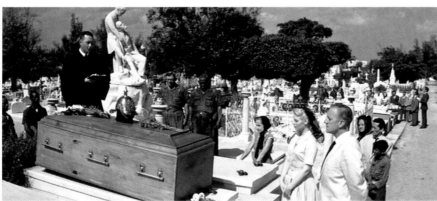

Havana's baroque Cristóbal Colón cemetery provides the setting for two funerals that bring *Our Man in Havana* to its ironic conclusion, with Jim Wormold and his daughter Milly paying tribute to the unfortunate Dr Hasselbacher.

fantasy world is overtaken by the reality of a plot to kill him, the tone changes in a series of scenes set in seedy cabarets and bars, studio-built but based on the crew's hectic nightlife while in Havana. The climactic shooting of Wormold's would-be assassin uses Havana's distinctive arcades, filmed with a tilted camera in an echo of *The Third Man*'s famous expressionistic style.

### *The World of Suzie Wong* (1960)

The combination of his fake Chinese settings for *The Inn of the Sixth Happiness* and the successful mix of location shooting with studio work in *Our Man in Havana* made John an ideal choice for *The World of Suzie Wong*, set in Hong Kong. This had started life as a novel, which then became a successful play in the hands of the Broadway producer Joshua Logan, already responsible for launching Marilyn Monroe in *Bus Stop* (1956) and for the interracial romance *Sayonara* (1957). Suzie is a bar girl in Hong Kong's Wan-Chai district, catering to the constant stream of sailors who pass through in search of a good time. But despite her trade, in true romantic style she remains an innocent and persuades William Holden when they first meet on a crowded ferry that she's a haughty heiress. Holden plays Robert Lomax, a modernised version of the traditional Westerner who has come East to find himself, in this case an architect who wants to be a painter, and he is soon installed on an upper floor of the Nam Kok hotel, where the Wan-Chai girls ply their trade in the basement bar.

Following the same pattern as *Our Man in Havana*, *Suzie Wong* began with a location shoot in Hong Kong to exploit its more extensive exteriors and local colour, before returning to Shepperton for the core dramatic scenes. John relished the bustle of the colony but, as before, left Syd Cain in charge on location when he returned to prepare the hotel interiors and two important studio exteriors: the street outside the hotel and a poor district where Suzie has lodged her secret child, which then becomes the scene of a climactic natural disaster.

The Nam Kok settings show how thoroughly John and his colleagues had assimilated the vernacular design style of Hong Kong, with its widespread use of woven bamboo and intricate ironwork. A circular motif unifies many of the hotel settings, including

John's studio interiors for the Nam Kok hotel, where much of *The World of Suzie Wong* (1960) is set, use woven bamboo and traditional ironwork to create an 'old colonial' atmosphere.

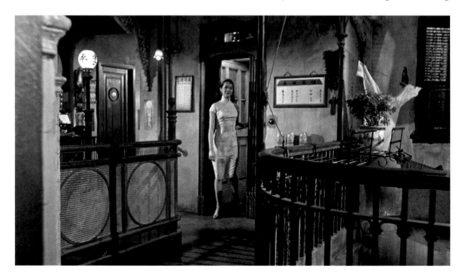

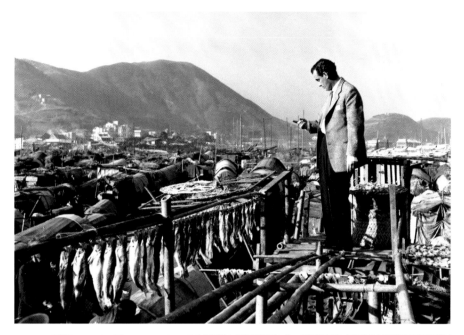

John supervising the dressing of a location-built fish market set for *The World of Suzie Wong*.

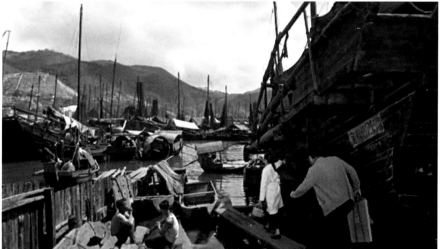

Making effective use of the location shoot, Suzie (Nancy Kwan) takes William Holden, a would-be artist, to see the 'real' Hong Kong in an extended sequence filmed around the harbour.

the transitional spaces of the lobby, stairs and landings. The staircase into the basement is spiral, as in Wormold's Havana apartment; the front desk is a quadrant when seen from above; and almost all the doors and screens have circular panels. These circles, and the textures associated with them, contrast sharply with the bland rectilinear lines of European spaces, such as the bank, where Robert first encounters British colonial Hong Kong, the manager's apartment to which he is invited for dinner and the stuffy European club where he and Suzie are patronised by the staff. Here the 'negative design' used for

The bar of the Nam Kok hotel is the focus of interaction between the wan-chai girls and their mainly sailor clients. The style of Phyllis Dalton's distinctive high-collared sheath dresses was revived in Wong Kar-Wai's *In the Mood for Love.*

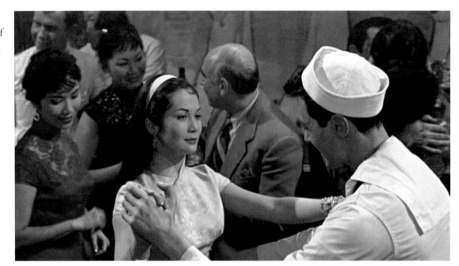

these frigid, disapproving spaces sets off the exotic Chinese demi-monde that stimulates Robert's burgeoning artistic imagination. As his relationship with Suzie develops, so his confidence in his painting grows and the room fills with colourful canvases.

Costume plays a vital part in the dramatic progression of the film, with Robert's dark suits steadily giving way to a blue artist's jacket, albeit punctuated by occasional awkward forays into European society in formal dress. But the key element of Phyllis Dalton's costume design is the Wan-Chai girls' uniform of high-collared silk dress, deeply slit at the thigh to convey a teasing eroticism – a style that Wong Kar-wai would revive in his nostalgic *In the Mood for Love* (2000). The production of *Suzie Wong* also gave John a taste of the high tension that accompanied many major films. This was Ray Stark's first independent production, and on the first day of shooting he showed the ruthlessness for which he would become famous by firing the original director Jean Negulesco and replacing him with Richard Quine. Nonetheless, the film was well received, with *Variety* considering it an improvement on the stage version, and noting that 'the ultra-picturesque environment of teeming Hong Kong brings a note of ethnic charm to the production'.

# Close-up 1

## *The Inn of the Sixth Happiness*: Finding China in Wales:

*The Inn of the Sixth Happiness* is set in mainland northern China, where there was
no chance of filming in 1957, less than ten years after Mao's Long March and the
installation of a Communist government. The island of Taiwan, where General Chiang
Kai-shek had retreated with his nationalist government in 1949, might have provided
an alternative location. John went to reconnoitre, guided by the film's real-life subject,
the missionary Gladys Aylward, who then lived in Taiwan. He remembered that he was
'not impressed' by the landscapes he found, although Aylward provided much valuable
background information. However, Taiwan's leaders decided that supporting a film
that showed the 'old China' of mandarin rule, foot-binding and missionaries would not
project a positive image of their regime, and withdrew cooperation.

For the first time in his career – but not the last – a production depended on John's
judgement about the feasibility of an alternative base for principal photography, when
the 'original' was ruled out by political considerations. Once he had realised that the
rugged landscape of the story's setting could be found much closer to home, in the
mountainous north-west region of Wales then known as Caernarvonshire, the issue

Gladys Aylward (Ingrid
Bergman) starts on the
path that will eventually
take her to China
working as a servant
in London, and John
no doubt recalled his
schooldays in Highgate
when choosing this
impressive façade.

Figures in Chinese dress and foreground props were the key to ensuring that North Wales successfully represented China, as Alyward approaches the remote town of Yang Cheng.

became how to 'dress' this area to create the illusion of the barren Chinese province of Shanxi, to the south-west of Beijing. Apart from the similarity of its mountains and sparse trees, the key to using what is now Gwynedd, including the Snowdonia National Park, lay in its emptiness: with few buildings or identifiable landmarks, the production was free to introduce a variety of Chinese elements.

The art department were charged with creating the film's two major location set-pieces: the remote town of Yang Cheng (Yuncheng), where Aylward worked as a missionary from 1930, and its subsequent destruction by bombing as a harbinger of the Japanese invasion that led to her celebrated rescue of a hundred children. Once Aylward, played by Ingrid Bergman, arrives in China after her journey on the Transsiberian railway, her and our first taste of China is the bustling market of Tientsin, dominated by the blue clothing of the extras. When she sets out on a mule to the remote Shanxi region, the siting of a foot-powered irrigation pump as a key foreground construction helps establish the backwardness of 'China'. Costume and vehicles remain the only dressing of the Welsh hillside, with conical straw hats playing an important role as well as a reed roof on a boat, before the dramatic 'reveal' of the ramparts of Yang

The ramparts of Yang Cheng were a major construction project, to clinch the sense of being in traditional China, but are only seen fully in long-shot, when Alyward arrives and leaves during the Japanese invasion.

Cheng, seen from the valley below. The scale of this construction, thrown across the hillside, is especially impressive in CinemaScope and did not require any detail, since it is only seen from a distance in establishing shots.

Most of the interior of the town is studio-built, with the shabby forecourt of the 'Inn of the Sixth Happiness' (in reality known as the 'Inn of Eight Happinesses') providing an important setting for many of the events that mark Aylward's journey from her arrival as a gauche outsider to taking over after the death of her mentor Jeannie Lawson (Athene Seyler) and becoming a trusted protégé of the local governor in his campaign to end the custom of foot-binding. Chinese lettering profusely painted on doorways and buildings plays an important part in maintaining the sense of an exotic culture, although one that Aylward increasingly understands and where she is accepted as Jan-ai (literally 'she who loves people'; in fact Aylward was known as Ai-wei-de, 'the virtuous one').

The interior of the inn, where Lawson and Aylward try to hold the attention of mule-drivers by telling then Bible stories ('Chinese people love stories') is deliberately

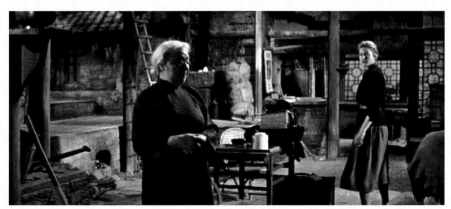

The studio interior of the inn where Aylward and Jeannie Lawson (Athene Seyler) set out to attract potential converts with good food and story-telling .

The design for the Mandarin's house, where Robert Donat becomes a reluctant admirer of Alyward's determination, uses a mass of traditional Chinese decoration, including a stylised garden seen through the window.

Welsh mountains with added temporary buildings to create an outlying village where Alyward has her first experience of acting as the Mandarin's 'foot inspector', to end the custom of tightly binding girls' feet.

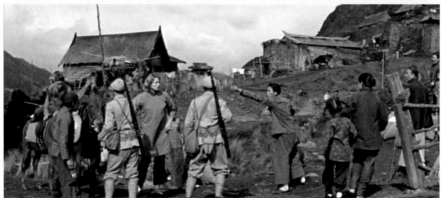

plain, featuring a large raised platform over the stove that becomes a heated communal bed. Later, it will be decorated with biblical pictures in Chinese style. By contrast, the palace of the Mandarin governor, played by Robert Donat in what would be his last role, is rich with intricate decorative Chinoiserie, and the vistas seen through its windows are modelled on traditional Chinese landscape painting, suggesting that this is already a lost world. Even within the highly coloured world of the Mandarin, first seen with his concubines in vividly contrasting dresses, there is a careful use of 'withheld' colour. Aylward appears normally in her blue tunic, but for the party that he throws in honour of the government representative, Captain Lin Nan (Curt Jurgens), who has fallen love with Aylward, the Mandarin gives her a bold red dress to wear, echoing the red robe he wears while painting during one of her earlier visits. The climax of the party is a dinner round a large circular table, accompanied by a Peking Opera entertainment that is cut short by news of the Japanese advance. Later, after the town has been bombed, the Mandarin sits with his officials for a last meal at the same table, now entirely dressed in black and grey, relieved only by the blue edging of his undershirt.

Another exterior setting is the village where Aylward passes her first test as Foot Inspector, persuading the reluctant women to think of their children's future health. Here, Chinese-style roofs with pointed gables have been added to the basic stone structures, which may well have been Welsh farm buildings. And in a pattern of visual 'rhymes' that John would use throughout his career, the close-ups of bound feet are later echoed by the bloody rags on the feet of Aylward's children as they near the end of their long march to safety.

Before this, the film is punctuated by its most dramatic sequence: the bombing of Yang Cheng by the Japanese. This is handled in highly effective, textbook style. Aylward is working in the fields when the menacing sound of aircraft is heard off screen. Three planes appear and begin to strafe and bomb. A series of spectacular explosions rip through the buildings of Yang Cheng, intercut with panic-stricken close-ups of adults and children. After the Mandarin addresses the people, a departing column snaking down the mountain is seen from the same angle that provided Aylward's first sight of the city, now with black smoke rising. And following her escape having bid farewell to her dying helper Yang, she hides from the advancing Japanese soldiers among the gravestones in the same cemetery where Jeannie Lawson is buried.

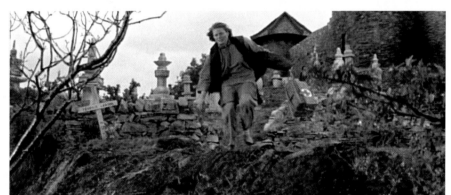

Aylward narrowly escapes the Japanese assault by fleeing through the cemetery, filled with traditional Chinese gravestones, and with a portion of town rampart visible behind.

The distressed and deserted exterior studio set of Yang Cheng, in sharp contrast to its earlier bustle, effectively conveys the devastation of the Japanese invasion.

The rugged mountains of Gwynedd, and one of its rivers, become the main setting for the climax of *The Inn of the Sixth Happiness*, as Aylward hides her children from the Japanese invaders and leads them to safety.

Alyward leads her band of refugee children across the barren landscape, menaced by advancing Japanese troops, but helped by a former inmate of the local prison, where she had successfully ended a riot, and by a bandit leader she had befriended. Here it is the wild landscape of Gwynedd that becomes the star of the film, as John had realised it would, providing spectacular vistas, a rushing river to cross and a distant view of the Yellow River, which is their goal as the children sing the film's hit song, an updated version of 'This Old Man'. Aylward's journey ends with her triumphant reception by the very missionary who had initially rejected her as 'unqualified'.

# Chapter 3

Meetings with Remarkable Men

Designing *The World of Suzie Wong* and *Our Man in Havana* had given John a taste for projects with exotic settings that posed a challenge to the art department. He also appreciated the chance to learn from directors of stature, such as Carol Reed. Returning to Shepperton to design a 'very British' political comedy by the Sidney Gilliatt–Frank Launder team, *Left, Right and Centre* (1959), did not inspire him. Nor did the Peter Sellers prison-based comedy, *Two-Way Stretch* (1960), also made at Shepperton. There were exciting new developments in British filmmaking at this time, such as *Saturday Night and Sunday Morning* (1960), shot entirely on location in Nottingham, and *A Taste of Honey* (1961), filmed in Manchester and Blackpool. But the routine diet of studio-based comedies and dramas made few demands on their art directors. He was about to be rescued.

Out of the blue came an invitation to travel to Paris for a meeting with the only truly international British director, David Lean. Ever since the great box-office and Oscars success of *The Bridge on the River Kwai* (1957), Lean had been looking for a subject with similar epic potential. The life of Gandhi attracted him and led to a script commissioned from Emeric Pressburger, which Lean then rejected. Miraculously, a project that had been passed around for over thirty years – the life of T. E. Lawrence – came together through the determination and ingenuity of *Kwai*'s producer, Sam Spiegel, who would make the film with Columbia's backing. The production was publicly launched in February 1960, although few of the elements were then in place, including who would play the lead. While speculation ran high, with names ranging from Marlon Brando to Albert Finney, Lean was assembling his team, and John surmised that 'he thought I'd been good enough for Carol Reed so perhaps he should meet me and talk about it'. Summoned to take tea with Lean at the Georges V hotel on the Champs-Elysées, John was introduced to the future Mrs Lean, Leila Matkar.

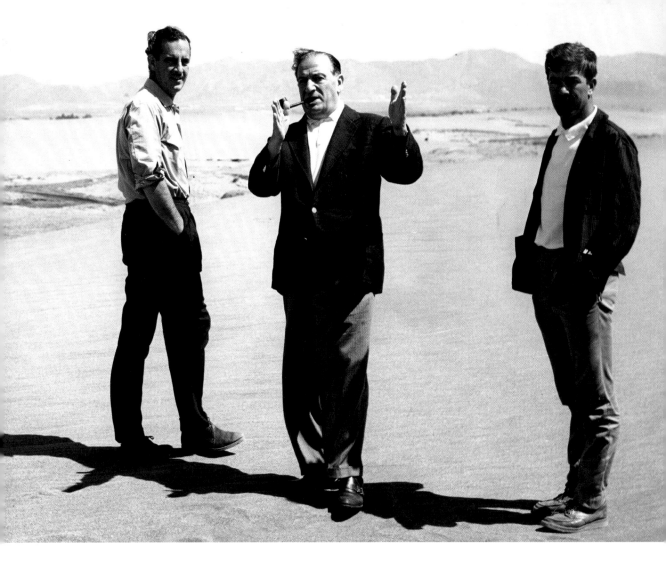

The redoubtable producer of *Lawrence of Arabia*, Sam Spiegel, in the desert with Terence Marsh and John, who he would increasingly rely on for logistical decisions and to communicate with Lean.

His first assignment was to visit Jordan with Sam Spiegel, a trip that prefigured the peacemaking role he would play during the film's stormy production. Spiegel fascinated and impressed John. He had made a personal fortune with *Kwai*, part of which he spent on a 500-ton yacht, which would figure prominently in the logistics of *Lawrence*. Austrian by birth, he had lived in Jerusalem in the 1920s and worked in production in Germany up to 1933, before moving to the United States, where he became 'S. P. Eagle' for a decade in Hollywood. His company, Horizon Pictures, was based in Britain from the early 1950s and usually produced for Columbia. By the time John started working for him, he had already won Best Picture Oscars for *On the Waterfront* (1954) and *Kwai*.

John visited Wadi Rum, the desert area that lies north of Aqaba, where T. E. Lawrence had established his base during the Arab Revolt of 1917–18 and duly fell under the spell of its eerie landscape of strangely shaped rock outcrops rising out of the sand. The spectacular Nabatean city of Petra, cut into the rock, is nearby and to the north is Mount Nebo, the site of Moses's death as recorded in the Book of Deuteronomy. Having revered

Lawrence since his youth, he now began to understand the extraordinary appeal of this ancient landscape in which he had created his own, modern legend. But an unpleasant shock awaited him back in England. John Bryan, whom he still admired enormously, had also been assigned to the film, a decision Lean seemed unwilling to explain. Swallowing his pride, John decided to stay on, and went back to Jordan, where Bryan suggested that he should 'look after the accounts and administration, while I get on with designing the picture'. Then, in another twist to the story, Lean announced that Bryan was leaving, because his health wasn't up to such a strenuous shoot in the desert, and John was invited to 'take over and get started properly on making the film'.

A typically posed photograph by Lean of the spectacular desert city of Petra, which he decided not to include among the film's locations to avoid distraction.

The suddenness of his apparent demotion and promotion troubled John, but there was no more time to lose on a production that had already been marking time for too long. He threw himself into finding the locations for what would be our introduction to the desert, after Lawrence leaves Cairo with his single Arab guide. 'There was something not quite right about the white flatness of Al Jafr, where we would eventually shoot the mirage. The desert has to stretch your eyeballs more.' Thanks to the advice of a Bedouin soldier in the service of King Hussein, John visited Jebel Tubeiq, near the Saudi Arabian border, and decided this would be the perfect setting for Lawrence's first desert journey. Both Lean and Spiegel were initially furious at this suggestion: Lean because he had just fired the scriptwriter Michael Wilson, with whom he had worked on *Kwai*, and was starting work with Robert Bolt; and Spiegel because of the new location's remoteness and the cost of servicing the large unit that would be required. But Lean quickly saw its pictorial potential and signalled his agreement by complaining to John that he hadn't warned him to bring his toothbrush.

Deciding to film at remote Jubel Tubeiq caused logistical problems and expense, but John had adopted Lean's insistence on trying to communicate the true desert experience.

When Robert Bolt joined Lawrence to revise Michael Wilson's original script, John quickly came to appreciate his qualities, and later annotated this photograph of Bolt on an early location visit.

Robert Bolt had no previous film experience, but was riding high on the success of his play *A Man for All Seasons* – the film version of which John would later design. Soon he would be working closely with Lean and John, not only on dialogue and structure, but also on the transitions between sequences that Lean considered so important. How to introduce the desert? John had deliberately located Lawrence's map room in Cairo in a basement, to prepare for the dramatic impact of the desert, and had decorated the office in which he is first briefed with a painting of heavy artillery, to recall the distant Western Front. Now, with Lean and Bolt, he would plan the most important transition in the film, from Cairo to the desert. Lawrence strikes a match, as he tells Claude Rains that his mission will be 'fun' – and 'wham: the desert. No dialogue, no music', just the boldly simplified image of the sun appearing over the horizon heralding the entrance of the tiny figures of Lawrence and his guide, accompanied by Maurice Jarre's stirring music.

John insisted that what has become one of the most memorable moments in modern cinema emerged from a brainstorming session between Bolt, Lean and himself. He also talked of working with Lean as 'a game: who was going to get the bright idea first?' While he suggested that Lean 'almost invariably did get it first, which made it marvellous to work with him', others who worked on the films they made together recall how the director came to trust John's judgement and to accept his radical solutions to major challenges.

After shooting the well episode (see 'Close-up') and the great scenes of Feisal's and Auda's camps in Wadi Rum – where insisted on building real tents whose 'interiors'

'Wham – the desert. No dialogue no music'. John worked closely with Lean on planning this most vital moment in the film, when we discover the grandeur of the desert and its 'eyeball-stretching' scale in a bold transition from microcosm, Lawrence's match flame, to macrocosm, as we see the vast expanse of desert landscape. John insisted that it was usually Lean who proposed these dramatic moments of punctuation, but admitted that he was increasingly a part of the brainstorming process that led to them. And planning such transitions to achieve maximum impact became an essential part of his design technique.

The Wadi Rum in Jordan lay at the centre of the film's evocation of the desert and the Bedouin, and provided the arena in which its most impressive scenes of massed Arab cavalry were staged.

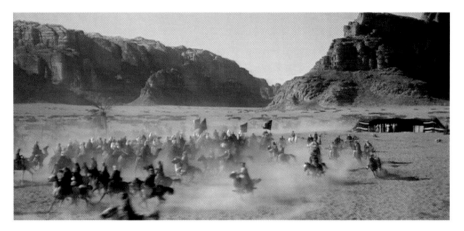

would be infused with desert atmosphere – it became clear to Spiegel and to John that the remaining major scenes could not be filmed in Jordan or any nearby country. With Spiegel's blessing, John travelled to Spain and enlisted the help of contacts from his Warwick days. While accounts differ about who discovered which location, two key centres emerged: Seville and Almeria, which was then little more than an Andalusian fishing village. In Seville, John was able to dress various 1930s buildings decorated in the Moorish style to represent Cairo and Damascus. Around Almeria, he was able to stage the train derailing scene, directing one of the cameras himself, and to build a dramatically simplified version of the real Aqaba (see 'Close-up').

These are the visible achievements of the art department, some of which are remarkable: tributes to Spiegel's skill in persuading Columbia to back a film once estimated at $3 million that would eventually cost $11 million; and also reminders of how cheap labour was in both Jordan and Spain at this time, allowing major effects to be achieved by sheer manpower. But John was also becoming a much more important figure than would normally be the case for the production designer. Lean had learned to trust his judgement and admire his resourcefulness in Jordan. Outraged, however, by the decision to move from Jordan, Lean arrived in Spain, after an eleven week shut-down of the production, in an antagonistic mood. 'You got me out of Jordan. Are you sure we can finish the film here?' John knew that he had still not solved many of the outstanding

An important reason for moving the production from Jordan to Spain was to use the ensemble of Moorish-style buildings erected in Seville for an international exposition, These doubled as Cairo and Damascus.

location problems, but bluffed to encourage Lean. In the nick of time, his art director, John Stoll, reported that the exhibition buildings in Seville could become Cairo, and maybe also Damascus.

Leadership, teamwork and diplomacy became key features of John's contribution to *Lawrence*. Terence Marsh recalls his courage:

> One of the great things about John was that he was never afraid to take responsibility. In our business, time and money are so precious, that decisions can cost a lot of money or save it. Most production people would say 'that's someone else's decision'. But John would say, 'I'm telling you it can be done and I'll back that decision', and consequently he sort of ran the movie. Sam kept hands off, and the production manager John Palmer, a wonderful man, had so much day-to-day administration to manage – the thousands of people, the horses and camels, and the feeding – that John [Box] would take control. 'This is what we'll do: we'll go here, we'll build the train, we'll lay the tracks on the sand dunes at Almeria. We'll get a quantity surveyor down to say what we need to do to put the lines in. And during the time we're doing this, he's building that. At Pinewood, the production manager would say, 'We're on stage B, and then Stage C', and we hardly ever moved out of the studio. We'd build the exterior of a house on the stage. The gravel drive would be cork chippings, so that the tyres didn't make a noise; and on location, there'd be a double in a hat on long shot running to the car, and that would be it. But to do everything out there and for real, and to meet someone like David, who was full of himself after *Bridge on the River Kwai* had been a smash hit – that was something else!

The only way that John could operate on such a scale was by trusting his team to play their parts, as Marsh remembered:

> There was a lot of pressure. You've got to be able to delegate, because you can't do everything yourself on big movies – which was a hard lesson for me to learn. I could never really let go of the reins the way John did. Once you did something for him and it was OK, he'd let you get on with it. He trusted you – to build Aqaba, to do this, to go to Granada, and report back and send stills. Obviously he would do the main designing sketches, and you'd have these as your blueprint to work to.

Spiegel insisted that there should be a sketch artist to provide Lean with set-up visuals in order to save time during shooting. But Lean had no wish for such assistance and ignored the sketches, intent on waiting for the right angle of sunlight or cloud formations. A common interest in still photography created a bond between John and Lean, and John would supply the director with the photographs he needed to plan key shots. Terence Marsh recalls: 'Photographs were very important to David … he had a very, very

good eye. Pity the poor sketch artists, who eventually took refuge in alcohol – like a lot of the actors!'

The costume designer Phyllis Dalton had worked on a number of John's earlier films, including *Suzie Wong* and *Our Man in Havana*, and they had developed a close rapport. 'John always believed in putting things in context, looking at costumes in the settings where they would be seen. And he would be there if you were showing things to David, because sometimes directors need reminding that there's a reason why they have this or that.' The wardrobe requirements for *Lawrence* might appear simple: no women and everyone either in army uniform or Arab dress. Some of the costumes were indeed easy to source: Dalton ordered Jack Hawkins's and Peter O'Toole's from Allenby's actual tailor, Gieves & Hawkes in Savile Row, although O'Toole's uniform was carefully designed to emphasise Lawrence's awkwardness as a soldier. But Turkish army uniform of the period proved harder to research, despite ready cooperation from the Turkish government and the resources of the Imperial War Museum, and was eventually manufactured in bulk by a north of England clothing company.

Even Arab dress, apparently timeless to untrained Western eyes, posed problems. 'The Jordanian extras didn't want to wear the white shirts that their grandfathers had worn, or go barefoot. But they agreed when the King told them it was necessary for the film.' Hussein, then only twenty-six, had become King of Jordan ten years earlier in dramatic circumstances, having narrowly escaped the assassination that claimed his grandfather, and after his own father had been declared mentally unfit to rule. He was not only an enthusiastic supporter of the film, but through it also met his second wife,

Bedouin extras were provided with sets of clothing graduated according to condition, but were initially reluctant to wear old-fashioned dress until King Hussein urged them to support the film. Photograph by Phyllis Dalton.

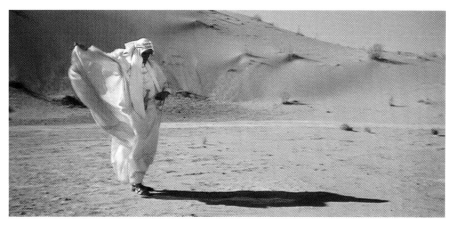

Peter O'Toole's costume followed the same principle as those of the extras and became a subtle commentary on his growing disenchantment, as it deteriorates from pristine, when he first admires his image as an 'honorary Arab', to gossamer-thin at the end of his mission.

Toni Gardiner, one of the secretarial crew in Amman. Phyllis Dalton had researched the distinctive dress of the many Bedouin tribes, and every extra was equipped with a suitcase containing ten costumes in progressive states of decay and age.

Lawrence celebrates his acceptance by the Bedouin as 'El Laurens' by admiring his new image, resplendent in white robes, as reflected in the blade of his dagger. John and Lean decided to reveal his growing self-doubt and disillusion by means of subtle changes in his costume. The material would become flimsier in successive scenes, until it is 'as thin as butter muslin' by the end. 'The audience is not supposed to notice, but they're meant to feel it.' The same visualisation of Lawrence's state of mind is continued into the final shots, as he leaves the desert, visible only through a dust-covered windscreen. 'You don't get the full image of Lawrence. It's not big set stuff, but it's so important. And when he does raise himself above the windscreen for a moment, Peter played that so beautifully.'

All who worked on the film agree that John's authority grew during the eighteen months of production, as Lean became increasingly willing to trust his judgement, to

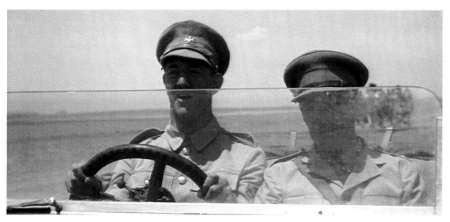

The final image of the film is of Lawrence barely visible through a dusty windscreen, simultaneously showing his disengagement from the desert and hinting at the iconic status he will achieve.

the point where it is now almost impossible to say whose input was greater in some of the film's most famous sequences. And in spite of the legendary feats of logistics and construction required for some episodes, many of the most effective scenes are also the simplest. For the crucial sequence of Lawrence's humiliation by his Turkish captors, John was clear that no detail of the set must distract attention from the drama unfolding between the actors:

> It has to be just the Bey (José Ferrer), the look in his eyes, Lawrence about to be humili-ated, stretched out on a bed. There was a detail, Lawrence's hands held by a Turkish soldier, who keeps stroking him, as if to say, 'You're going to like this'. The set had a balcony, and David had the idea to put the Bey on the balcony and play the scene off him: Ferrer holds up a handkerchief and David told him he had to have an orgasm while watching Lawrence's humiliation.' We shot the sequence, and it was very powerful, with no design aspect imposing itself.

John's diplomatic skills became crucial during the production of *Lawrence*, when the already fraught relationship between Lean and Spiegel reached the point that they refused to speak directly to each other. He tried to be impartial, 'for the sake of the film', although both would try to use him to advance their own position.

Lean would vent his frustration in threatening letters, and on one occasion he de-manded that John deliver one of these missives personally to Spiegel on his yacht in Monte Carlo. Exhausted by all his art department responsibilities, but at Lean's insist-ence, John duly arrived with the letter, whereupon Spiegel demanded that he stay for dinner and sleep on the yacht. When John awoke late the following morning, he found they had sailed overnight to Portofino, where Spiegel was on deck instructing his crew on which of the local girls who had swum out to the yacht should be rescued for his further entertainment. Like Lean, John found Spiegel's playboy activities hard to stomach when the production was under such pressure, so he asked for an answer to Lean's letter and returned to Spain with the curt and obscene response.

Although Spain had provided many of locations needed, a few unfilmed scenes remained by mid-1962. In desperation, the unit moved across the Mediterranean to Morocco, to an inland site some nine hours from Casablanca. Here, in a large and unpic-turesque expanse of desert, they would film the advance of the Arab army on Damascus and the massacre of the Turks at Tafas, using Moroccan soldiers as extras. Here they would also film the shot that recalls Lawrence's earlier contemplation of his 'Arab' image, when he sees his tarnished image in the same dagger, now bloodstained after the mas-sacre. The film's final shots were made back in England in September, then Lean began intensive work in the editing room with Anne Coates, while sound and Maurice Jarre's haunting music were also added. Miraculously, the film was ready for its world premiere

on 10 December 1962 – when, notoriously, the Duke of Edinburgh asked Lean if he was about to see 'a good flick?'.

By the time *Lawrence* had won seven Academy Awards, including one for Best Art Direction and Set Decoration, shared between John, John Stoll and the set dresser Dario Simoni, John was trying to come to terms with the sense of anticlimax back in England:

> It was one of the big things in one's life, with so many remarkable people involved, and it turned out to be a remarkable film. I was very difficult to live with as a person afterwards, because it had changed me, as a person, as well as in terms of filmmaking.

He needed a rest, and time with his family, but a call came from Ray Stark, the producer of *Susie Wong*, who wanted John to design a film in Ireland, *Of Human Bondage*, based on Somerset Maugham's autobiographical novel about a young medical student and his sentimental education. Doris, John's wife, encouraged him to accept, pointing out that they could visit him in Ireland; and so he took up the offer, enlisting Terence Marsh as his art director.

Ray Stark was another producer in the Spiegel mould, famous for his manipulative and controlling ways. Immediately before *Human Bondage*, he had been production executive for Seven Arts on *West Side Story*, which had swept the board with ten Oscars at the 1962 Academy Awards. No sooner had John started on the Maugham adaptation in Dublin, with the redoubtable Hollywood professional Henry Hathaway directing, than Stark fired Hathaway. Bryan Forbes, who was acting in the film and had written the script, took over, before Ken Hughes came on board – and promptly dropped Forbes from the cast. Terence Marsh recalls overhearing the clash between Stark and Hathaway, with 'worse language than he'd ever heard'; while John remembered the pleasure of discovering Dublin, with the actress Siobhan McKenna as his guide. He would soon be able to repay her kindness by persuading Lean that she should play Lara's mother in *Dr Zhivago*.

Although this third version of Maugham's novel was heavily criticised at the time for the casting of Kim Novak and Laurence Harvey in the roles originally played by Bette Davis and Leslie Howard, there is much to be said for Novak's portrayal of the downtrodden waitress Mildred (and it was allegedly Hathaway's unsympathetic treatment of her that led to his dismissal). For what would be his last film in black and white, John conjured an atmospheric Victorian London, making good use of Dublin's historic buildings and the work of the scenic artist Adolphe Van Montagu.

# Close-up 2

*Lawrence of Arabia*: 'You'll never do better!' – From the Desert to a Spanish Damascus

The desert is such a physical presence – 'eyeball stretching' as John put it – in *Lawrence of Arabia* that it is easy to underestimate how much artifice was needed to achieve this impact. But John and his art department were faced with considerable problems in capturing the spectacle. Other settings were also vital to frame the desert scenes and advance the narrative, and the boldest move for the production was to leave Jordan, initially against Lean's wishes, in search of different locations

At the beginning of Lawrence's desert trek in search of Arab allies, he has a dramatic encounter that marks the first stage of his initiation into Bedouin customs. While drinking at a well, a shot rings out and his guide falls. A blurred figure appears as if out of a mirage and gallops towards him, finally revealing Omar Sharif dressed in black as Sherif Ali. For the most arid desert scenes, John had found a strange flat area of 'absolute whiteness', Jebel Tubeiq, on the Jordanian–Saudi border. Now he was faced with the considerable problem of creating an image of a camel and rider appearing gradually out of a mirage. Part of the problem was photographic, and the director of photography Freddie Young had found a massive 500mm telephoto lens in Hollywood that would allow the audience to see details of the heatwave and the blueness invisible to the naked eye'.[1] But Lean wanted the shot to be continuous and to run as long as possible, potentially for the full 1,000 ft the camera's magazine would hold, which would last nearly ten minutes in 65mm.[2]

---

1    Freddie Young, *Seventy Light Years: A Life in the Movies*, Faber, 1999, p. 93.
2    Brownlow, *David Lean*, Richard Cohen Books, 1996, p. 769, n. 91.

John, for his part, was worried by the lack of 'concentration' in the image, both for the audience, unaware of what was about to unfold, and for Peter O'Toole, who was nervous on the morning of the shoot. The first part of his solution was to 'paint' the area that Sharif would cross, sprinkling black basalt to create subtle perspective lines leading from the foreground well and camera position – a feat that involved considerable overnight work. Then, shortly before the first take, he had the idea of creating an extra camel track towards the well, to help O'Toole focus on the otherwise featureless expanse. The result was one of the most memorable, and apparently simple, shots in the film, completed by the strange swishing sound of the camel approaching. 'David came over to me and said: "I don't know how long you're going to be around in film, but that was creative designing. You'll never do better!" And Peter came up and just gave me a big hug.'

The greatest contrast to the well, in terms of doing more rather than less for a single shot, came after the unit's move to Spain, in search of fresh locations for the many un-filmed scenes. John had already surveyed the landscape around the port of Aqaba, which served as a base for the production unit, and rejected the possibility of filming one of Lawrence's boldest tactical coups *in situ*. Assuming that Aqaba would only be challenged from the sea, rather than from its barren desert hinterland in 1917, the Turks had gun emplacements facing seawards. Lawrence led his Bedouin army across the desert to attack from the land, and Lean's intention was again to film this in another extended single shot. Having found that the real Aqaba 'didn't formulate itself dramatically', John was looking for an alternative in Spain. Eventually he found a dry river-bed at Carboneras, near the unit's new base in Almeria, and conceived the bold plan of building the whole town of Aqaba as a set, intended to be filmed from one angle only.

Lawrence's first meeting with Sherif Ali (Omar Sharif) at a desert well was elaborately planned to achieve maximum impact. Lean originally intended to shoot it in one very long shot, but later decided to shorten this and add closer shots. John's contribution was to 'dress' the desert with differently coloured sand and pebbles, providing both the actors and viewers with perspectival emphasis.

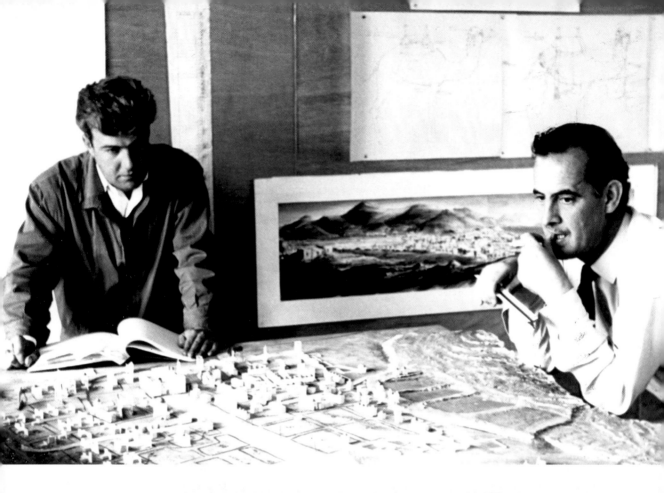

Above: John with
Terence Marsh and
the model they created
for an 'Aqaba' to be
built in Spain, to make
possible the exhilarating
charge and victory that
confirm Lawrence's
military reputation.
Right: photographs
documenting the
dummy Aqaba as it
takes shape under
Marsh's supervision.

Opposite: the interior
of the Plaza de Espana
in Seville provided the
basis of an impressive
council chamber for the
Arab forces after they
have taken Damascus.

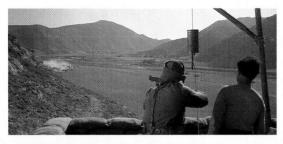
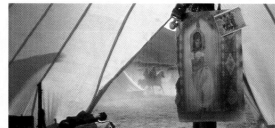

When the art department produced a model, Sam Spiegel accused John of 'building a city' and swept buildings off the model. Terence Marsh, then an assistant art director, was deputed to oversee clearance of the river-bed and construction of the fake houses, living on the site for several months while 300 Spanish labourers prepared this vast open-air set. Many of the stones cleared to form pathways for the camels were used in the new buildings, and for the sea wall that John added as a riposte to Spiegel. Again, the sweeping pan that shows Lawrence's attack proved a triumph of grand simplicity in both direction and design, although the cost of building Aqaba continued to rankle with Spiegel even after the film's successful release – until he was reminded that he had failed to turn up at the crucial meeting at Carboneras to approve the set.

A group of buildings in Seville originally created for the Spanish-American exhibition of 1929 proved invaluable as settings that could double for Cairo and Damascus. The sweeping crescent of the Plaza de España was a late example of the Andalusian Mudéjar or Moorish style, which had been widely used for synagogues and movie theatres, and its self-conscious historicist use in Seville was a godsend for *Lawrence*. No doubt because they had abandoned Jordan, Lean and Box were still strongly motivated to make the film look as authentic as possible. Terence Marsh recalls how John's search

Frames from the capture of Aqaba, as the Turkish defenders first see Lawrence's Bedouin army appear from the undefended desert hinterland. A close-up of a belly-dancer's picture helps ensure the audience knows that this is held by Turkish troops, as well as providing a poignant detail before the battle. And the final image of the gun turret pointing obtusely towards the sea underlines the strategic cunning of the plan.

The search for
ideal shots led to a
temporary new level
being constructed on a
building in Seville and
false domes being fitted,
so that General Allenby
(Jack Hawkins) can be
shown looking out over
'Damascus'.

The need for speed and
economy encouraged
John to use an existing
hut and an unexpected
cut to a ship's funnel,
after its siren has
been heard, to signal
that Lawrence and
his companion have
actually reached the
Suez Canal.

for 'the best set-ups wherever they happened to be and no matter how inconvenient'
led to building a rooftop office on a museum in Seville just for the potential backdrop
of domes. John led Terence onto a sloping tiled roof and outlined the plan, which then
had to be explained to the disbelieving construction manager, Peter Dukelow. But to
achieve the desired view, all the buildings visible from the new window also had to
be fitted with temporary domes. David was reportedly very pleased, although few are
likely to register this as one of the film's memorable images.

    With time and budget running out, the art department had to resort to increas-
ingly ingenious solutions. One outstanding problem was how the news of the victory
at Aqaba was to be brought to Cairo. There was no question of going back to the real
port, but John remembered an abandoned shepherd's hut near Almeria:

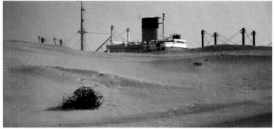

I thought, if we shoot Lawrence and his remaining young companion (after the other
was lost in quicksand) and put up some barbed wire, that will tell you that we're out
of the desert. Then we cut to this shepherd's hut, suitably re-dressed, and as they move
towards it you hear a totally unexpected sound, a ship's horn. When they come out on
the other side, we see just a funnel behind the sandbank – and it's the Suez Canal!

Rarely was there a more economical and effective example of Vetchinsky's old trick
of using sound to cue a change of scene.

# Chapter 4

Bringing the Revolution to Spain: Doctor Zhivago

John had to leave *The Wild Affair* to Terence Marsh when he was summoned by Lean to start work on *Doctor Zhivago*.

The art department had played an important part in keeping *Of Human Bondage* on track during its tumultuous production, and the producers, Seven Arts, asked if John would design their next film. *The Wild Affair*, based on a novel by William Sanson and marking a new departure for documentarist John Krish, was to be one of the first portrayals of 'swinging London', with Nancy Kwan as a young office worker dressed by Mary Quant and sporting a geometric Vidal Sassoon hairstyle. But no sooner had John and Terence Marsh started work on the film at Twickenham than the call came from Lean: Carlo Ponti had bought the rights to *Doctor Zhivago*, he was going to direct and wanted John to design it. Terence Marsh was left to complete *The Wild Affair* before joining John, who set off in Lean's Rolls-Royce to scout for locations.

Boris Pasternak's semi-autobiographical novel tells the story of Yuri Zhivago, orphaned as a child, who becomes a doctor in pre-Revolutionary Russia and marries Tonya, the daughter of his guardians, the Gromekos. He is starting to win a reputation as a promising poet (like Pasternak) when the First World War intervenes and he eventually ends up working in a field hospital. Here he falls in love with Lara, whom he knew slightly in Moscow. She had been seduced by an opportunistic lawyer, Komarovsky, before marrying a young revolutionary zealot, Pasha. The 1917 Revolution separates Yuri and Lara, although they are briefly reunited at the Gromeko estate, before Komarovsky returns to take Lara off to the Far East. Yuri goes back to Moscow in the early 1920s, becoming an uneasy member of the new Soviet society before his premature death in 1929. Written secretly during the late 1940s and 50s, the novel was rejected by the leading Soviet literary journal, then smuggled out to the West, where it was published in 1957 in Russian and in Italian (enabling Ponti to secure the rights ahead of other bidders). Pasternak was awarded the Nobel Prize in 1958, which was perceived as provocation in the USSR and marked the end of Khrushchev's 'Thaw'. Although Pasternak declined the prize, he was

Boris Pasternak, author of the semi-autobiographical *Doctor Zhivago*, had to refuse the Nobel Prize when his novel was condemned in the Soviet Union. At the height of the Cold War, it became an international best-seller.

Carlo Ponti, the producer who had secured *Zhivago* against stiff competition, hoped that his wife, Sophia Loren, might play the heroine Lara.

expelled from the Writers' Union and died in 1960. Partly fuelled by this controversy, *Doctor Zhivago* became a worldwide bestseller as the Cold War intensified.

Lean was keen to escape from Spiegel after their two, increasingly acrimonious, films together; and his success with *Lawrence* made him an attractive director for Ponti's partners, MGM, who were desperate for a major box-office success after the costly disaster of their *Mutiny on the Bounty* in 1962. MGM executives, led by the studio's new president Richard O'Brien, came to Rome in June 1963 to agree a deal that would grant Lean exceptionally generous terms and considerable control over the production, with Ponti proving a notably pliant producer compared with the manipulative Spiegel.

The initial problems, however, were the now-usual ones – apart from the scriptwriter, who had to be Robert Bolt. While Bolt was enthusiastic about another subject with real literary quality and a political background that recalled his own radical youth, there remained the daunting questions of where to shoot and who to cast as the Revolution-crossed lovers. John would play a leading part in both decisions, revealing how much Lean had come to trust him during the long saga of *Lawrence*.

John recalled an invitation from the authorities in Moscow, 'where they wanted to explain why [Lean] shouldn't make the film'. But what were the alternatives to shooting in the Soviet Union? Terence Marsh was deputed to pay lip service to Ponti's belief that the film could be shot in Italy. As he set off on an extraordinary tour around northern Italy and the Dolomites, driving in an open Alfa Romeo with an aristocratic friend of Ponti's, John told him, 'under no circumstances is David going to film in Italy, but we have to scout it before discounting it'. Meanwhile, John went to reconnoitre Yugoslavia, which was 'right on the doorstep of Russia' and obviously had some scenic potential. But 'the atmosphere was completely wrong, so we wouldn't get the best performances out of the actors'. John and David travelled together to Sweden and then Finland, where they found 'marvellous locations, on high ground overlooking Russia'. But however photogenic and atmospheric they might be, these locations were 'logistically hopeless', even to veterans of *Lawrence*.

> *Zhivago* was going to be a big film and wherever we did it we would almost certainly have to build Moscow. So there was no way Finland could be the base for the film, although we agreed we'd shoot some scenes there, such as Zhivago on his own in the cold.

MGM suggested that the filmmakers consider Canada, and John toured some of its frozen north, finding it 'visually fascinating, but impossible to film in'. Again, he could see that actors would find it hard to create the sense of being in Russia where 'the idiom was so American'.

Whether John always had the idea of returning to Spain is unclear. But after he and Terry Marsh discovered Soria in central Spain, they realised this would be an ideal loca-

Lean with John in front of the house built at Soria to represent Yuri Zhivago's childhood home, Varykino. The external design came, at the last moment, from a vintage Russian postage stamp, noticed among props by John.

tion in which to build the house at Varykino, with the certainty of snow and a nearby railway with steam trains. The Moscow set could be built somewhere near Madrid, where there was a good studio for interiors, and as John put it to Lean when he brought him out to inspect their findings: 'you're going to make a film about Communist Russia in Fascist Spain'.

The other major issue to resolve was casting. Inevitably, many names were floated and perhaps even considered seriously – from Brando and Garbo, to James Mason (as Komarovsky), Sophia Loren (Ponti's wife and his hope for Lara), Jane Fonda and Sarah Miles (who would become Bolt's wife in 1967). There are different accounts of how Lean found Julie Christie, although possibly he had multiple recommendations. John remembered having already seen her in *Billy Liar*, and after a screening during the Stockholm trip, Lean pronounced her 'perfect for Lara'. According to Kevin Brownlow, Lean also took the precaution of asking John Ford, who had directed her in *Young Cassidy* (1965) and considered her 'the best young actress who has ever come into the business'. Actors suggested to play Zhivago ranged from Peter O'Toole to Paul

Newman, but according to John, Lean justified his choice of Omar Sharif by observing that he was willing to 'take direction', in addition to being outstandingly handsome and a highly suitable romantic lead.

Tom Courtenay was another discovery from *Billy Liar*, cast as the idealistic student Pasha who becomes Lara's first husband and later a feared Bolshevik military commander under the *nom de guerre* Strelnikov – a role that had originally be envisaged for Sharif. Courtenay was certainly convincing as the student revolutionary, but John recalled that he did not seem so plausible as the ruthless Strelnikov. His solution was to paint the front of the locomotive that announces Strelnikov's arrival red. 'I suddenly had the idea of the image and the cut: it's a locomotive going past the camera and it's red – the Revolution – and then you cut to Strelnikov, setting up the character by an image.' It is unlikely that either John or Lean had seen Alexander Dovzhenko's classic Soviet silent *Arsenal* (1929), in which the coming of the Revolution is also vividly conveyed by the image of a speeding train. But as John observed, 'it worked, and David was very pleased with it'.

The luckiest find in Madrid was a new housing development near the CEA Studio on which the production was able to strike a deal with the developer. Terry Marsh recalls:

> He would delay the building of his estate, so we could use the whole site as our workshop and build the Moscow street on his already paved street. So we built everything, including the cathedral, which was about 60 feet, even though it was in miniature.

The main Moscow street set was constructed on a building site about to be developed, allowing John to devise an unusually complete environment which became a virtual community during the production. Compare the rising ground and intersection with his set for *Oliver!*

'Freedom and Brotherhood' the banner proclaims as an intended peaceful demonstration makes its way from what appears to be the Kremlin and Red Square. The topography of *Zhivago* is impressionistic rather than accurate, intended to match an international audience's vague idea of Moscow before and after its revolutions.

For John, the most vital feature of the site was that 'the road went uphill – very important to a designer because you can use perspective to make it seem longer than it is'. Tramcars were also important for the narrative, with Zhivago boarding one when he is first in Moscow as a student and seeing Lara on another at what proves to be the end of his life; and Madrid could supply these. A second, 'working-class' street was built parallel to the main Moscow thoroughfare, with smaller connecting streets, 'so that there was always something interesting in the background'. This sense of proximity between different social classes provides an effective setting for Lara's introductory sequence, when she leaves the main street and walks through a poorer district where she finds Pasha distributing revolutionary leaflets.

The overall effect is of a 'typical' Moscow, denoted by a distant view of the Kremlin towers and cathedral domes down the main street, and later by part of its distinctive crenellated wall, visible as the demonstrators march past. Otherwise, the set provided a range of more or less generic turn-of-the-century streets. One of these, the scene of the main demonstration and cavalry attack, is referred to by Komarovsky as 'Kropotkin Street', the name assigned to Prechistenka Street after the Revolution, and is not an approach to Red Square, as implied by the demonstration. A selection of statues, including an anachronistic one in Tverskaya Street, as Zhivago catches his first tram, also help to link this imagined Moscow with the equally hazy impression that audiences would have had of that city in the 1960s.

An unusual feature of the Moscow sets built in Madrid was that many were constructed in composite, so that they included fully realised interiors. Lean disliked process photography, using back-projection for exterior scenes shot in the studio. Building composite sets enabled the laboratory, where Zhivago is first seen as an adult, training to become doctor, to be clearly set in the bustling city, visible outside its windows, with no need for an introductory establishing shot. It also allowed characters to move inside from the street in continuous action, as happens when the young Zhivago alights from the tram he has unwittingly shared with Lara and enters the Gromekos' house. The following

The scale of the Zhivago construction made possible composite sets, so that an actor could be seen entering from the street – as Yuri does here – and going upstairs to a salon, from which the same street is visible. This helped actors ground their characters and also gave Lean more options than with partial sets that could only be filmed from pre-determined angles. It also created a series of visually identifiable 'places' for audiences in what could be a confusing narrative.

scene, set in their upstairs salon, shows for the first time the large window that gives out onto the street, and the balcony from which Yuri will witness the Cossack attack on the demonstrators. However topographically inaccurate this compression of locations might be, it provides an admirably solid visual structure for the network of relationships that the film needs to establish early on – and gave Lean the freedom in shooting that he had craved since the sets designed by John Bryan for *Great Expectations* and *Oliver Twist* (1948), which could only be filmed from one angle.

This standing set became the responsibility of Roy Walker, assistant art director, 'who was there through all the seasons, and for the night shooting', as Terry Marsh remembers:

It became such a little town that people moved into the back of the buildings, and there were several tapas bars, a shoe repairer and a knife sharpener. They all had their signs up and you could have a *fundador* and a shrimp at the back of a Russian house. The extras and the crew used to drop in and it became a real village.

Although creating Moscow in Madrid solved some problems, *Zhivago* still required many other settings for its epic sweep. The most important of these was the country estate of Varykino, near Yuryatin in the Ural mountains, which had belonged to the Gromeko family, but had been appropriated after the 1917 Revolution. Since this is where Yuri and Lara enjoy a brief idyll together, it has to become the emotional heart of the film. John was dissatisfied with his initial design for the main Varykino house, concerned that it fell short of what was required. But at the last possible moment, chance intervened and among a batch of period props he spotted a Russian postage stamp that carried an engraving of a villa with the distinctive asymmetrical row of domes and veranda. He seized

A sketch for Yuri's childhood home, Varykino, representing it as a haven within a snow-covered landscape.

In reality, the location chosen for building Varykino did not have its usual snowfall, which meant acting quickly to use what did fall and extensive use of artificial snow.

on this immediately, and Lean agreed that it could have the desired impact. Full-scale plans were quickly produced for what would become probably the most distinctive visual image of the entire film, and Varykino was built in Soria, as a framework, its elaborate superstructure of domes realised in plaster.

Unfortunately, the expected heavy snow did not arrive in Soria, although there was just enough for some convincing long shots of the sledge to be filmed as the crew dashed north from Madrid. The rest would have to be artificially created, as the 'Moscow' snow had been. Most importantly of all, the interior of the Varykino house had to be created in the studio as a kind of enchanted domain in which Yuri and Lara find refuge from the outside world. The house is supposed to have been boarded up during the Revolution, and John took his inspiration from photographs of the 1911 Scott Antarctic expedition taken after snow had blown in through a small hole in the tent and frosted the interior. But how to achieve this effect?

The crucial image of the 'ice palace' interior of Varykino, where Yuri brings Lara to rekindle their love and find his own poetic inspiration, owed much to the inspiration of a celebrated set by John Bryan: the dusty room to which Miss Haversham has retreated in Lean's *Great Expectations*.

The solution owed much to another key member of the crew, the ever-inventive Eddie Fowlie. Credited as 'property master', Fowlie had formed a close relationship with Lean during *The Bridge on the River Kwai* and became indispensable to him on subsequent films. He was resented by some for apparently trying a little too hard to win Lean's approval, and for claiming credit for solutions that were not his alone. But John had great faith in Eddie's ingenuity, and would call him every morning on *Zhivago* to plant a seed for the day's work: 'the thought for the day is …' For the Varykino 'ice palace' interior, they worked closely together: Fowlie would throw molten wax over the furniture and props, which John then 'froze' with cold water before it was coated in mica to create an icy sparkle. The effect is famously magical: a successor to the great dusty, cobwebbed set created twenty years earlier by John Bryan for Miss Haversham's room in *Great Expectations* – both highly evocative images of 'time suspended'.

Fowlie was also instrumental in arranging artificial snow that was more convincing than MGM's specialists could contrive. For a battle scene involving a cavalry charge that has inevitable echoes of both Eisenstein's battle on the ice in *Alexander Nevsky* (1938) and the taking of Aqaba in *Lawrence*, he spread industrial quantities of marble dust on a cement base and – no doubt under John's supervision – created the illusion of a lake by means of a small boat, apparently moored and floating in water.

Just as the exterior long shots of the Varykino house had to make an immediate emotional impact, suggesting an archaic refuge, almost a nursery image, so Yuri and Lara's final parting, as she drives off with the scheming Komarovsky, needed to register emotionally. 'So we designed it with a staircase going up: Zhivago climbs the stairs and looks out of the window to see the sleigh getting smaller and smaller – which we'd already shot when there was real snow.' Both the exterior image and various interior sets of Varykino create what might be called 'affective space', images of place that are heavily imbued with the core emotions of *Zhivago*: nostalgia and the search for home amid brutal turbulence. And it is perhaps their triumph in this respect that resonated so successfully with audiences.

The temporary home that Varykino represents is made especially poignant by the epic journeys that frame it, all of which needed additional locations. The great rail journey east from Moscow, undertaken by the Gromekos, with Yuri, Tonya and their child, has them crowded like animals in a train, and was largely shot in Spain, although with inserts

How to achieve the fairytale frosted look for Varykino, as Yuri and Lara enter, was a challenge for John and Eddie Fowlie. They solved it by using hot wax, quickly cooled and dusted with mica.

For the sequences that needed large amounts of real snow, a unit was despatched to Finland, where Terry Marsh planted a row of telegraph poles to give perspective to an otherwise featureless landscape.

filmed elsewhere to record the first appearance of the Urals and the effects of the civil war on the peasants. Zhivago's journey on foot after he leaves the band of Red partisans, who capture and hold him to serve as their doctor, was filmed in a crowded two weeks in Finland, at the sites John and Lean had identified on their initial recce, but which John was now too busy to attend. Terry Marsh oversaw the shoot in Finland, planting a line of telegraph poles to create perspective in the snow, much as they had done in the equally featureless desert for *Lawrence*, and creating the extraordinary images of snow-covered trenches and a frozen machine-gunner to stand for the Great War that is the prelude to the Russian Revolution.

When filming finished in October 1965, after more than two hundred and thirty days, Lean went to the MGM studio in Los Angeles to try to complete the editing by the end of the year. John was designing the titles in Madrid when he was unexpectedly summoned to Hollywood, to be present throughout the process. Acknowledging that he had been so involved in all aspects of the film, 'David wanted to try things out on me'. Unsurprisingly, John learned a lot from this unique opportunity to sit in on a master-editor's shaping of the material they had filmed together. When they reached a scene that had seemed good in the rushes but now appeared not to work, Lean explained that this was because of the sequence that introduced it: 'we have to go back two minutes to find the rhythm'. The last of the *Lawrence* team to join *Zhivago* was the composer Maurice Jarre, who managed to see some of the shooting in Spain before he was asked to produce a Russian-flavoured score, incorporating a balalaika theme similar to the traditional one that had been played on set to create atmosphere. His success would haunt all concerned; indeed, John admitted that 'much of the film's success was due to the music', even if its constant repetition eventually made it seem 'slushy and sentimental'.

Post-production continued at breakneck speed until late December, with the last reel reaching New York just in time for the premiere on 22 December 1965.

# Close-up 3

## *Doctor Zhivago*: Through a Glass Icily

During his location-finding trip to Finland with Lean, John became fascinated by the lakes that were beginning to freeze over and took photographs of them. Lean accused him of 'photographing rubbish', although later acknowledged John's enthusiasm by buying him the same expensive camera that he used. But for John, the pulsation of the ice suggested a direct visual metaphor for 'the pulsation of life' as the central theme of *Doctor Zhivago*, and he would add the photographs to his visual notes in preparation for the film. This may have been the origin of a motif that runs through the film and helps give visual unity to its schematic storyline. *Zhivago*'s characters repeatedly look through glass that is made opaque in some way, beginning with the wire mesh on a door at the industrial site where Alec Guinness, as Yuri's half-brother, starts to recount her parents' tragic story to their daughter, Tanya. Next, at the opening of the film's long flashback, after his mother's death, the young Yuri peers out through frosted glass, as if looking into his future.

The recurrent motif of characters looking through opaque or partially obscured glass begins with Lara's daughter (Rita Tushingham) seen through a mesh grille as she arrives in a factory office to hear the story of her mother. It reappears as the flashback starts, with young Yuri looking out of an icy window; and continues as Yuri looks into a microscope with a poet's eye.

The 'vision' motif recurs in many scenes, as characters are seen in mirrors, or through windows; and while it seems particularly associated with Yuri's vocation as a poet, it also serves to frame or 'fix' characters such as Pashka (Courtenay) and Komarovsky (Steiger) at crucial moments in their life.

The elliptical cut that introduces us to Yuri the medical student is to a microscope specimen seen in close-up, followed by a shot of him boarding a tram, slightly obscured by the window's reflections. Such visual devices recall the Russian 'formalist' critics' of the 1920s and their interest in literary devices that 'slow down' or complicate the smooth progress of a narrative. When Komarovsky first begins to take a sexual interest in the teenage Lara, as she sits in her mother's dressmaking atelier, his approach is filmed through several panes of glass, giving him a sinister, ghostly air that prefigures his role in her life. Later, after raping her, he will disappear in a matching image. Two scenes – Komarovsky's discovery that he has precipitated a suicide attempt by Lara's mother and the reconciliation between Lara and Pasha Antipov – are shot from outside through icy glass, as if the camera has discovered an intense drama that is already under way. The second of these includes a remarkable candle-flame effect that, as John recalled, Eddie Fowlie achieved by using ice and warm air. Its purpose was 'to disclose rather than show' – a maxim of Lean's that became the guiding principle of the film.

Much later, when Yuri and Lara reach their haven in the big house at Varykino and break in, their final discovery is the room where the poet Yuri first learned to write as a child, 'revealed' through frosted glass to underline its significance. And when their time together comes to an end as Komarovsky takes Lara away – but not before she has inspired a flood of new poems – Yuri's last direct view of her from the upper window requires him to smash a hole in the frosted glass, as if breaking the narrative chain of their love, and leading to an echo of the opening scene in Moscow, as he boards another tram and dies of a heart attack, believing he has seen her again.

Through this series of framing devices, based on seeing through glass 'darkly', John helped create the visual underpinning that Lean needed to give his story emotional

impact. Many of these devices hark back to the fluidity of silent film technique, and to its rediscovery in the dark Hollywood melodramas of the 1940s. John would also work closely with the other key crew members to help them realise their contribution to the whole. Phyllis Dalton was again the costume designer and, after the all-male cast of *Lawrence*, the attire of *Zhivago*'s female characters posed some different challenges:

> There has to be coordination between costume and the art department, and John was particularly good in that way. He'd come and tell us what he was doing and I'd do the same. This happened with the evening dress for Julie Christie.

The particular occasion was Lara's rendezvous with Komarovsky in a private room at the restaurant. Previously, she has stood in for her mother, accompanying him to a restaurant wearing a demure pale lavender dress, but this was to be an assignation:

> I had originally designed a black velvet dress, thinking this is what a young girl would choose for such an important occasion. But David Lean and Robert Bolt, being primitive British men, had different views and wanted red. The only way with David was to have both – he wasn't great at making up his mind unless he could see them. I think John was on my side, but the red works. They were right.

The image of ice melting creates a powerful metaphor for Yuri's poetic inspiration 'unfreezing', while the hole he punches in the upstairs window at Varykino, as Komarovsky takes Lara away, creates an equally strong metaphor for rupture and the shattering of their idyll.

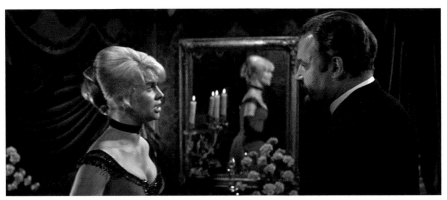

What should Lara (Julie Christie) wear for her imminent seduction by Komarovsky? Phyllis Dalton initially thought black, but Lean finally chose red – which Christie hated, although the discomfort may have helped her performance.

Holding back colour was an important technique for John, all the better to use it boldly for effect. When the Moscow demonstration is brutally broken up by Cossacks, a splash of blood in the show marks the end of peaceful hopes for change and ushers in an era of increasing violence.

Opposite: The theme of 'the pulsation of life' that John had identified is developed in a series of images that map the coming of Spring onto Yuri's discovery that Lara is working in a library near Varykino. The ice melts and daffodils appear at Varykino; then Yuri meets Lara, and a dissolve from the flowers to her face suggests a poet's associative eye.

In fact, Julie Christie hated the colour and felt she couldn't play the scene in red. John's argument, or at least his diplomatic suggestion, was: 'red's not your colour, but you'll play the scene perfectly because you'll be uncomfortable'. Phyllis reasoned that Komarovsky would probably have selected the dress for her.

The creative use of colour was probably John's greatest contribution to *Zhivago*, more important even than the major set designs. 'Ideally Moscow would be in black and white at the beginning. You keep all the colour out, until the Revolution starts to get under way and there's a crowd marching up the street with a red flag.' The central focus of the cavalry attack on the demonstration is a splash of blood that briefly fills the screen, breaking the hitherto muted monochrome palette. Before this, lilac and lavender have been discreetly introduced into the dressmaker's, from which Lara emerges into her first big scene with Komarovsky, surrounded by high society figures dressed in black and white against a sumptuous background. The contrast between this red interior decor and the red of blood spilled in the street conveys more about a revolution waiting to erupt than any dialogue could.

For the romantic drama that is the centre of Lean's and Bolt's interpretation of the novel, John reserved his boldest stroke of colour painting. After the bitter winter living in an outhouse at Varykino, Yuri looks out of the icy window and sees a blaze of yellow daffodils. This effect had been planned first with artificial flowers, then real bulbs were planted in advance to flower when needed (although the mild winter meant that they flowered too early and had to be potted). Inspired by this first sign of spring, Yuri decides to go to the nearby town, where his unexpected rediscovery of Lara is announced by a vase of daffodils in the library in which she works. The daffodils that have come to symbolise their love finally reappear at Yuri's funeral, set against his coffin in the muted colour that has returned for this final chapter, but – crucially – this is given its full impact by the image that follows, as Lara is last seen against a featureless dark wall.

The 'pulsation of life' that has figured throughout the story is now blotted out by a blankness that will only be relieved when Tanya, Yuri and Lara's daughter, appears with her fiancé and the balalaika that was all Yuri inherited from his mother. The art of film design, as John was learning, is about images acquiring emotional meaning in sequence and in time, rather than as isolated effects.

The final image of Lara, after Yuri has failed to make contact, shows her as a tiny figure against a black wall, dominated by a grimly smiling Stalin poster, summing up the film's message of individualism crushed by an impassive dictatorship.

# Chapter 5

A Case of Conscience

Within such magnificent settings as only England itself could provide to convey the resplendence and color of the play's 16th-century mise en scene …

Bosley Crowther, *New York Times* review

*Doctor Zhivago* opened triumphantly in Britain on 26 April 1966, a week after winning five Academy Awards, including Best Art Direction. Lean was upset that he had lost out on Best Director to Robert Wise, for *The Sound of Music*, and was undecided about his next project. Julie Christie won Best Actress, but for her role as an ambitious model in *Darling* rather than for Lara in *Zhivago*. 'Swinging Sixties' London had reached its climax, with the Beatles now conquering America, Pop and Op Art making headlines and reaching a wide public, Mods and Rockers clashing regularly, and an 'underground' art scene emerging in London, comprising the Indica bookshop and gallery, the Arts Lab and the London Filmmakers' Co-op. Fashion had become a new celebrity culture, with designers, models and photographers its heroes – celebrated in John Schlesinger's *Darling* and in Michelangelo Antonioni's *Blow Up*, made during 1966. Amid such goings-on, the idea of filming a historical play about Thomas More's conscientious refusal to sanction Henry VIII taking a new wife must have seemed quaint.

Yet Robert Bolt's play *A Man for All Seasons* had been a notable success at the beginning of the decade, first on the London stage in 1960 and then on Broadway a year later. Bolt had been a school history teacher, writing in his spare time, and it was *A Man for All Seasons* that catapulted him into a career as a professional writer, with the invitation to write a new script for *Lawrence of Arabia* one of his first major assignments. Bolt's interest in one of the most fateful scandals of English history – Henry VIII's determination to end his marriage to Katherine of Aragon so that he could marry Anne Boleyn – was not in the political or sexual machinations, but in the challenge this posed to those

unwilling to jettison their beliefs and follow the King. His hero was one of the casualties of the affair: the lawyer Thomas More, who had been promoted to the high office of Lord Chancellor by Henry. When Henry's determination to marry again in the hope of producing a son led him to break with the Catholic Church, More's conscience would not let him agree to the King's demand for approval.

The issue that leads More first to withdraw from his office, then from public life, and finally to face trial for treason after refusing to swear an oath demanded by the King, is a subtle and complex one. And since it turns on accepting More's Catholicism as his reason for refusing Henry, allied to his careful, convoluted lawyer's reasoning, it was unlikely to become fashionable in the hedonistic 1960s. However, the play appeared at an unusual moment in British theatre, sandwiched between John Arden's *Sergeant Musgrave's Dance* (1959) and John Osborne's *Luther* (1961). Both of these dealt with issues of principle and conscience in unusual ways, reflecting the belated influence of Bertolt Brecht on British drama. Bolt's play had its Brechtian aspect – a character representing the 'common man' who appears in different roles (dropped from his screenplay by Bolt as 'too theatrical') – but was attacked by the leading critic of the period, Kenneth Tynan, for *not* lining up with Brecht's portrayal of another great hero of conscience, Galileo.[1]

Bolt has More say at the climax of his trial that the issue is not whether the Pope has absolute authority, but that '*I* believe it', adding in mockery of a court he knows must find him guilty, 'I trust I make myself obscure?' In a public debate with Tynan, Bolt pinpointed the vital difference between the two plays and their heroes: 'Both were required by Authority to deny themselves. One complied; the other refused.' Both Galileo and More paid a 'frightful price': one forced to recant and keep silent; the other, to face 'the end of his life on any terms at all'.

No one doubted that the unlikely success of the agnostic Bolt making a hero out of a Catholic martyr owed much to Paul Scofield's committed performance, both in London and on Broadway. But when Columbia Pictures decided to film the play, most likely encouraged by the success of Bolt's scripts for *Lawrence* and *Doctor Zhivago*, would they have the nerve to cast an actor with little previous screen experience? Of course, the same could have been said of O'Toole in *Lawrence* and Omar Sharif in *Zhivago*. But *A Man for All Seasons* had neither sweeping spectacle nor a love story. The studio could have taken comfort from Alexander Korda's historic success with the film that launched his career in Britain, *The Private Life of Henry VIII* (1933), which had starred the unpromising Charles Laughton as Henry. But Henry is not even the central figure in Bolt's play, disappearing from view as More's lonely struggle proceeds. The nearest precedent would have been Peter Glenville's 1964 film from his own stage production of Jean Anouilh's *Becket*, about an earlier King Henry and his equally fatal falling out with an old friend,

---

1    *The Observer*, 1960; quoted in *the Guardian*, 23 February 1995.

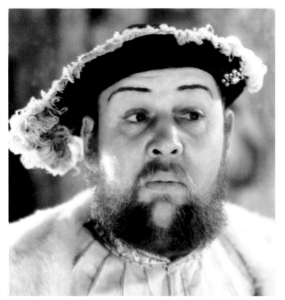 

Two faces of Henry:
Charles Laughton's
in *The Private Life of
Henry VIII* (1933), and
Robert Shaw as a more
attractively athletic
Henry – charming until
he realises Thomas More
will not accommodate
him – in *A Man for All
Seasons*.

Thomas Becket, murdered at his behest in Canterbury. But *Becket* had benefited from the chemistry between Peter O'Toole and Richard Burton, and had been impressively designed by John Bryan, with twice the budget that John would have at his disposal.

Columbia may also have been encouraged by the even greater success that *A Man for All Seasons* enjoyed on Broadway, where, according to Scofield, 'the audience seemed to find more contemporary parallels than in London'. More's 'moral strength' would certainly have chimed with the stand many Americans were making over the Vietnam War; and Bolt himself was an anti-war activist who had been arrested for anti-nuclear campaigning, although his play stays scrupulously within its Tudor worldview. But a costume drama must have seemed a risky proposition for Columbia in 1966, and the production was only offered to Fred Zinnemann after several of his more ambitious projects had collapsed. Nor was it the studio's main English production of that year. Having acquired the rights to the only James Bond title not owned by Cubby Broccoli's Eon Productions, *Casino Royale*, Columbia had agreed to back a very different kind of Bond film, a comedy-thriller with no fewer than six directors and as many actors playing Bond, which spun out of control as its star Peter Sellers became ever more demanding and self-indulgent.

As *Casino Royale* sucked in cash, production resources and executive concern, so *A Man for All Seasons* suffered benign neglect and the loss of studio space. But Zinnemann, Bolt and John would enjoy the last laugh. *Casino Royale* proved a ruinously expensive fiasco, while *A Man for All Seasons* won six Oscars and seven BAFTAs, and showed a high return on its meagre budget.

John had come to know Bolt well during the epic production of *Lawrence* – he had taken a photograph of Bolt asleep on the sand, captioned 'genius' – and he had seen and admired the play in its original production. Bolt wanted John to design the film, and may have influenced the decision to hire him, since John had no previous experience of designing any pre-1900 settings. Nor indeed was Zinnemann associated with historical subjects, having made his reputation with Westerns and melodramas. He had moved to London in the early 1960s after living in Los Angeles for twenty years, as his films shifted increasingly away from Hollywood subjects, and no doubt he considered having an English production designer essential for such a project – even if the budget was going to be much less than John had commanded on his films for Lean.

The new team gathered at Shepperton, conscious that they were not Columbia's highest priority. Zinnemann recalled how for the first few days, 'the crew did their work very well, as they would have done on any job', until Paul Scofield delivered his speech on the majesty of the law, 'and they were suddenly mesmerised by the magic of these words and remained that way for the rest of the filming'.[2] All concerned seem to remember it as an exceptionally happy film, helped by the fact that 'no attention was paid to us by the front office during the shooting, which is of course always a blessing'.

With a budget of only $2 million, Zinnemann was absolved from the need to seek major stars, and could follow his instinct to take risks in casting. In addition to the little-known Scofield, now firmly identified with his character, he cast John Hurt in his first screen role, playing Richard Rich, who first admires More, but then sees that he can profit from helping the King's case against the former Chancellor. Vanessa Redgrave was originally cast as More's daughter, but when she landed the main part in *The Prime of Miss Jean Brodie* on stage, the role went to Susannah York instead. However, Redgrave was persuaded to visit Shepperton for just one day, while also filming Antonioni's *Blow Up*, to make a brief appearance as the new object of Henry's passion, Anne Boleyn. Another more substantial guest appearance was Orson Welles as Cardinal Wolsey, whose death leads to More's promotion. Welles was already a notorious figure in the film world: revered for his classic films, *Citizen Kane* and *The Magnificent Ambersons* (1942), yet increasingly regarded as erratic and unreliable, with half-completed films and a succession of cameo appearances of varying quality.

Robert Shaw was a well-established Shakespearian actor, and busy in big-budget films as well as television, when he took the part of Henry VIII, bringing to it enormous charm as well as menace. His 'surprise' visit to More's house, to cajole him into being more cooperative over the proposed annulment of his marriage, is one of the visual highlights of a film that is otherwise largely confined to the studio back lot and interior sets. The rest of the hand-picked cast included Wendy Hiller as More's plain-spoken wife; Leo McKern

2    Fred Zinnemann, *An Autobiography*, Bloomsbury, 1992, pp. 202–4.

as Thomas Cromwell, who succeeds More as Chancellor, and had also appeared in the original production on stage; and Nigel Davenport as the bluff but ultimately devious Duke of Norfolk.

The low budget combined with the inevitable costs involved in period costume meant that location shooting would be severely limited, and studio construction would also have to be economical. After nearly five years of working largely on location and abroad, John and his art department colleagues were back in the studio and having to rely on the illusionistic skills they had learned in their early years with Vetchinsky – 'sleight of hand and cut-outs', as Terence Marsh described it.

Part of the challenge they faced was that a considerable amount of well-known visual source material exists for the period in which the film is set, including Holbein's famous portrait of the Chancellor and a More family group, as well as portraits of Henry and representations of More's trial. Several of the key buildings are also well-preserved historic landmarks, notably Hampton Court Palace and the Tower of London. John, however, was clear that period detail – even if they could have afforded it – should not be allowed to overwhelm Bolt's drama of conscience. The play's original staging had been 'Brechtian' in its scenic austerity, and the need to simplify would support the thrust of the film, provided it did not undermine its credibility. In the event, only one actual shot of Hampton Court and none of the Tower appear.

Zinnemann was astonished by John's ability to conjure a credible Hampton Court Palace out of painted flats, and eventually happy to go along with the art department strategy of 'sleight of hand', leavened by bigger spending on a few set-pieces, such as Henry's visit to More and the interior of the More house. In addition to building on the Shepperton back lot, John and Marsh used a small wood within the studio grounds for other exteriors, as *Casino Royale* spilled over into space previously allocated to them. 'We were the poor relation, the little $2 million art-house film. They'd say, "You're losing that stage, you'll have to do it somewhere else."' Somewhere else turned out to be Pinewood, where John and Marsh built the Thames-side setting for More's journey by river to see Wolsey.

Even the weather played its part in creating the illusion. Zinnemann wanted snow for the scene where Henry visits the dying Wolsey, but as it was being shot in April, this was unlikely. Having brought in reserves of fire-fighting foam to simulate the effect, snow miraculously fell overnight and lay just long enough to secure the necessary shots. For the scene in More's garden, the wind blew on cue to underline Henry's growing anger at More's intransigence. And only when shooting had finished did heavy rain start to fall.

How well does the design of the film stand up in retrospect? Compared with the increasing elaborateness of subsequent films, its sets and costumes seem stark and devoid of the 'period detail' that we have come to expect in historical fiction, and that would be opulently displayed in the same year's *A Lion in Winter*. In some studio-built scenes, this looks almost like a deliberate strategy to 'modernise' the distant past, in the way that a stage designer might, or as Jean-Pierre Kohut-Svelko did for Eric Rohmer's

*Perceval le Gallois* (1978). A scene such as the cardinals sitting in conclave, for instance, was organised as a circle with only net curtaining behind to imply stained glass. John, however, insisted that the film always 'respected its period'. Instead of a mass of authentic detail, careful use is made of key images and elements to anchor the film in the Tudor era. Constructing Henry's three boats was expensive, but the unforgettable image of royal exuberance they made possible justified the outlay. The costume designers were Elizabeth Haffenden, who had originally helped launch John's career, and her regular partner Joan Bridge, a former Technicolor consultant. Taking their cue from the relative austerity of costume seen in Holbein's portraits, they used shape, texture and a restricted colour range, with much black and white, while focusing attention on details such as the Chancellor's chain of office, which symbolises the power that comes to More, then leaves him as he falls into disfavour. At the climax of the trial for treason, after More seems resigned to his fate, he stops Rich on his way out to inspect his chain of office. When he discovers that this refers to Rich's reward for perjury – he has become Solicitor-General for Wales – he mocks him for having forfeited his immortal soul merely for Wales.

Not everyone was convinced by this minimalist approach to period decor and costume. Marsh remembers his and John's mentor Carmen Dillon being scandalised by the 'skimpiness' of scenes such as Wolsey's red chamber at Hampton Court after John won the BAFTA award for Best British Art Direction. But the film was widely admired for its refusal to wrap Bolt's script in a sugar coating of 'period' – even if this was due in large part to poverty – while also conveying a strong impression of authenticity and even lavishness. Clearly, many critics, including the *New York Times*'s Bosley Crowther, believed they had seen much more of 'Tudor England' than was really the case.

Holbein's famous portrait of Sir Thomas More was an inevitable reference for the designers of *A Man for All Seasons*, and its sobriety is reflected in Scofield's demeanour when he is imprisoned in the Tower.

# Close-up 4

*A Man for All Seasons*: Cut-price Tudor

King Henry is first seen paying a surprise visit to Thomas More, arriving by barge at More s riverside house. John recalled how he wanted the royal barges to be like Aston Martins, stylish as well as luxurious. His art director, Terence Marsh, found a royal barge of a similar period in the National Maritime Museum at Greenwich and took this as a model for the three vessels they decided to build. These, along with the detailed interior of More s house, and a riverside set built on the outdoor tank at Pinewood, were the most expensive projects for the art department.

But where would these elegant boats take to the water? John knew that it would be impossible to shoot on the Thames, not only because of its congested banks, but also

Rather than go on location to the real Hampton Court Palace, John argued it was more economical and effective to build in the studio only what needed to be seen. Thus More enters an appropriately brooding palace for his interview with Wolsey.

because of its tides. His other art department assistant, Roy Walker, 'did some research, and found that the Beaulieu estate in Hampshire had a stretch of river that would be the ideal substitute for an unspoilt Thames, once the private yachts were removed.' But not for More's house, which was situated in sixteenth-century rural Chelsea. The art department found a suitable building in Oxfordshire, at Studley Priory, a former Benedictine abbey that was now a hotel. How then to link the river and the house, actually two hundred miles apart? 'We devised the idea that there's a wall, to keep the river out. So down at Beaulieu, Henry gets out of the boat and walks up to the wall, then cut, and on other side you're in Oxfordshire at More's house.' But there was a further problem to be solved. If Robert Shaw had leaped out of his barge into the river at Beaulieu, he would have sunk in mud well above his knees. Roy Walker's solution was to install wire mesh below the area where Henry and his courtiers would come ashore, allowing Robert Shaw to stride gallantly up to the wall carrying just enough mud to convey Harry's impulsive nature.

A more serious challenge was Hampton Court Palace, which had actually been built by Wolsey in the latest Italianate style before he was forced to cede it to the King. Perhaps not surprisingly, Zinnemann wanted to show the magnificence of this great Renaissance palace, as it survives today. John, however, disagreed, as much on dramatic as budgetary grounds. Starting from the principle that 'you build for a set-up', he argued that they need only show the archway as More enters the palace, and that a reasonable facsimile of the façade could be built with flats. Zinnemann would later write that John had built Hampton Court with just three flats for £5,000, which may not have been entirely accurate, but John knew he could get away with a simplified version for this evening arrival, even 'lopping off a storey'. More crucially, he felt strongly that Cardinal Wolsey's office, the centre of his web of power, should not be grand, but exactly the opposite:

Opposite page: Terence Marsh researched the kind of royal barge that Henry might have used on the Thames and had three built for his 'surprise' visit to More's house at Chelsea. The riverbank where Henry wades ashore (supported by wire mesh) was actually at Beaulieu, and the house he then approaches in this virtuoso display of 'magic geography' is Studley Priory in Oxfordshire.

John justified the economy of design in *A Man for All Seasons* in terms of focusing on its powerful drama and acting. And for the scale of Wolsey's menacing all-red chamber, he recalled how Sam Spiegel always made the room seem smaller. Orson Welles was so impressed that he added red eye make-up.

The strength of this scene is in the dialogue and the characters. Play the scene in a small room; with Wolsey sitting at his desk and not even bothering to get up. The desk will be smaller than it should be, which will make Wolsey look larger. No architectural detail except a window, because they have to look out to see Anne Boleyn come up, no furniture or dressing to impinge on the drama of the scene.

John's rationale came from his own experience of being in the presence of power – not a statesman but the producer Sam Spiegel. 'I always felt that the room was getting smaller and smaller as I talked to Sam, and I was getting trapped in it.' In the boldest stroke of all, he proposed that the walls should be the same colour as Wolsey's red cardinal's robes. 'Fred didn't agree for a while,' he recalled, 'but finally he said yes.' And on the day of shooting, Orson Welles thought the idea so good that he arrived on set with red make-up to enhance the crimson menace of the scene.

To depict a deserted palace, however, would falsify the reality of Wolsey's power, so John's solution was to have More leave the interview through the antechamber occupied by Thomas Cromwell, and to show the mass of petitioners held at bay. As Eisenstein had realised in *Ivan the Terrible*, twenty years earlier, a mass of huddled, crowded bodies conveyed a powerful visual sense of feudal power in action.

More is taken to his trial from the Tower of London, and returned there after his sentence for execution. John and Zinnemann had no wish, or budget, to establish the Tower as a location. So More's arrival is handled with austere economy: the Warden's voice is heard over the image of a barred window. To signal the passing of more than a year, John devised three vignettes of the outside world seen through this window. In the first, a group of young people are playing merrily; snow covers the ground in the second; and in the third, a young man and woman face each other, clearly in love. Apart from showing the passage of time from the prisoner's viewpoint, reminding us of the family life he is cut off from, these images echo the seasonal illustrations that were

common in illuminated manuscripts – which had also been a reference for Carmen Dillon in Olivier's *Henry V*.

Following More's removal to Richmond Palace for one of his many interrogations – with a single shot of merry-making at the palace framed by red curtains – is the emotional scene of his wife and daughter's visit to the Tower, allowed only in order that they might put pressure on him to accept the King's authority. Here John used a variation on the Hampton Court scene with Wolsey, except that More's cramped dark cell is painted black, establishing the poignant tone of this last meeting, the bars and grille providing the only detail.

With the limited budget a constant concern, John contemplated the setting for the climactic show trial, which took place at Westminster. Using a surviving historic location, such as Westminster Abbey, was impossible, so this would have to be a studio set. John recalled his only visit to a bull-fight in Spain, and how he had hated the feeling of a crowd gathered to witness blood-letting. 'There needed to be an idea for the scene, and I thought of making it like a bull-ring, with More in the middle in a flat area, the judges high up with a coast of arms behind them and spectators at the sides.' The set, built at Shepperton, is strikingly bare of ornamentation and was influenced by a Tudor illustration of trial, showing the bodies of spectators packed close together.

To convey the passing of time, without resorting to captions, John devised a series of vignettes of life going on outside the Tower, the seasons passing. These images, heavily framed by the dark walls, also recall medieval manuscript illustration, which had been used in Olivier's *Henry the Fift*.

More's wife, daughter and son-in-law are allowed to visit him in the Tower, in order to put pressure on him to swear the oath that Henry requires. Rowland Lockey's group portrait of the More family, after Holbein, of the family in happier times again provides a reference for this utterly simple yet moving scene.

A 16th-century illustration of Sir Thomas More's trial confirms the basic geometry of the trial setting, while John drew on the idea of a bull-fighting arena for Scofield's entrance, with spectators penned around him, and the judges sitting high above. Background colour is severely restrained so that the judges' red robes and Rich's blue-green costume will stand out.

John's rationale for this simplicity was also dramatic: 'we rubbed out all the detail and gothic architecture, because we wanted to concentrate on the essentials'. More's entrance by a narrow corridor cut through the wooden seating is exactly like that of an amphitheatre; and the scene that greets him is grey and symmetrical, the judges flanked on either side by three statues set in niches.

Apart from the scene's intricate dialogue and powerful performances, with More defying the judges' attempts to trap him, and using his barrister's skills to discredit their only witness – his former young admirer, Richard Rich – the only visual enhancement is provided by the costumes. Elizabeth Haffenden's and Joan Bridge's designs followed the design philosophy of the film, avoiding detail in favour of bold shapes and contrasts, establishing a primary contrast between black and white. Against the near-monochrome of the courtroom set, the judges' crimson robes stand out, while Rich appears in a jarring bluish-green that insinuates his treachery.

After the sentence, the film moves swiftly to its close. There is a cut from the grey expanse of the court chamber to a large close-up of chestnut in bloom, with a bee entering one of the blossom 'candles'. The next shot is of More making his speech before the execution, the foliage and blossom visible behind him on the battlement. However, as the shot of the bee had been taken much earlier in the production, when it was time to shoot the execution scene, the chestnut was no longer in bloom. John assured Zinnemann that the art department would find a solution. This involved Terence Marsh getting up before dawn to harvest lilac from the small wood near Shepperton, and wiring this onto chestnut branches for just long enough to shoot the scene. The dramatic focus is, of course, on More's dignity in his last moments and the savagery of the sentence being carried out, but nevertheless it was important to the director and the art department that the imagery established by the close-up was sustained.

# Chapter 6

## Learning on the Job

*A Man for All Seasons* had proved a godsend to Columbia, and consolidated John's reputation as a resourceful designer of period subjects, at a time when such films had developed a reputation for extravagance and were becoming unfashionable. So when Columbia struck a deal with Romulus to film Lionel Bart's 1960 musical *Oliver!*, John was an obvious choice to design what would have to be a major studio construction job. 'Dickensian London had all but disappeared, after all the property development, so it had to be in the studio. Besides, you couldn't take dancers out onto the streets.'

In fact, musicals *had* been moving out of the studio into the streets during the previous decade. *West Side Story* (1961) used location shooting on the streets of Manhattan to enhance its realism and signal a break with the studio-based fantasy musical; and Jacques Demy's *The Umbrellas of Cherbourg* (1964), piloting a European version of the musical, owed much of its appeal to being filmed entirely on location in Cherbourg. British pop musicals – from Cliff Richards's *The Young Ones* (1961) and The Beatles' *A Hard Day's Night* (1964) to the Dave Clark Five in *Catch Us If You Can* (1965) – all now routinely took to English streets (and beaches), as if to distance themselves from the synthetic studio settings of American rockers such as Elvis. And following *Oliver!*, Richard Attenborough would base his *Oh! What a Lovely War* (1969) in Edwardian Brighton.

These quintessentially English musicals, with their strong music-hall associations, shared a common source of inspiration, namely Joan Littlewood's Theatre Workshop, based at the Theatre Royal in London's East End. While *Lovely War* was a Workshop original in 1963, Littlewood had earlier been instrumental in launching the songwriter Lionel Bart on a career in musical theatre with a contemporary 'Cockney comedy', *Fings Ain't Wot They Used T'be*, in 1959. This success encouraged Bart to tackle one of Dickens's most disturbing novels, ruthlessly discarding much of the detail and darkness, to create what was variously hailed by critics as a triumphant revival of the traditional

blood and thunder melodrama, a 'starveling musical from the workhouse', and the work of a 'Cockney Offenbach'.[1] *Oliver!* ran for over seven years in London, and for two years on Broadway, with many other productions making it a worldwide hit.

But how would it translate to the screen? As John noted, even if they had wanted to take the dancers out onto the streets, little of Dickens's London remained, and nothing at all of the tangle of poverty-stricken houses near Saffron Hill, where Dickens located Fagin's nest of juvenile thieves. Not that Bart's musical had ever set out to portray a realistic nineteenth-century London, and apart from the instantly memorable songs, much of its original impact was credited to Sean Kenny's highly original revolving set. Although *Time* described it as a 'sombre, hewn-wood set', another British stage designer, one of many inspired by Kenny's radical approach, speaks of it as 'sculptural and skeletal … [placing] the actors right in the midst of their revolving, three-dimensional environment rather than emoting against a pictorial background'.[2] But while this helped make the stage musical a major success, it would hardly work on film. A substantial acreage of Dickensian London would have to be created as the setting for Bart's colourful characters.

Despite the uncertain fortunes of the big studio musical in the mid-1960s, Columbia were prepared to back the building of a major set at Shepperton. At this stage of the project, the director was to be Lewis Gilbert, who was riding high after the success of *Alfie* (1966) and was then busy on the fifth Bond film, *You Only Live Twice* (1967). John had plenty of research to do and ideas were beginning to take shape as he immersed himself in Bart's music – despite being totally unmusical. Terence Marsh, who was to serve as art director again, remembered taking John to the Village Gate jazz club in New York to hear the great pianist Teddy Wilson. They arrived while the interval pianist was playing, and John announced how much he liked Wilson. Later, he nobly accompanied Marsh to hear Eddie Condon, 'sitting through the whole evening until two, even though it must have sounded like a dreadful row to him'.

P. C. Samuel, Columbia's head of production in Britain, had asked John to accompany him to a meeting with the studio heads in Los Angeles to discuss this major production. The main issue was casting. With such a high outlay, Columbia were nervous about having anything less than a celebrity cast, and Richard Burton and Elizabeth Taylor were being considered for Bill Sikes and Nancy. John and Samuel argued strongly against this approach, urging the case for more plausible actors. John had seen the original stage production and insisted that no one could beat Ron Moody as Fagin, a part he had created and made his own. Georgia Brown had a similar claim to the role of Nancy, so the choice of Shani Wallis needed some justification. Following a meeting with the actress, John felt

---

1    Press responses to the first production reported in Samantha Ellis, 'Lionel Bart's *Oliver!*, June 1960', *Guardian*, 18 June 2003.

2    *Time*, 11 January 1963. Tony Walton, 'Variety Is the Spice', *The Old Radleian* online (2001) at: www.radley.org.uk/or/OldRadleian/2001/variety.html (accessed 24 September 2008).

she was insufficiently interested in the role. In the event, her Nancy was to prove one of the most memorable aspects of the film, and the climax of her career.

Meanwhile, it had become clear that Lewis Gilbert would not be free to direct, due to contractual obligations. John recalled how the producer John Woolf came to see him at Shepperton, where the art department was already hard at work, to discuss potential substitutes. When he finally suggested Carol Reed, John was immediately enthusiastic: 'You've got it. He knows nothing about musicals – like me – but he's a great director of children, in fact, a great director.' Others have suggested that John may have proposed Reed, but in any case once he agreed, the project began to take creative shape. Now the need for expertise in musicals became even more pressing, especially after discovering that Bart was unable to edit his own music to fit the film. During another trip to America, this time with Reed, John was introduced to Johnny Green, an experienced composer and music editor, and to the Broadway choreographer Onna White. The musical novices were now ready to embark on what would be one of the rare full-scale British efforts in this genre in a spirit of happy collaboration:

The *Oliver!* art department in front of the carousel: John (extreme right), with (from right) Terry Marsh and assistant art directors Bob Cartwright and Roy Walker.

Production still of
'Consider Yourself',
the big song and dance
number that greets
Oliver when he arrives in
London, staged on the
main street/market set.

In those days there used to be a certain rivalry between British and American filmmakers, but not in this case. Johnny and Onna were so good, so helpful, and they just fitted into a team. I would work with Onna on how she was going to do the choreography, and Johnny would be editing the music ahead of time to fit it. I would give them the sets, explaining what was possible, and when we had it all worked out, we'd go to Carol and tell him he still had to direct it!

The extended 'Who Will Buy?' sequence was a result of this collaborative process, with John proposing that they introduce window-cleaners and a host of other trades, while the presence of a pond in the park naturally led to the suggestion that one of the file of kindergarten girls should sit down in it and burst into tears, effectively punctuating the rhythm of the scene. The sheer scale of this Bloomsbury crescent set, which had originally been inspired by a group of real trees growing on the Shepperton lot, called forth much of the activity that fills it – a striking example of what Charles and Mirella Affron call 'set as narrative'.[3]

---

3    Charles and Mirella Affron, *Sets in Motion: Art Direction and Film Narrative*, Rutgers University Press, 1995, pp. 158ff. See also Appendix. Although the exact significance of the Pan-like flute-playing figure (first seen in one of the trees in the garden), who later grimaces directly to the camera, remains obscure (a private joke by Reed?).

Three phases of the film's second major production number, 'Who Will Buy?', staged in a 'Bloomsbury Square' set, when Oliver has been rescued from Fagin's gang by Mr Brownlow.

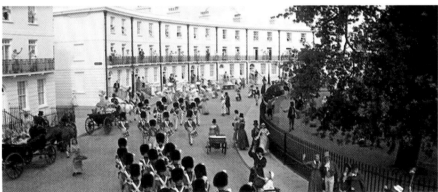

Phyllis Dalton was back as costume designer, after the 'interruption' of *A Man for All Seasons*, and relished the challenge. Working from Dickens was an inspiration – 'he always helps with detail' – although this advantage was offset by the acknowledged difficulty of costuming dancers and singers. But above all, *Oliver!* was the first major Dickens film to be made in colour, after nearly seventy years of black-and-white adaptations, backed by the earlier tradition of monochrome illustrations of the novels.

What was wonderful about working with John again was his willingness to collaborate. If he thought a scene needed an accent of colour, we'd discuss it and take the actor and the costume out onto the set to see them in the proper context – as happened with the Artful Dodger's hat.

This was very different from the experience of a film like *Suzie Wong*,

where the director wanted to see costumes in his hotel room, far from the set, with all the wives and hangers-on, which is humiliating and awful for the designer. It's probably the end of the day and everyone's having a drink and can't wait to get rid of you. It took me years to get up the courage to say, 'No, I can't do that', but with John it was quite different.

Chance first brought Oliver to Mr Brownlow's attention, through an attempt to pick his pocket. But he also realises that Oliver may be his vanished niece's boy, thanks to his resemblance to a portrait of her – just as Oliver is about to run an errand and be recaptured by the gang.

Inevitably, John was also involved in making sure that the narrative coincidence at the heart of Dickens's novel would be grasped by audiences with different expectations from those attending a stage musical. Oliver's rescue from the rough justice of the magistrate, Mr Fang, by the man he robbed sets in motion the discovery of his mother's identity that will lead to his eventual salvation. A portrait of a young woman at Mr Brownlow's house attracts Oliver's attention – 'it makes my heart beat as if it was alive and wanted to speak to me' – and observing the boy as he sleeps beneath it, Brownlow realises how much he resembles the woman. In the film, this moment of recognition is condensed and happens just as Oliver is about to run an errand for Mr Brownlow. John commissioned a portrait based on the young Mark Lester's features, which ensures that the audience shares Mr Brownlow's shock of recognition – just before Oliver is recaptured by Sikes and Nancy.

Everyone who worked on *Oliver!* has a story to tell about Carol Reed's preoccupation with birds, which he adored. Fagin was to have an owl in his ramshackle attic, and Reed asked if he could take the bird home 'to get to know it', only to report the following day that the part would have to be 'recast' after the owl had made a mess of his house. For 'Consider Yourself', the big number that marks Oliver's arrival in London, John had the idea of releasing a flock of pigeons 'to give it energy'. Carol loved the idea, and undertook personally to release one pigeon close to the camera. However, when the bird failed to fly into picture, retreating instead into the studio, John noticed that

A menacing build-up to the entry of Bill Sikes (played by Carol Reed's nephew Oliver Reed), whose shadow announces his appearance at the waterside tavern and links the imagery of *Oliver!* with that of London's darker side, traditionally associated with Limehouse and Whitechapel.

Reed was watching it rather than the dancers. 'I said, "with due respect, you've got some dancers getting exhausted out there", and he says, "Oh God, of course – cut!".' Coming to *Oliver!* with no previous experience of musicals, Reed was even prepared to question the dramatic relevance of some of the film's major song-and-dance numbers, including 'Who Will Buy?', which indeed does nothing to advance the narrative, despite its lavish spectacle.

What mattered most for him was the dramatic tension of one of Dickens's most harrowing stories, and the actors. Reed had been hired partly on the strength of his track record in directing children, from *The Fallen Idol* (1948) to *A Kid for Two Farthings* (1954), and his Oliver, as played by Mark Lester, has a sweetness and vulnerability that makes his ill-treatment, first by the workhouse beadle and the undertaker to whom he's sold, then by Fagin and Sikes, all the more distressing. By the same token, Reed was not afraid to make his Bill Sikes a truly malevolent figure – possibly helped by the fact that he was directing his own nephew, Oliver Reed, who gives one of his most disciplined performances. Helped by Reed's dramatic rather than decorative approach, the musical numbers, rather than appearing extraneous (as they had, for instance, in another London period musical, *Half a Sixpence*, 1967), make explicit the emotional ties between the characters. As Peter Evans has observed, 'Consider Yourself One of Us' orchestrates London's offer to the orphan waif; 'Be Back Soon' shows the 'bad father' Fagin taking an almost benevolent attitude to his brood; and 'As Long as He Needs Me' voices Nancy's poignant, unconditional love for Bill.[4]

As John had discovered on *Zhivago*, creating an environment that communicated its own atmosphere could have a beneficial effect on the actors, helping them to tune in to the story's setting as they gathered from many different backgrounds. Harry Secombe, who played the beadle, Mr Bumble, recalled the impact of the *Oliver!* sets:

4    P. W. Evans, *Carol Reed*, Manchester University Press, 2008.

The design of Fagin's den had to accommodate dancing space with sleeping areas for the boys and the miser's hidden hoard. The tattered Union Jack evokes popular Carnaby Street imagery of the 1960s, while a cramped entrance helps to choreograph arrivals and departures.

The parade of market types and trades that appear in 'Consider Yourself' bring a Busby Berkeley scale of narrative to this belated great British musical.

the money being spent on the project was tangible. To wander round the outdoor sets was to be taken back in time. The recreation of early Victorian London was authentic down to the smallest detail. There were even real loaves of bread in the baker's shop windows.[5]

Sean Kenny had brought Brecht's version of realism to the popular stage, combining authentic detail with a 'skeletal' three-dimensional structure. John intensified the sense of authenticity for this first screen portrayal of Dickens's London in colour, helped by the renewed vogue for Edwardian and Victorian style that was a part of 'swinging London' – and which may have inspired the tattered Union Jack that forms part of the decor of Fagin's den. But he also created a sense of social reality, as he had done for the early Moscow scenes in *Zhivago* that connect the lives of the rich and the poor. Indeed, the elaborate sets for *Oliver!* could be said to restore the material and social dimension that is missing from Bart's highly schematic account of the novel, with its emphasis almost entirely on the larger-than-life characters of Fagin, Sikes and the Dodger. The film's two major sets – the

5    Morris Bright, *Shepperton Studios: A Visual Celebration*, Southbank Publishing, 2005, p. 206.

market street that accommodates 'Consider Yourself' and the stylish crescent of 'Who Will Buy?' – both support a scale of activity that amounts to a kaleidoscopic visual essay on different social aspects of the Victorian city. The main street, with its suggestion of Covent Garden, erupts into a living inventory of the crafts and trades that serviced the metropolis, while the Bloomsbury crescent in which Oliver miraculously wakes up after being rescued also reveals the extent of the domestic services that supported the Victorian upper classes – as well as offering many delightful narrative details that emerged from the process of filling the film's rich canvas.

Both of these sequences are heavily stylised and follow the musical genre's conventions of dynamism and symmetry. But their character types and social overtones are also as clear as the messages that emanate from Busby Berkeley's Depression-era musicals. The colours may be bright and the dancers athletic, yet these are also recognisably the denizens of Dickens's journalistic view of the great city, with its extreme contrasts of wealth and poverty. For Terence Marsh, like John, it was a welcome return to the era when British cinema made 'great London films, like *Waterloo Bridge*, *London Belongs to Me* and Ealing films such as *The Blue Lamp*'.

*Oliver!* met with a rapturous reception, especially in the United States, and won five Academy Awards, including Best Picture, Best Director, one for John and his art department team, and for Phyllis Dalton's costumes. Strangely, despite being heavily nominated, it won no BAFTA awards, which mostly went to *2001: A Space Odyssey*. Dickens, perhaps, was proving to be more appreciated abroad – or was it British embarrassment about producing such a sumptuous *musical*? Roger Ebert spoke for many American critics when he praised the film's taste, 'it never stoops for cheap effects and never insults our intelligence', singling out John's 'magnificent sets that reproduce Victorian England in perfect detail – and never to excess' (*Chicago Sun-Times*, 22 December 1968). *Time* was even more complimentary, quoting the axiom in musical theatre that 'you can't whistle the scenery', to predict that film audiences *would* whistle John's 'miraculous recreations of higher and lower London' (*Time*, 18 December 1968). Inevitably, the film's relative realism has been overtaken by more challenging visions of the Victorian metropolis, ranging from the calculated shocks of the *Elephant Man* (1980) and *From Hell* (2001), to Polanski's later *Oliver Twist* (2005), which boasts magnificently squalid and teeming sets (by Allan Starski) that surely owe something to *Oliver!*. But with the passage of time, its extraordinary fusion of talents and integrity have also come to seem little short of miraculous.

# Close-up 5

*Oliver!*

When John started work on *Oliver!*, he was well aware of two important precedents: the classic David Lean film of 1948 and Sean Kenny's innovative sets for the original 1960 stage production of Bart's musical. Neither was directly relevant to the task in hand, although both would provide indirect inspiration.

Lean's film and John Bryan's austere design for it were certainly the most important influence on the opening workhouse sequence and its famous climax, where Oliver asks for more, However, in place of the expressionistic Lean/Bryan prelude, with Oliver's mother hurrying across a blasted heath to the gates of the workhouse, John devised an economical sequence in a different register to convey the mechanical misery of the institution. A drawing of the exterior in nineteenth-century style, with its gates proclaiming that it is an institution for orphans and paupers, dissolves to another drawing of a giant treadmill-powered flour mill. This image in turn dissolves to the actual machine, operated by a row of boys hard at work, before we see John's greatly expanded version of Bryan's glistening black brickwork, with symmetrical prison-like staircases. While the effect is similar – repeating the image of the starving boys peering through a skylight as their board tuck into a feast – John was not in a position to employ Bryan's use of chiaroscuro lighting and forced perspective for effect, but instead had to provide a real space suitable for the dance and chase sequence built around 'Food, Glorious Food'.

With no prelude to set the bleak tone of Oliver's origins, as in Lean's *Oliver Twist*, John devised an opening sequence that avokes 19th-century engraving style by showing a series of illustrations, the last of which, a giant treadmill, 'comes to life', with boys toiling on it like modern galley-slaves.

Gustave Doré's engravings of London had been a source for John Bryan's *Oliver Twist*, and John Box would also pay tribute to Doré's 'St Paul's from the Brewery Bridge'.

Everything in the workhouse and subsequent undertaker's sequences, apart from the officials' costumes, is rendered as close to monochrome as possible, although not as dark as Bryan's vision. John acknowledged that 'London used to be smoky in Dickens's time and everything would have been blackish. But I didn't want to make anything grim, because we were making a musical, which had to be cheerful and bright.'

John Bryan's design for *Oliver Twist* had drawn upon a number of graphic sources, including the Neo-Romantic movement among English artists of the 1940s, such as John Piper, Michael Ayrton and Graham Sutherland. But another key reference was Gustave Doré's book of engravings, *London: A Pilgrimage* (1872).[1] Several of Doré's picturesquely crowded scenes provided Bryan with key details of his *Oliver Twist* sets: notably a precarious wooden footbridge that appears in Doré's 'St Paul's from the Brewery Bridge' (p. 130) and is reconstructed for the 'rookery' where Fagin lives with his school of pickpockets. Of the opinion that 'what was good enough for John Bryan was good enough for me', John also looked at Doré for inspiration.

The dome of St Paul's rises majestically above the crowded chimneys of Doré's stylised view of Victorian London, and John would deliberately hold back this iconic image until the later stages of Nancy's fatal devotion to Sikes, so that it appears like a benediction over her tragic progress. The 'brewery bridge' is expanded to become a series of wooden walkways and stairs that lead up to Fagin's den and the warehouses where Sikes will finally face the mob incensed by his brutality. The bridge provides a suitably bizarre stage for Fagin's dance, showing how seamlessly scenography and

1 Gustave Doré and Blanchard Jerrold, *London, A Pilgrimage* (1872). References here to the Dover edition, *Doré's London: All 180 Illustrations*, Dover Pictorial Archives, 2004.

The bridge, derived from Doré and Bryan, that forms the entrance to Fagin's den becomes an important setting for song and dance, as well as action, in *Oliver!* Both Fagin and Nancy (Shani Wallis) perform important numbers on it.

choreography were combined, and according to Terence Marsh it was built twice: 'on the big set and again on a smaller stage, for the closer shots, so that you get St Paul's in a different perspective in some shots'. The stairway was carefully engineered so that at the climax of Sikes's attempt to hold Oliver hostage it would be released and swing free, stuntmen clinging to it in a thrilling, and unrepeatable, 'one shot deal'.

But the most important influence of Doré on *Oliver!* appears in the main street set, built, as in *Zhivago*, on John's favourite 'rising ground, to get perspective'. Here, a key source was Doré's 'Ludgate Hill – a Block on the Street' (p. 115), which shows an almost amorphous mass of people, omnibuses and carts wedged into a narrow street that stretches under a bridge, with St Paul's appearing mistily in the background. John's main street radically reshapes this, and introduces elements of Covent Garden's market architecture to 'motivate' the dance sequence that includes foodstuff of all kinds. But what links it directly to Doré is the appearance of a train steaming across the bridge. John's reasoning is instructive:

The bridge and rickety steps that lead up to it retain a sense of squalor and danger that is largely missing from *Oliver!* and provide a suitably perilous framework for the climatic chase after Sikes.

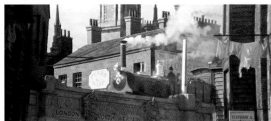

Oliver's run away from the undertakers and arrives in London. Big challenge: how to do it? There's got to be something in the street, so that it's not just another set. I hit on the idea of having the train go across it – a steam train, that gives the scene energy, and a chance to get a reaction from Oliver, who's never seen a train before. And that leads up to his meeting with Jack Wild [the Artful Dodger] and 'Consider Yourself'.

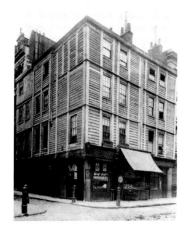

Doré's train was of course in monochrome, and forms only a small part of the crowded composition of 'Ludgate Hill'. But John's bright red locomotive becomes the visual focus for Oliver's first, astonished view of London, as he emerges from beneath a wagon-load of bright green cabbages – and, after the drab monochrome of the workhouse and the undertaker's, also helps cue us into an increasingly colourful world that will reach its climax in the chocolate-box fantasy of 'Who Will Buy?'.

Despite inevitable compromises, John and the art department carried out their usual thorough historical research. A valuable resource turned out to be the photographic collection built up in the late nineteenth century by the Society for Photographing Relics of Old London, which recorded parts of the city that were due for demolition. The historian Colin Sorenson identified one of the Society's photographs, of Fore Street, as a source for the slatted wooden buildings that form a background to the scenes involving Fagin's young pickpockets, Sikes and Nancy.[2] The decision to reproduce this may well have been guided by Sean Kenny's remarkable 1960 stage set, with its lattice of wooden struts and spars projecting out towards the audience. The crucial difference is that while Kenny revolutionised stage design by making it more 'skeletal' and suggestive, the film sets for *Oliver!* created a new sense of the Victorian city as a lived-in space. And, ironically, what was initially only built for this production became one of Shepperton's enduring assets, endlessly refurbished and re-dressed for dozens of later films as Britain's only standing street set.

Doré's 'Ludgate Hill' supplied the train crossing a busy street, which John translated into vivid red, as Oliver's first 'London' sight. Victorian photographs of old buildings provided other references.

2    Colin Sorenson, *London on Film*, Museum of London, 1996, p. 105.

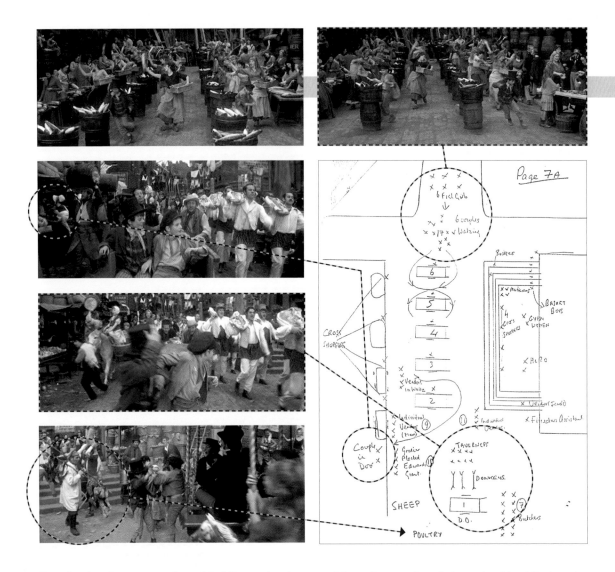

Reproduced on these pages are three original diagrams kept by John from the production of *Oliver!* They record some of the unusually detailed preparation that went into making what was for most of the British personnel involved their first experience of a modern screen musical. Although there had been popular British musicals in the 1930s, the dynamism and scale of Hollywood musicals in the 1940s and 1950s seemed to inhibit British efforts – until the late 1950s saw a new wave of films built around pop and rock performers, such as Cliff Richard, Tommy Steele and, of course, The Beatles. But American musicals had not stood still during this period, so that by 1967, when *Oliver!* began to take shape, there was a steep learning curve for all concerned.

Johnny Green was brought in to adapt Lionel Bart's music, since Bart had no experience of such exacting work, and Onna White elaborated the choreography. But for the big production numbers, especially 'Consider Yourself' and 'Who Will Buy?', it was necessary for them to work closely with the art and wardrobe departments, to plan exactly who and what would appear in shot as groups of dancers moved, and what path the camera would follow to capture all this.

These diagrams cover the planning of 'Consider Yourself', and chart the dancers' 'entrances and pre-set positions' in relation to the camera's movements, with a separate diagram for the placing of characters on the carousel which stands beside the market hall steps.

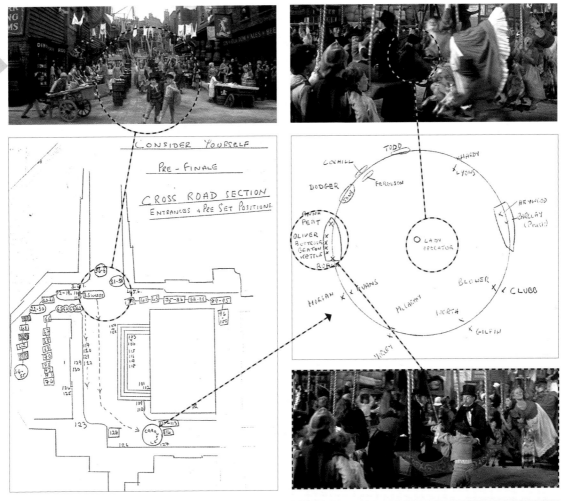

This may have been what was actually filmed, or at least planned, but inevitably it does not correspond precisely with what we see on screen. It would have been filmed to playback of the music in question, to establish speed and synchronisation points. But different angles and takes would then be available to the editor, for composing the final visual sequence.

What these records bear witness to is the sheer scale of planning needed – much of which seems to have been co-ordinated by the art department, under John's leadership. Although it was to be the only musical that he, or Carol Reed, made, it has stood the test of time remarkably well. And soon after, Terry Marsh and Ossie Morris would bring their experience to bear on another successful Dickens musical, *Scrooge* (1970).

# Chapter 7

## Adventures in Production and Direction

Before John embarked on his first production, *The Looking Glass War* (1969), adaptations of John Le Carre's *The Spy Who Came in from the Cold* (below left) and Len Deighton's *The Ipcress File* had already set the new tone of disenchanted spy thrillers.

With *Oliver!*, John had completed an unparalleled run of commercially successful films, and was faced with a dilemma. Should he move on from design to produce or direct, taking more responsibility for his career by initiating projects and so benefiting more from their success? He discussed the idea with Lean, who insisted that he was 'much more valuable as a designer'. But an unexpected offer came from Mike Frankovich, Columbia's head of production in Europe on *A Man for All Seasons* and *Oliver!*, but who was now returning to Hollywood with a deal to produce for the studio. Calculating that he needed to have five productions under way, with at least one in Europe, he realised he could only manage this if at least one was safely subcontracted to another producer. So while Frankovich busied himself with such comedies as *Bob and Carol and Ted and Alice* and *Cactus Rose* (both 1969), John was signed up to make his producing debut with a first-time director, Frank Pierson. Pierson had enjoyed a recent run of successes as a writer, with *Cat Ballou* (1965) and *Cool Hand Luke* (1967), but was now attempting what John also contemplated.

Their subject was *The Looking Glass War*, the third novel by John Le Carré, a diplomat who had personal experience of Cold War intelligence and, along with Len Deighton,

An upside-down world graphically portrayed in the opening scene of *The Looking Glass War*, as a British agent debriefs a pilot shortly before meeting his death on a lonely road.

was taking spy fiction in a new direction. Le Carré's *The Spy Who Came in from the Cold*, published in 1963 and filmed in 1966, with Richard Burton and Claire Bloom, had been a considerable success, offering a grittier, more realistic view of espionage, in contrast to the increasingly glossy histrionics of the Bond series. In many ways, the image of Britain's secret service depicted in *The Looking Glass War* is not so different from Graham Greene's comic portrayal in *Our Man in Havana* (Greene was an early admirer of Le Carré), a similarity reinforced by the appearance of Ralph Richardson as a Blimpish intelligence chief, together with Paul Rogers.

John's initial responsibility was casting, and he had hopes of securing the Russian ballet star Rudolph Nureyev, who had defected to the West in 1961, to play the central role of an enigmatic Polish seaman recruited and ultimately sacrificed by MI6. But when Nureyev thought better of playing such a political role, he turned instead to an American newcomer, Christopher Jones, paired with the young Swedish actress Pia Degermark, newly famous after her appearance as the star-crossed lover of Bo Widerberg's *Elvira Madigan* (1967). Both of these actors would meet with early misfortune in their personal lives that ended their promising screen careers, but the film's other discovery was Anthony Hopkins, who plays the angry, eventually disillusioned young spymaster with passion and tremendous physicality.

With casting complete and a polished script by Pierson, John found the role of producer frustrating. He had quickly decided that Spain would provide all the exteriors required for the scenes set in East Germany, while the studio scenes would be shot at Shepperton and the film's design was in the hands of his trusted art director Terry Marsh. How much they consulted is unclear, but the design has a bold simplicity typical of earlier Box–Marsh collaborations. The motif of ghostly reflections in glass appears as background to crisply modern opening credits, and is carried into the first scene, set in a Finnish airport bar, with a mirrored counter eerily reflecting the British agent and his contact, only to reappear in the final image of the Polish agent mown down by East German security police. Perhaps surprisingly, the dominant colour throughout is white. The high-level political intrigue

From corridors of
power in Geneva to
a secret interrogation
centre and a gloomy
office in London:
Operation Mayfly is
cynically set in motion
by the old guard of
British intelligence, led
by Ralph Richardson.

that frames 'Operation Mayfly' is first discussed in a dazzling Geneva palace, immediately
followed by the Polish seaman's first interrogation by MI6 officers, in an off-white sound-
proofed cell. White furniture predominates, bare white walls provide the background to
Anthony Hopkins's disintegrating marriage, and there is the almost surreal image of a cy-
cling team all in white, as the agent reaches his goal in East Germany. Amid this modernity,
with its rather deliberate Pop Art trappings, MI6 appears to be still living and working in
the tweedy ethos of the Second World War, which was indeed Le Carré's central theme.

A notable feature of Terence Marsh's design for *Looking Glass War* is its extensive use of white, for settings in London and East Germany, as if to suggest there is little to choose between these Cold Warriors and their regimes.

John showed the completed film to Columbia executives in New York, after first receiving Lean's approval (and the compliment of Christopher Jones being cast for *Ryan's Daughter*, 1970), and everyone appeared pleased with his first effort as a producer. It was not a commercial success, however, probably because of its confusingly pessimistic themes and range of disagreeable characters. As Hitchcock discovered with his comparable film *Torn Curtain* three years earlier, Cold War cynicism and violence in the bleak setting of East Germany were not intrinsically attractive, without a strong plot .

Having discovered that producing was not his metier, John hankered after a chance to direct. He and his wife were keen theatregoers, and he had been impressed by a Royal Shakespeare Company production of a play by one of the new generation of political playwrights, David Mercer. Mercer had made his name with a series of original plays for television, one of which had already been adapted for cinema as *Morgan: A Suitable Case for Treatment* (Karel Reisz, 1966). Prolific and much sought after, he began to write for the stage and was 'adopted' by the RSC, as part of its commitment to new writing. Mercer combined in his own experience and his work two of the decade's major preoccupations: the 'New Left' revival of Marxist politics and new approaches to psychiatry that drew upon Freud and existentialism. His second play, *Belcher's Luck*, dealt with a dying aristocrat and his contested legacy, intended as 'a metaphor for England and its class structure', and it was this that John optioned for his debut as a director.

Almost immediately he was contacted by the producer Harry Saltzman, already famous for having launched the British 'new wave' with *Saturday Night and Sunday Morning* (1960) and the Bond franchise, as Cubby Broccoli's original partner, who was also interested in Mercer's play. Saltzman offered to finance a three-picture deal: one subject chosen by each, and a mutual choice. John's agent advised going to Columbia instead, since they had a high regard for his talents, and a deal proved forthcoming, although it offered little funding during development. John enjoyed working with Mercer on the script: 'he could be quite wild when he wasn't working, but when he was, he was

highly professional and couldn't have been a better partner'. With the script finished, John began casting, and approached John Hurt, who had appeared in the RSC production and whom he knew from *A Man for All Seasons*; Richard Attenborough and John Gielgud were also signed up. Terry Marsh was engaged as production designer and started scouting locations. Then, abruptly, Columbia's personnel changed and the former actor and agent John Van Eyssen, who had been in charge of UK production for some time, became the studio's head of worldwide production, and announced that Columbia would no longer back *Belcher's Luck*.

John was devastated, but also urgently needed work to support his family. On cue, Sam Spiegel re-entered his life with a carefully crafted offer. Would he take on B-unit direction – not second unit, but a fully crewed unit to cover all the exteriors – on *Nicholas and Alexandra*? John had already turned down an offer to design this film, unwilling to repeat his work on *Doctor Zhivago*, but this was tempting, since it would at least give him some experience of directing what Spiegel airily described as 'too big a film for one director'. The main director would be Franklin Schaffner, highly experienced in directing television drama, who had recently enjoyed a series of successes with unusual historical epics, from *The War Lord* (1965), with Charlton Heston, to *Planet of the Apes* (1968) and *Patton* (1970), from a script by the young Francis Coppola. Spiegel proposed that Schaffner would handle all the interior scenes, while John would be responsible for all the exteriors. The designer was to be Vincent Korda, brother of Alexander and another of John's heroes. But Korda's last job had been nearly a decade earlier, on *The Longest Day* (1962), so the news that Spiegel had reluctantly fired him can hardly have come as a complete surprise. John protested, but realised that he was now committed to acting as overall production designer.

Almost immediately, he began to make the kind of logistical decisions he had done on *Lawrence* and *Zhivago*. Instead of shooting in Austria, as Spiegel proposed, he insisted on Spain, which could provide the limited number of exteriors needed for what would be primarily a family drama. The royal palace in Madrid could double for at least some palace scenes, but the main problem would be – as it had been for Zhivago – the unreliability of snow. John remembered scouting northern Yugoslavia for *Zhivago* and went back to reassess it. By Christmas of 1970, he was anxiously awaiting the first snowfall in Zagreb, with a unit that included the Spanish cinematographer Manuel Berenguer (who had filled in between Nic Roeg's departure and Freddie Young's arrival on *Zhivago*), Robert Laing as art director and Anthony Powell as costume designer. When snow finally began to fall on New Year's Day, they rushed to film the first major scene of mass violence, as the charismatic Father Gapon leads a mass demonstration in St Petersburg in 1905 to plead with the Tsar for better treatment of his people, only to be met with gunfire from the Imperial Guard that initiates the cycle of repression leading up to the revolutions of 1917.

The similarities to events and scenes in *Zhivago* are hard to ignore, and must have weighed heavily on John, although here the 'big history' that Pasternak's novel managed to illuminate from the margins is tackled head-on.[1] The 1905 Bloody Sunday sequence is an effective depiction of the confusion that can turn a confrontation into a massacre, as a mounted officer falls off his horse, apparently leaving the troops without clear orders, and a brief flash of red at the first volley initiates images of the crowd's panic. The scene ends with a bloodied Gapon and a fresh-faced young man, later identified as the Social Democratic leader Alexander Kerensky, agreeing that Nicholas is a 'murderer'. Later scenes that bear the hallmarks of John's style include a delightful seaside interlude, shot at Castell-Platja d'Aro near Girona; the assassination of the reforming prime minister Stolypin during an opera performance at which the Tsar is also present, where the lurid folkloristic backdrop of the opera is soon followed by a grim tableau of the hangings and repression that this act unleashes; and Lenin's arrival at the Finland Station in St Petersburg in 1917, a scene already famous from Eisenstein's staging of it in *October*

Returning to revolutionary Russia for a second time with *Nicholas and Alexandra* (1971), John directed the second unit for many sequences, including the confrontation in 1905 between Father Gapon and his followers, come to petition the Tsar, and the Imperial guard. His treatment makes an interesting comparison with the equivalent demonstration in *Doctor Zhivago*.

---

1   *Nicholas and Alexandra* was based on a bestselling historical novel by Robert K. Massie published in 1966.

Chronicling the last years of the Romanov dynasty involved a range of exotic settings, including the Tsar's Black Sea retreat and the assassination of his prime minister Solypin during an opera performance.

When Nicholas takes personal command of his troops during World War One, his relative Grand Duke Nicholas takes him for a quiet walk in the forest to offer some frank advice. By contrast, the dissolute Rasputin is assassinated by a group of nobles at a specially staged orgy.

(1928), which is here realised almost entirely in monochrome, broken only by red propaganda banners.[2]

The story of the last Romanovs has an undeniable poignancy, especially in its final phase, as the family is bundled unceremoniously from one place of detention to another, the earlier bickering between Nicholas and his domineering German-born wife Alexandra now replaced by a common concern to protect their children, particularly the haemophiliac Alexei. Michael Jayston, in one of his few cinema roles, and Janet Suzman, whom John recommended to Spiegel after seeing her in Shakespeare, give affecting and nuanced performances in roles that are schematically conceived; while a seemingly endless succession of great actors – mostly with heavy beards – come and go as the statesmen and revolutionaries of the period. Tom Baker, in his pre-*Dr Who* period, gives a suitably wild-eyed account of the monk Rasputin, whose power over Alexandra helps stoke anti-Romanov feeling in all quarters, before his assassination in a sequence that tries gamely to invoke opium-fuelled decadence and homosexuality in contrast to the prevailing symmetry and opulence of the court scenes.

After the weight of ceremony and history that burdened *Nicholas and Alexandra*, John's next projects would take him further into the realm of decadence. Both *Travels with My Aunt* (1972) and *The Great Gatsby* (see Close-up) depended crucially on the creation of a hedonistic world that the audience sees through the eyes of an inhibited central character. Adapted from Graham Greene's 1969 novel, *Travels* is the story of assistant

2    Stolypin was assassinated in August 1911 at the Kiev Opera, in the presence of the Tsar, as recounted by Alexander Solzhenitsyn in his novel *August 1914*. *The Tale of Tsar Saltan* has been illustrated by many Russian artists, but this stage design seems to be in the vividly coloured style of Nicholas Roerich.

bank manager Henry Pulling, who meets his aunt Augusta at his mother's cremation and is dragooned into setting off with her on a madcap expedition to Paris that will lead to Istanbul, Spain and eventually North Africa. The film was originally developed and scripted by Katherine Hepburn as a project to reunite her with George Cukor. But when John came on board, he was disturbed to discover that Hepburn had altered the role substantially to fit her own abilities. Accounts vary as to who decided to replace Hepburn with Maggie Smith, but since the producer Robert Fryer had previously launched Smith's mature career with *The Prime of Miss Jean Brodie* (1969), which also starred her then husband Robert Stephens, she would have been an obvious choice. Smith was thirty-eight when she took on the role, recounted in flashbacks, of the schoolgirl

Augusta (Maggie Smith) falls under the spell of M. Visconti (Robert Stephens, her real husband at the time) in the opulent Train Bleu restaurant of the Gare de Lyon in Paris during a school trip abroad.

Augusta who falls for Stephens's con man, Ercole Visconti, and the courtesan she later becomes, as well as the outrageous elderly Augusta who lives with a black fortune-teller and lover half her age (played by the American Lou Gossett). It is a virtuoso performance, even if mannered to the point of caricature, for which she received an Academy Award nomination.

Equally mannered is the film's design, which was also Academy nominated. John was impressed by the impeccable taste of Cukor's own Hollywood house, but the two seem to have encouraged each other to excess, abetted by Anthony Powell, whose melodramatic costumes did win an Oscar. The main technical challenges facing John were to integrate fantastic studio-built interiors with establishing shots in a range of real locations, many of which proved difficult to film in, and also to maintain the required level of high theatricality without descending into mere kitsch. As on *Nicholas and Alexandra*, he also acted as second unit director, retaining many of the same team, including Robert Laing, and bringing in the set decorator Dario Simoni, who had worked on both *Lawrence* and *Zhivago*.

A bare crematorium chapel and Henry's suburban garden establish the confines of his previous, apparently virginal, existence. From the moment when he innocently enters a bustling Victorian pub – actually the Salisbury on St Martin's Lane – which leads to Augusta's black, lilac and silver-themed flat above, he embarks on a version of the magical mystery tour that had become common in 1960s films. Augusta may be a figure from another age, but the eclectic decor of her flat recalls such icons of late-1960s style as *Performance*, *Leo the Last* (both 1970, the latter also featuring Lou Gossett) and *Blow Up*. Despite its contemporary setting, the guiding style of the film is Belle Epoque, with the famous Train Bleu restaurant of the Gare de Lyon in Paris providing the sumptuous location for Augusta's pivotal first meeting with Visconti and frequent station scenes evoking

Launched on a career as a courtesan, Augusta is in Venice when M. Visconti re-enters her life. Augusta's extravagant tastes dictate that much of the film consists of luxurious settings conjured up with great ingenuity by John and his team.

the romance of Pullman travel.[3] But it is the Georges V hotel in Paris, with its *faux* nineteenth-century decor (it was built in 1928) that is clearly Augusta's spiritual, as well as actual, home during her long liaison with her official lover, M. Dambreuse. Using the foyer of the real hotel, renamed the St Georges, with Augusta located in an 'Albion' wing, John and his art department colleagues created rococo interiors that are the equal of Smith's outrageous performance and Powell's extravagantly theatrical costumes.

As the film careers towards its North African denouement (omitting the last part of Greene's novel, set amid revolution in Latin America), with an ambiguous ending in the typical style of a late-1960s 'caper' movie, decor plays a smaller role and much depends on whether we accept Henry's growing feeling for the unrepentant adventuress who is his true mother. Many have found Smith's Augusta too strong for their taste, despite the foil of Alec McCowen's impeccably restrained Henry, but the film was a favourite of John's, and remains a tour de force of art direction, with artifice, embellishment and narrative all intertwined.[4]

Passing from a recent novel by a living writer to an American classic kept John in the field of literary adaptation, with the attendant pitfall of being judged either inaccurate or over-literal. The story behind the third adaptation of F. Scott Fitzgerald's 1925 novella *The Great Gatsby* almost mirrors the book itself, turning as it does on the effects of glamour and power in American society. The new head of Paramount, Robert Evans, bought the rights in 1971 for his then wife Ali MacGraw, who was to star as Daisy, and she chose Jack Clayton as director. However, after McGraw left Evans for her co-star in *The Getaway* (1972), Steve McQueen, the casting of the film became a free for all, with many actors under consideration, ranging from Warren Beatty, Jack Nicholson and even McQueen for Gatsby to Katherine Ross, Candice Bergen and Faye Dunaway for Daisy, before the final choice of Robert Redford and Mia Farrow.

Further complications ensued. A script by the fashionable novelist Truman Capote was rejected as too dialogue-heavy, which led to an emergency rewrite commissioned from Francis Ford Coppola, newly famous for *The Godfather* (1972). The original costume designer, Shirley Russell, withdrew and there was a further delay before Theoni Aldredge, previously a designer for the stage, came on board. Then, faced with a rising budget, it was decided to economise by shooting interiors and some exteriors in Britain at Pinewood – John certainly helped make this possible, although he was indignant that

3    The Gare de Lyon was built as part of the 1900 Exposition Universelle, and its ceiling remains one of the finest relics of *Belle Epoque* Paris.

4    See Affrons' categories.

the producer, David Merrick, later blamed him for the decision. More disturbing from John's point of view, having always enjoyed good relations with most of his colleagues, was the director's seemingly unprovoked hostility towards him. At one point, Clayton physically attacked the swimming-pool set, explaining that he wasn't angry about it, but with John.[5] Whatever the difficulties between them, which neither spoke of openly, Clayton had certainly prepared himself carefully to take on this American classic, consulting all the leading Fitzgerald authorities, including the author's daughter, Scottie. After all, his own breakthrough film, *Room at the Top* (1959), had dealt frankly for the first time in British cinema with class, sex and money, and had even included a tragic car crash. Yet, as Clayton realised, Fitzgerald's novel, for all its powerful evocation of the Jazz Age and of the shallowness of America's rich, is distinctly light on plot and evasive on many crucial details that needed to be visualised on film, relying heavily on what an early critic admitted was the 'charm and beauty of the writing'.[6]

John was certainly apprehensive about the likely reception of a Fitzgerald adaptation made by British filmmakers, and partly filmed in England. However, *Gatsby* finally began

*The Great Gatsby*: production sketch for the Buchanans' sitting room in their mansion on Long Island, where Daisy's old friend Nick Carraway visits early in the film.

---

5 The hostility may have resulted from Clayton expecting to direct *The Looking Glass War*, and blaming John for preventing this. See the interview in Penelope Houston, 'Gatsby', *Sight and Sound*, vol. 43, no. 2, Spring 1974, p. 79.

6 H. L. Mencken, review in the *Baltimore Sun*, quoted in Arthur Mizener, *The Far Side of Paradise: A Biography of F. Scott Fitzgerald* (1959), Heinemann, 1969, p. 183.

The 'big house' at Pinewood Studios provided a background for exteriors on *The Great Gatsby*, where the production moved after its location shoot in America. Here, it has Gatsby's swimming pool as a temporary extension.

shooting on location in the United States in the wet summer of 1973. John had undertaken a recce of the novel's main setting, around East Egg 'on that slender riotous island which extends itself due east of New York', as Fitzgerald described Long Island. When this proved unsuitable for a recreation of the 1920s, he turned his attention to Rhode Island, where many of its rich inhabitants still lived in a similar style to the 1920s and

The 'cottages' of Newport, Rhode Island, provided exteriors and some luxurious interiors for *Gatsby*. Here, Gatsby (Robert Redford) welcomes Daisy (Mia Farrow) to his mansion.

were happy to appear as extras in the Gatsby party scenes, along with clean-cut students from the US Naval War College in Newport. Several of Newport's palatial 'cottages' built by the nineteenth-century plutocrats stood in for Long Island's mansions: notably The Breakers, a seventy-room palazzo built by Cornelius Vanderbilt in the 1890s, and Rosecliff, the home of silver heiress Theresa Fair Oelrichs, noted for her lavish parties, which provided a suitably grand exterior for Gatsby's mansion. John transformed an existing swimming pool into a pond and fountain as the centrepiece for the parties that Gatsby gives in the Oelrichs tradition, and erected marquees around it, with coloured stripes that could be changed to mark the passage of time.

Unexpectedly, the British filmmakers also discovered the violence that marked American union disputes over jurisdiction. The sequences where the Long Islanders drive to New York for entertainment were filmed at various Manhattan locations, including the Waldorf-Astoria and Plaza hotel. When shooting in New York, the production came under the New York union 'locals', but Rhode Island fell under the Boston unions, who made their antagonism clear in a series of attacks on hotel rooms and cars. Back at Pinewood, John put into action the plan he had earlier conceived of using the centre-piece of the studio itself, Heatherden Hall:

> I found myself looking at the Pinewood mansion and decided we were going to use it for the Gatsby house. Not for the parties, but for the entrance. There was a car park, which we cleared out, then we built columns in the American style, and added a balustrade. A very important set was the swimming pool, which we created out of a sunken tennis court beside the house.

Pinewood Studio was offered the opportunity to co-invest in building this 'elegant and airy amenity, pavilioned in a splendour of plate-glass mirrors and signs of the zo-diac', but declined, so all that remained afterwards was 'a large and extremely ugly hole in the ground'.[7]

Another key setting was the garage, run by George and his wife Myrtle, who is also the mistress of Tom Buchanan, Daisy's brutish husband. This is located in an area de-scribed by Fitzgerald as a 'valley of ashes', through which the road between West Egg and New York passes, and is overlooked by a large oculist's hoarding, featuring 'a pair of enormous yellow spectacles'. Unable to find any suitable location in Rhode Island, John discovered a nondescript area on the edge of the Pinewood lot that would allow a com-bined exterior and interior set to be built, 'which helped create the feeling that we were really there'. But even with this, friction arose when Clayton noticed that Dr Eckleburg's sign had 'oculist' spelled 'occulist' – an art department error that he threatened to report

---

7    Quotations from Penelope Houston, who visited the set (article cited above).

A giant advertising sign overlooks the Wilson garage and its staring eyes suggest to the increasingly desperate Tom Wilson that 'God sees everything'. When the sign was found to have misspelt 'oculist', Jack Clayton threatened to fine John, but the error remains and perhaps adds to the quaintness of this abandoned sign.

to the producer, but which remained uncorrected. The scene of Gatsby's funeral was also filmed at Pinewood, with some help from a North London cemetery and carefully reproduced American-style gravestones.

*Gatsby* was Paramount's major spring release for 1974, and did relatively good business at the box office, despite sniping from critics who claimed that it was untrue or an inadequate version of the novel. Clayton remarked ruefully that he hadn't realised there were so many Fitzgerald experts, but took comfort from the endorsement of Fitzgerald's daughter and no doubt from Tennesee Williams's verdict in his 1975 memoirs that the film 'surpassed' the novel.[8] The film won two Academy Awards, for Theoni Aldredge's costumes and Nelson Riddle's arrangement of period music, while John had to be content with the BAFTA award for art direction. Although disagreement has continued over the film's interpretation of the novel, few have questioned its achievement in bringing to the screen, for the first time in colour, the opulence and decadence of America's Jazz Age.

---

8   Neil Sinyard quotes Williams in his study of Jack Clayton's work, and provides a detailed defence of Clayton's interpretation of the novel. This includes quoting Fitzgerald's self-criticism, in a letter to Edmund Wilson, of the 'BIG FAULT' of giving 'no account of the emotional relations between Gatsby and Daisy after their reunion' – a lack that Clayton felt he had to make good, and for which he was widely criticised. Neil Sinyard, *Jack Clayton*, Manchester University Press, 2000, p. 146.

# Close-up 6

*The Great Gatsby*

Fitzgerald's novel is narrated by a participant observer, Nick Carraway, who is related to Daisy and knew her husband at college, but is insulated from the excesses of the Buchanan–Gatsby world by his modest means. It is through his description and commentary that we view their 'vast carelessness', but in a film we inevitably see both more and less than the novel conveys. By the time John joined *Gatsby*, Jack Clayton had already been working on it intensively for nearly two years and had commissioned a second script, in order to introduce more variety and visuality into the film – to which John would give concrete shape. Given Coppola's later claim that Clayton had distorted his script, and John's recollection of Clayton's antagonism towards him, it is difficult to be sure exactly what creative role John played in translating Nick Carraway's vision into images, although it is unlikely that he would have failed to offer structuring ideas.

Fidelity to Fitzgerald's vision and the spell it had cast for nearly fifty years was uppermost in the minds of the filmmakers. The opening sequence, for instance, covers almost exactly the same narrative ground as the novel's first chapter, omitting only Nick's account of his own family background. But it does so by making significant changes in the action. Rather than driving to visit his cousin Daisy and her boorish husband Tom, as he does in the novel, Nick sails a small motor dinghy inexpertly across the bay, establishing him as perhaps more independent than his rich neighbours, but also less assured. Using the boat allows him to be met by Tom in polo gear, and taken in a chauffeur-driven car on the last part of the journey, emphasising this difference. Returning at dusk after his visit, which has revealed the fragility of the Buchanan marriage, he leaves from their jetty, which features a flashing green light; as he disembarks on the other side, a line from the opening of the book – 'Gatsby ... who represented everything for which I have an unaffected scorn ... turned out all right in the end' – spoken by Nick in voiceover, cues our first image of the enigmatic Gatsby, seen in near-silhouette on a higher level and partly framed by a marble upright, gazing

As Nick Carraway takes his leave of the Buchanans, we see the green light that, in the novel, Gatsby will stare at across the bay. And at the end of the boat trip he will see Gatsby for the first time, brooding silently.

across the bay towards the distant flashing light.[1] Thus, half a page of Fitzgerald's first description of Gatsby has been condensed into several shots; and the spatial structure of Nick's point-of-view shots is surely attributable to John's location work in Rhode Island. The symbol of the green light, which in the novel represents Gatsby's dream of regaining Daisy, has also been explained – or perhaps made too literal?[2]

The most overtly symbolic element in the novel is the Wilsons' garage, set in a 'valley of ashes' overlooked by the giant spectacles of the oculist's sign. Scholarly

Wilson's garage stands in the 'valley of ashes' that Fitzgerald vividly described, and John realised on the Pinewood lot, no doubt recalling the 'Ashcan school' in American painting that had set out to represent the reality of the urban landscape.

---

1 Nick's summary verdict on Gatsby appears on the second page of the novel. *The Great Gatsby* (1926), Penguin Books, 1994, p. 8.
2 The 'single green light … that might have been the end of a dock', towards which Gatsby stares at the end of the first chapter (p. 28), is not identified with Daisy at this stage.

tradition ascribes these to Fitzgerald's reading of T. S. Eliot's *The Wasteland* several years before writing *Gatsby*, and his desire to invoke 'a sense of eternity' in relation to the squalid behaviour of those who 'floated in the wake of his dreams'.[3] Unsurprisingly, John was unable to find a location near Long Island that replicated this extraordinary scene, since it is precisely a vision: 'a fantastic farm where ashes grow like wheat', a grim parody of a true pastoral landscape.[4] The set he built from scratch on the Pinewood lot therefore represents what is probably his most original contribution to *Gatsby*, apart from the blending of genuine 'gilded age' Rhode Island exteriors with studio interiors and façades. This filling station has red gas pumps, which perhaps inevitably recall Edward Hopper's famous 1940 painting *Gas*, except that these are dull obelisks compared with Hopper's glowing beacons, and Wilson's Garage is grimy and run-down, as if realised from an image by a member of the 'Ashcan' group of American

Two paintings that offer reference points for the Wilson garage scenes. Maurice Kish's *East River* (*c.* 1932) records the smoke and industry of New York's environs, while Edward Hopper's *Gas* (1940, detail) has become the iconic portrayal of the promise of motoring in America.

---

3    Fitzgerald had been strongly affected by his reading of *The Wasteland* in 1922, shortly before writing *Gatsby*, and Eliot had reciprocated, calling *Gatsby* 'the first real advance in American fiction in recent years', according to Milton Stern, *The Golden Moment: The Novels of F. Scott Fitzgerald*, University of Illinois Press, 1970, p. 363. Fitzgerald's editor, Maxwell Perkins, was delighted by the oculist's sign, suggesting that it invoked 'the sense of eternity'.

4    *Gatsby*, Chapter 2, p. 29.

Tom Buchanan (Bruce Dern) ushers Nick into his elegant sitting room, where Daisy and her friend Jordan are lounging in the oppressive heat that hangs over the entire action of the film. Compare with the sketch on p. 109.

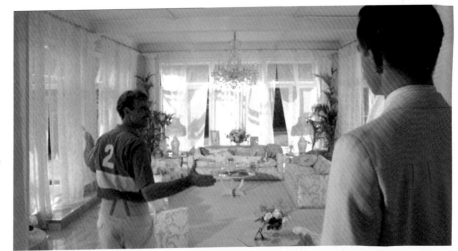

In the comparative darkness of Wilson's garage, Tom brazenly acknowledges Myrtle (Karen Black), with whom he is having an affair. The cluttered, artisanal interior of the garage makes a striking contrast with the luminous world of the very rich, as Tom effectively tries to buy Wilson's complicity.

painters.[5] The black smoke that curls up from several points around the set banishes any thought of Pinewood's leafy Buckinghamshire setting, and recalls instead Maurice Kish's New York paintings of the 1930s, such as *East River*.

The advantage of building this at Pinewood was that it could be a combination exterior–interior set, allowing shots looking outward through the grimy, wire-meshed window, as when Tom first insolently takes Nick to 'meet his girl', Myrtle. The dark, meticulously detailed interior, full of engineering props, contrasts vividly with the

5    The Ashcan School, so named in 1916, was originally a group of eight young New York artists taught by Robert Henri who exhibited their distinctive versions of urban realism in 1908, and defined a new direction in American art. John Sloane and George Bellows were more typical, but the label was also applied to Edward Hopper. See Stephen Coppel, *The American Scene: Prints from Hopper to Pollock*,

brilliant white of the Buchanan and Gatsby mansions. And at the climax of the narrative, when Myrtle has broken free of her husband's imprisonment, only to be run down by Daisy driving Gatsby's car recklessly, the same composite set now serves as the night-time arena where Tom recoils aghast from the sight of Myrtle's corpse, and her husband broods on his loss and plans revenge on her presumed killer, Gatsby.

The two worlds are more closely linked in a sequence of images that bears the stamp of John's work on scene transitions with Lean. After Nick has left the Buchanan house, with Gatsby hovering outside to 'protect' Daisy, a close-up of Dr Eckleburg's disembodied eyes dissolves to a matched shot of the yellow car's headlights, one smudged with blood. As the shot pans to a mudguard, also bloodstained and dented, it dissolves to a long shot in the garage, where the table on which Myrtle's body had lain is now empty, though smeared with blood, and George silently broods, while his well-meaning neighbour tries to comfort him. The tragic, mistaken connections that will lead to Gatsby's death by George's hand are here made powerfully explicit through linked images, *before* we see the wide exterior shot dominated by the oculist's hoarding, which relates to Fitzgerald's most explicit equation between Dr Eckleburg's eyes and Wilson's obsessive insistence that 'God sees everything' (p. 166).

George (Scott Wilson) has locked up Myrtle in a desperate attempt to keep her, but when she escapes, she is run down by Gatsby's car, driven by the inexperienced Daisy. The multiple ironies of this tragic accident are explored in a sequence of images linking Dr Eckleberg's all-seeing eyes with the bloodstained headlights of the car that bear the imprint of John Box's fascination with transitions.

# Chapter 8

New Directors and Directions

During the five years after *Oliver!*, as John tried to gain more control over his career, he discovered that he was temperamentally unsuited to producing and had got no further in directing than the second unit. Yet he continued to be in demand as a production designer – indeed, he was now sought after by a new generation of directors. One of these was Norman Jewison, a Canadian-born producer and director living in the UK during the early 1970s, best known for *In the Heat of the Night* (1967), an outspoken challenge to racial intolerance in the American South that had won five Oscars. His most recent projects had been two Jewish-themed musicals, *Fiddler on the Roof* (1971) and *Jesus Christ Superstar* (1973), both involving extensive location filming but based in the UK. Now he was to follow an emerging trend and move into the 'near future' with *Rollerball*.

Films that predicted a bleak future for mankind were hardly new. Between the wars there had been Fritz Lang's *Metropolis* (1927) and Alexander Korda's *Things to Come* (1936), both remembered more for their spectacular design than for their narrative drive. And in 1968, the image of science fiction had been dramatically improved by two very different landmark films: *2001: A Space Odyssey* and *Planet of the Apes*. But the new decade had seen a cluster of films prophesying either dehumanised society or ecological disaster, or a combination of the two. These included *THX 1138* (1970), *No Blade of Grass* (1970), *The Omega Man* (1971), *A Clockwork Orange* (1971), *Soylent Green* (1973), and in 1973 two more exotic variations, *Zardoz* and *Westworld*. When Jewison approached John to design another cautionary vision of the future, he welcomed the opportunity to tackle a new challenge.

*Rollerball* had started life as a short story in *Esquire* by William Harrison, a literature professor from Arkansas, and caught Jewison's attention as the basis for a parable about the increasing power of corporations to feed the compliant masses with artificial manufactured entertainment. In Harrison's story, 'Roller Ball Murder', a violent sport has been

systematically promoted by the ruling corporations to monopolise popular attention and absorb energies that might otherwise lead to dissent. Like the Roman plebs of old, the fans of Rollerball are encouraged to vent their bloodlust as their modern gladiators perform in the stadiums. In the aftermath of the riots of 1968, the French Situationists' critique of a society of 'spectacle' had wide currency; and the 1972 Olympics had provided a grim reminder of the potent political symbolism of sport, when Palestinian terrorists held Israeli athletes hostage before the world's media.

For the murderous sport that dominates the future-world of *Rollerball*, John adapted the velodrome of the Munich Olympics to create a hi-tech arena.

John's first task was to design the game of Rollerball, which is both complex and impossibly violent in the original story, and had to become 'practical' for the film. He set off for Munich, 'thinking about the Olympics and the basic idea of violence in sport which starts to affect the people watching'. Keeping Harrison's roller skaters and motorcyclists (but dropping another group of players wielding 'lacrosse-like paddles'), he drew on his own love of sport to develop a plausible game, with rules for possession of the ball and scoring:

'Rollerball', as developed by John, involves tag teams of roller-skaters and motorcyclists who battle for control of a metal ball which they must lodge in a goal – somewhat like an acted-out version of roulette.

James Caan leads the victorious Houston team, and his growing fame worries the executives who control the game and through it the wider society. Gladiatorial tactics, including deliberate injury of opponents, seems to be allowed.

We started experimenting in one of the indoor stadiums. I thought at first that the motorcyclists would chew up the skaters, but the skaters were incredible, they were so quick and fast they could have upended the motorcyclists if they'd wanted – which they weren't required to do in the rehearsals. I realised I'd have to get the gradients right, to avoid mayhem.

Norman Jewison recalled that it was John's model of the arena that convinced him the game was filmable, and construction proceeded in the former Olympic velodrome. The budget was far from lavish, so costs had to be carefully controlled. By a stroke of luck, the ideal structure for the headquarters of the Houston-based 'Energy Corporation' that controls Rollerball stood close to the Olympic site in Munich. BMW's new HQ, popularly known as the 'four cylinder tower', had been completed just in time for the

1972 Games, and when the production secured permission to film both outside and inside, Karl Schwanzer's futuristic structure fitted exactly the concept of a 'near future' that was believably close to the present. The nearby BMW museum, shaped like a giant circular tyre-case on its side, was also used as part of the 'Houston' exteriors.

The new BMW headquarters building in Munich, in the form of giant cylinders balanced on a slender base, served as an 'instant' futuristic image.

The film centres on Jonathan E., the game's star gladiator, impressively played by the highly athletic James Caan, whose popularity leads the corporation's chief, Bartholomew, an icy John Houseman, to try to force him to retire. Rollerball, we are told, is not a game 'in which a man is supposed to grow strong' and four tournaments mark out the corporations' war of attrition, where the rules are deliberately changed to ensure even greater carnage. The same amphitheatre was used for all four, with only the colours of the teams and their frenzied supporters marking any difference – an effect that underlines the global homogeneity created by corporate dictatorship. Above the angled track, deliberately designed to resemble a giant roulette wheel, where a gun located at the rim fires the steel ball into play, large monitors relay the action to the spectators; indeed, one of the film's most successful design predictions is a standard 'multivision' installation in the interiors, where three small screens above a main screen allow access to different images.

Another effective unifying device is the film's futuristic typeface, used for all on-screen graphics: a rounded block face suggesting the computerisation that has effectively replaced books in the world of 2018. Computers were far from common in the mid-1970s, although their likely impact had been a staple of science fiction for many years, and *Rollerball* sits on the cusp of their becoming a reality. Jonathan's quest to discover just how the world came to be ruled by faceless corporations takes him first to a local library, where books have all been 'summarised', and then to a central archive, supposedly in Geneva. Here, Ralph Richardson's portrayal of the eccentric Librarian provides the film's only real comedy, as he complains about the erratic behaviour of the central computer, Zero, which has just 'lost' the entire thirteenth century. Approached by metallic corridors and staircases, Zero turns out to be a bubbling cylindrical tank, like a giant colander with glass windows, which suffers a cybernetic breakdown when asked to give Jonathan the information he wants, reduced to squawking 'negative, negative, negative'. Richardson's cameo provided a link with *Things to Come*, designed by John's mentor John Bryan, in

which he had played a dictator who brings civilisation to the brink of extinction, before a new order of technocrats imposes order – somewhat as the corporations have enforced in *Rollerball*.

As Jonathan becomes a reluctant rebel, insisting on remaining a player, he attends an elite party, originally intended to mark his retirement. During the lavish event that reflects the decadence of the ruling executives (witness the still-shocking scene of great simplicity where revellers blast a row of trees for amusement), he enjoys a brief idyllic reunion with his former wife, played by the ex-model Maud Adams, who was taken from him by an executive. This sequence is set in lush countryside and forest, with a modern ranch-style house (actually in Kent) standing in for the exterior of Jonathan's privileged retreat. The interior is decorated in earthy shades of warm brown and tan, with reclining leather chairs around a simulated open fire that unobtrusively supports John's idea of a

Below: Caan relaxes with his current girlfriend and trainer in a futuristic version of Roman dining, part of the film's reliance on 'timeless' classicism. The society's privileged indulge in blasting trees for sport.

timeless 'classical' lifestyle and dress for these patricians of the future, in particular the women:

> We weren't setting out to show something startlingly futuristic, which the audience would reject. It had to be recognisable to present-day audiences, because the great trick you're doing in any film is to take the audience inside. They're not watching a film; they're part of the life that's going on.

Critical reaction to *Rollerball* was mixed, with many finding its vision of the future schematic, and questioning whether the film did not glorify the vicarious violence it claimed to denounce. But the impact of the arena sequences was undeniable, and the elegant restraint of John's future world brought him a BAFTA award for the second year running.

## *Sorcerer* (1977)

The next new generation director to approach John was William Friedkin, famous in the mid-1970s for his two sensational hits, *The French Connection* (1971) and *The Exorcist* (1973). Friedkin told John that he had always wanted to make an outright adventure film, but found that he kept coming back to the French *Wages of Fear* as the best of its kind, and had decided to remake it on a larger international scale. Henri-Georges Clouzot's acclaimed 1953 film purports to be set in an unnamed Latin American country, but was actually filmed in the South of France, around Nîmes and the mouth of the river Rhône. As a specialist in hyper-realism, Friedkin naturally wanted to film on location, so he sent John off to find suitable locations for the classic story of four desperate men who undertake a near-suicidal jungle mission to deliver unstable nitroglycerine by truck to the site of an oil-well fire.

> I found South America fascinating, but I had to apply it to the story. Peru seemed as if it was going to be the answer, but it wasn't. Venezuela was interesting, but it wasn't right either. You needed mountains and strange countryside inland; then you had to come down to the sea, with coconut plantations. Equador fitted the bill, especially for the big scene with the trucks crossing a river. So after several months out there, I contacted Billy and told him to get his jungle gear and come out and take a look for himself.

Friedkin was happy with the locations John proposed, and they also devised plans to incorporate the volcanoes encircling Equador's capital Quito. Then Universal abruptly announced that they would not support the film in any Latin American country. Wondering why he had been sent on a wild goose chase, John returned to London. Just

Opposite: Caan's luxury home is decorated in autumnal tones, in contrast to the steely blue and white of the executive zone, where he is summoned to meet the all-powerful John Houseman. Trying to discover what has happened to the censored past, he visits a central computer in Geneva, presided over by Ralph Richardson's eccentric chief archivist. A computer-style typeface appears throughout the film, reinforcing the sense of a totally controlled society.

before Christmas 1975, Friedkin phoned to say that Paramount were willing to back the picture, but only if it was filmed in the Dominican Republic, where the studio's parent group Gulf+Western owned a major sugar company.

John and Friedkin set out early in the new year to recce what was now their only possible jungle setting, on the Carribean island of Hispaniola, and decided that it could work. However, when they came to plan the all-important river-crossing sequence, John discovered he had been misinformed about the water levels, and this sequence was eventually staged in Mexico, although not without more off-screen drama:

The sweaty world of *Sorcerer* is a hell where men who can no longer live in their own worlds have come to be forgotten, undertaking dangerous work and passing time in a seedy bar – until an oil-well fire offers volunteers the chance to undertake a near-suicidal mission for a large reward.

The bridge was probably the most difficult location set on location I ever had to deal with. We had these huge ten-ton trucks and we had to build a rickety-looking suspension bridge to carry them over racing water. On the day of shooting the bridge, Billy turned strange – he was clearly nervous. He said that the approach track wasn't right. I'd had enough of this bridge by then, so I said: 'You've seen this in advance and everything was fine – now it's the day of shooting …' These are the sorts of things that happen to a designer. Fortunately, I had an extremely able lieutenant, Roy Walker, who had quietly gone off and used a

bulldozer to create a new track, which was ready by the end of the day. But I was nervous by this time – I thought we were going to lose the truck, with people in it.

In a film that generates extraordinary suspense of the most visceral kind, this sequence vividly conveys the real danger that accompanied its shooting, as the rope bridge sways, the trucks leaning dangerously as they navigate gaping holes and planks giving way under their weight.

However, long before this climactic scene, we have been introduced to the small town where the four drivers are recruited, an unusually convincing scene of poverty, ripe for exploitation by the corrupt local police and the American-owned oil company. Amid the corrugated-iron hovels and garbage-strewn streets, a seedy saloon ironically named El Corsario (The Pirate) provides the only communal space, where a wary German-speaking barman hints at past or present Nazis on the run. In this tropical climate, sweat runs as freely as in the Long Island of *Gatsby*, but here it becomes an integral part of the minutely realised texture of hopeless lives. The mechanics of the oil well and the disastrous explosion that triggers the eventual mission are conveyed swiftly and starkly, with a series of cataclys-

The four who agree to drive a cargo of unstable explosive to extinguish the fire face a route of desperate challenges, including crumbling roads and a collapsing bridge – all shot under almost equally desperate conditions on location in the Dominican Republic.

The last stages of Roy Scheider's drive take him through a weirdly beautiful landscape that make this a dream-like experience.

A sketch by John for the jungle store where the explosive is discovered to be dangerously unstable.

mic explosions ripping through the surrounding structures, followed by a brutal sequence that shows the burned bodies being returned to their relatives and the resulting attack on the company's guards. With a colour palette reduced to shades of blue and amber-rust, this is perhaps the most concentrated, atmospheric achievement in John's post-*Lawrence* career.

But such results were not achieved without tension behind the camera. Indeed, so demanding was Friedkin that his original English director of photography, Dick Bush, left the film and his number two, John Stephens, completed it. The logistics of filming were complex: John recalled having to build an airstrip to bring in equipment and to facilitate the extensive use of helicopters, all of which must have reminded him of *Lawrence* fifteen years earlier. There were also deep disagreements about the film's structure. Unlike the original *Wages of Fear*, which launches the deadly mission before revealing what had brought each of the drivers to such desperation, Friedkin insisted on outlining their

backgrounds at the beginning of the film in a series of episodes set in Mexico, Israel, France and the United States. Filmed on location, each of these is a mini-narrative in its own right. A hit man strikes in a hotel in Vera Cruz; Arab terrorists plant a bomb in Jerusalem, with only one escaping the military response; a Paris banker facing disgrace flees after his partner commits suicide; and the driver of a getaway car survives a crash when the thieves fall out after robbing a New Jersey church.

John argued that providing this motivation at the outset 'took the mystery out of why they're undertaking this mission' and was a fundamental mistake, dispelling suspense. But part of the designer's job, he believed, is to 'direct yourself towards your director. There will be disagreements, but he or she is the director and you must get in line, or leave.' The film notably failed to perform at the box office – admittedly with the misfortune to open against *Star Wars* – and it is tempting to blame this failure at least partly on Friedkin's intransigence. But there are other potential reasons, beginning with the obscure title. The casting was also severely compromised, with Roy Scheider eventually playing the part originally assigned to Steve McQueen, and Clint Eastwood as a possible replacement. Friedkin considered Scheider's casting in the lead role a mistake. But despite becoming his least seen work, it remains his own favourite among all his films ('the only one I can watch because it came out almost exactly as I intended'[1]) and has developed a vigorous band of supporters among internet commentators. And for John, it helped develop an interest in Latin America that would eventually lead him to champion *Nostromo*.[2]

## Tahiti and *The Keep* (1983)

If the commercial failure of *Sorcerer* was a disappointment for Friedkin, John was about to face one of the most difficult decisions of his career. David Lean had left his base in Rome to live in Tahiti, where he had become fascinated by the history of the *Bounty* mutiny in the late 18th century. New perspectives had emerged on the classic story of the clash between Captain Bligh and his one-time mate Fletcher Christian, and Lean persuaded Robert Bolt to start work on a script that grew into a project for two films covering the epic story of the mutiny and its tragic aftermath. By the summer of 1977, John was part of the team, visiting a boatyard in Copenhagen to consider commissioning a vessel for the film. But when he arrived to see Lean in Bora Bora in the autumn, he had severe reservations about how practical it would be to film in such a remote, and expensive,

Lean's 'Mutiny on the Bounty' project, set in Tahiti, had already been announced in the trade press when a report of John's withdrawal, on grounds of practicality, apparently damaged its prospects.

Warner Bros. announces David Lean's next film based on "Captain Bligh and Mister Christian" By Richard Hough. Robert Bolt is writing the screenplay. John Box is designing. Phil Kellogg is producing.

Preparations are underway in the South Seas to start shooting in 1978.

---

1    Quoted in Thomas D. Clagett, *William Friedkin: Films of Aberration, Obsession and Reality*, Jefferson, 2003.

2    See comments on the film in IMDb Users section.

location. Put on the spot by Lean to commit or not at a breakfast meeting, he withdrew from the project in a move that caused him much heart-searching and deeply hurt Lean. The *Bounty* project would limp on until 1980, before being finally abandoned. John and David did not speak for another five years, until they were unexpectedly reunited on *A Passage to India*.

One of John's reasons for withdrawing from the *Bounty* was that he did not want to spend another indefinite period away from his wife and family. But this was also an anxious time for a designer nearing sixty, working in an industry that was increasingly linked with and staffed by graduates of advertising and television. Projects came and went, until his next firm offer came from another American director with a background in television and ambitions to work in less formulaic ways on the big screen. Michael Mann (b. 1943) had written and produced on such series as *Starsky and Hutch* (1975–7) and *Police Story* (1976–8), before a television film, *The Jericho Mile* (1979), attracted awards and achieved a limited European cinema release in 1980. Mann made his first full cinema feature, the stylish crime thriller *Thief*, in the following year, before turning to very different material for his second.

*The Keep* was a neo-gothic popular fantasy novel by F. Paul Wilson that became a bestseller before being bought by Mann. The setting was a mythic Eastern Europe, the land of supernatural legends ever since Bram Stoker's *Dracula* and Jules Verne's *Castle of the Carpathians*. But the period is 1941, as a German unit arrives in this remote Carpathian village to occupy the ancient fortress that dominates it. Their confidence is soon shaken by a series of unexplained deaths and phenomena, which climax in the revelation that the keep holds captive a Golem figure of vast power, which will wreak destruction if re-

A quarry in North Wales solved the problem of finding a suitably forbidding landscape for *The Keep* (1983), but created its own logistical problems.

leased by a willing human accomplice.[3] Two parallel struggles develop: between the 'good' German commander and a brutal SS officer sent to overrule him; and between a Jewish scholar, brought from a concentration camp to advise on the castle's inscriptions, and a mysterious avenger, Glaeken Trismegestus, who travels from Greece to destroy the monster. When the professor falls under the Golem's spell, to the horror of his daughter, Eva, only Glaeken is equipped to stop it with his equally supernatural powers.

The mythology of Transylvania, as figured in Jules Verne's *Castle of the Carpathians*, and Albert Speer's designs for a Nazi monument in Nuremburg were two influences on the visualisation of *The Keep*.

Mann had high ambitions for his second film, wanting to shape a parable about the psychopathology of fascism from the genre material of Wilson's novel, and so making its characters emblematic and its main settings evocative rather than realist. For the exteriors, John created a convincing Romanian-style village in a slate quarry in his beloved North Wales, while most of the film was shot on stages at Shepperton, using little more than sculpted beams of light and textured surfaces to create an epic arena for this struggle against the seductive worship of power. Mann's eclectic references included Hitler's favourite architect, Albert Speer, Sergei Eisenstein's treatment of the Teutonic Knights in *Alexander Nevsky* (1938) and German Expressionist cinema of the 1920s, especially for its architectural qualities, as in Fritz Lang's *Destiny* (1921) and Friedrich Murnau's *Faust* (1926).

But the riskiest aspect of the film was its supernatural core – a risk that Ridley Scott had triumphantly overcome with *Alien* (1979), making his monster both genuinely scary and psychologically credible. Mann's Molasar is conceived as something akin to Milton's Satan, a bad mutation of something once good, who evolves in the course of the film from the immaterial into a very visible fantasy figure to be defeated in a final battle. In the increasingly specialised business of fantasy cinema, the art department had no responsibility for Molasar, which was handled by a range of visual and mechanical effects

---

3    A Golem, in Jewish mythology, is a superhuman creature created from inanimate matter.

The golem-like figure Molasar grows in strength, from a ghostly cloud to a muscled colossus, but in the process loses the mystery that is most effective in the first part of the film. Much of the special-effects work had to be completed by others after Wally Veevers' death during production.

and make-up experts, headed by the veteran Wally Veevers – revered for his contribution to films ranging from *Things to Come* and *The Thief of Bagdad* (1941) to *2001*, *Superman* (1978) and, most recently, John Boorman's visionary *Excalibur* (1981). Sadly, Veevers died during the making of *The Keep*, with his work unfinished, making an already difficult task even more fraught, as colleagues tried to realise his intentions.[4]

By common consent, the later part of *The Keep* does not maintain the intensity and suggestiveness of the early sequences. This cannot be entirely blamed on the over-literal realisation of Molasar as a muscular superhero, or on the film being cut back to a bare 96 minutes, on studio terms, which removed the two more elaborate endings that were shot – one of which took the exhausted crew to Spain for a conclusion in which Eva, her father and a now-human Glaeken have escaped the war. Mann regards the film as a valuable learning experience in his career, recognising that the script was not ready before he went into production. But what he and its many fans continue to value is the clarity of the underlying concept, which was fully realised in the film's design. Wilson's folksy village and its castle guarding a dark secret may be little more than modern gothic, but in Mann's and John's hands, it moved closer to a Modernist interpretation that reaches out from such works as Villiers de l'Isle-Adam's *Axël*, Balazs's and Bartok's *Duke Bluebeard's Castle* and Kafka's *The Castle* towards trying to grapple with the psychopathology of fascism in a highly original, if flawed, form.

---

4 Veevers was notorious for not committing anything to paper, so there was nothing to refer to when he died. Colleagues in effects rallied round to help, but there is evidence that the coherence of this aspect of the film was seriously damaged by his death.

# Close-up 7

## *The Keep*

The setting for Michael Mann's Second World War occult tale was supposed to invoke Transylvania, although it is identified on screen as the Carpathian Alps in Romania. John approached it as a generalised concept of remote Eastern Europe – 'somewhere like Albania' –its eerieness already implied in the opening sequence, as the German convoy arrives in a picturesque village to be greeted by the intense stares of the locals. But where to shoot this village and the castle that dominates it? Location scouts had been sent to many mountainous parts of Europe, in the Alps and the Pyrenees, but had failed to find any suitable 'black mountain passes'. The ingenious solution lay in realising that a rocky background could just as well be below ground as above it – which led John back to North Wales, where he had located the China of *The Inn of the Sixth Happiness*, and specifically to the old slate mines of Llanberis and Blaenau-Ffestiniog.

In the quarry which is the setting for the village, the Keep itself was represented only by a large flat, dressed to represent a craggy fortress wall.

Building elements of a village at the bottom of a quarry meant constructing a lift and using cranes for the lighting and heavy equipment, but provided a spectacular black backdrop for the bright cream houses and church, while also remaining within reach of modern amenities. Research in the Wallachian region of south-eastern Romania had produced an inventory of folk architecture, with distinctive roof designs and decorative gable-top finials. Bordering the Black Sea and Bulgaria, this former 'land of the Vlachs' shows traces of Byzantine influence, which would inform the religious paintings that decorate the village church and provide a contrast with the stark hammer-like emblem of irreligious power that decorates the interior of the castle.[1]

---

1    The emblem that decorates the castle could be described as a cross lacking its top arm, although it more closely resembles a motif from Norse mythology known as Thor's Hammer or 'Mjöllnir', an association that seems more relevant to its link with the monstrous Molasar.

Despite its simplicity of means – like John's studio-built Hampton Court (p. 81) and Malabar Caves (p. 152) – the exterior wall of the Keep is wholly believable, thanks to careful detailing and the perspectival effect of the bridge that leads to it.

There was no suitable castle in this part of Wales. But rather than shoot exteriors elsewhere, John realised that this film could actually benefit from *not* using a real castle. Fabricating a façade, with entrance and drawbridge, would enhance the stylisation needed for this symbol of malign power. The main reference used for this unhistorical castle were the buildings of Nazi architect Albert Speer, and, in particular, probably his early designs for the Nazi Party rally grounds in a former Zeppelin field at Nuremberg. Here Speer used massive blank façades, with minimal interruptions for windows and doorways, to convey a sense of power, which is echoed in the brooding stonework façade of the keep, with its sparse pattern of projecting stones. A wooden bridge across an apparently deep ditch forms a dramatic threshold between the natural and supernatural worlds (recalling the bridge that leads to Count Dracula's realm in Bram Stoker's seminal novel). And John's design for the strange trapezoidal gateway may have been influenced by his recent travels in Latin America for *Sorcerer*, where such doorways are a feature of Inca architecture, or it might refer more classically to the tomb of Atreus at Mycenae in Greece.[2]

2    Greek architecture was an important influence on Speer's work for Hitler, although the Pergamon Altar and Ishtar Gate, brought to Berlin from Asia Minor and displayed on Museum Island in 1930, are cited as the main influence on his Zeppelinfeld structures.

Despite its appearance of solidity, the keep's façade in the Welsh quarry was no more than a large flat, suitably dressed set, which was then matched with corresponding sets for the castle interiors built on stages at Shepperton. John recalled with some satisfaction how he was approached later by the makers of a *Hamlet*, who wondered which castle he had used! The ability to persuade the audience that they have seen both the outside and inside of a real structure remains a fundamental skill of production design, but here it was essential to serve the director's purpose by using a sparse vocabulary of architectural features and scale that would produce the feelings of 'powerlessness, abjectness and low self-esteem' he believed shaped the fascist personality. Equally, the 'dessicated' black walls were intended to create a sense of 'dread', strongly contrasting with the luminous white of the village interiors, and in particular the scene where the mysterious stranger seduces Eva, as if drawing strength from her for his battle against Molasar.

The interior space of the keep is deliberately confusing and undifferentiated, making it a kind of 'mental' space, just as Molasar is supposed to be a projection of others' desires.[3] Apart from some detailing in the troops' living quarters and the settings

The studio-built interior of the Keep suggests an even larger space than the exterior implies, and one that consists of subtly balanced geometric planes, as marked on this working photograph.

---

3   A similar idea to that of the planet Solaris creating visible projections of humans' desires, in Stanislaw Lem's 1961 novel of the same name and the two films based on it, by Tarkovsky and Soderbergh.

Scott Glenn as 'Glaeken Trismegestus', preparing for his final confrontation with Molasar, the embodiment of evil that has long been imprisoned in the Keep but is now unloosed.

for narrative scenes, it consists of large empty spaces that are delineated by some bold geometric shaping of the rough black walls, but are mainly defined by beams of steel-blue 'linear' light, created by using old carbon-arc lamps, backlighting the actors.

A key early sequence for establishing the spatial and emotional language of the film occurs when two soldiers, bent on discovering hidden treasure, prise off one of the glowing crosses and discover a tunnel behind. One crawls through it, and is then seen emerging from the other side, before a spectacular pull-back reduces his image to a pinprick of light on an otherwise dark screen, transforming it into a kind of portal into the inner, supernatural space of the keep. Apparently continuing to pull back, the camera reveals an enigmatic double row of columns in the midst of a vast space, suggesting antiquity, before a ghostly smoke-cloud rushes up towards the distant figure of the soldier – who is soon discovered by his comrade, in the film's first horrific image, to have lost his head and shoulders to the mysterious force.

As the struggle to contain the destructive force imprisoned within the keep mounts, the film's space becomes more abstract, creating an apocalyptic landscape of smoke and dry ice in which Professor Cuza is carrying out Molasar's wish. For this, John created castings to simulate the bodies of more soldiers who have been eviscerated and fused into the walls like excavated corpses, forming a memorably grisly prelude to the final cosmic confrontation between Glaeken and Molasar.

A production sketch by Bill Stallion for an overhead shot of the German garrison troops devastated by the power of Molasar. Only the shape of the arch, echoing the entrance, 'anchors' this near-abstract space.

A memorable detail of the apocalyptic finale is a number of German troops apparently fused into the wall by some great force, created by means of castings.

# Chapter 9

## Retrospective Visions

John was already working on his next film after *The Keep* when he received an unexpected call from the producer John Brabourne to ask if he would be interested in a film set in India, 'because he had some connection with the country'. John expressed excitement about returning to the sub-continent where he had spent his youth, and accepted their offer. Although Brabourne and his partner Richard Goodwin were not at liberty to reveal the title of the film, when they mentioned negotiations with Cambridge University, John guessed it was *A Passage to India*. But he could not have known the complications that lay behind this dream offer, problems that would continue during production.

The author of the 1924 novel, E. M. Forster, based his scathing account of British officialdom on a pre-First World War visit and his own experience as secretary to an Indian prince, when he had come to know and love the country through his friendship with a young Indian man. But Forster, like his friend T. E. Lawrence, deeply mistrusted the cinema and forbade any adaptation of his work during his lifetime. After his death in 1970, Kings College Cambridge, where he had lived for many years, became responsible for his literary rights and continued to reject approaches, until in 1980 a new Provost accepted Brabourne's proposal, no doubt helped by the fact that his father-in-law, Lord Mountbatten, had been the last Viceroy of India.

Brabourne and Goodwin had no difficulty signing up David Lean to direct, since he had long wanted to make a film in India and was desperate to return to directing after the failure of *Ryan's Daughter*. According to his wife, he volunteered for the project even before being asked and before he'd finished the novel! Brabourne and Goodwin had succeeded in piecing together a budget from various sources, including HBO, Columbia Pictures and EMI in Britain, that was adequate rather than generous. Lean and his faithful associate Eddie Fowlie went to India on an extended location scouting trip in 1982, where they settled on Bangalore as the film's main base. During this trip, Lean was

heard to wish he had John on hand and Fowlie encouraged him to make the first move. This had led to the producers' enquiry, but when John heard who the director was, he doubted that Lean would agree to work with him after their acrimonious parting in Tahiti. Nonetheless, he wrote contritely to say he would welcome the chance to make amends, whereupon Lean abruptly changed his mind again, still blaming John for the *Bounty* fiasco.[1] But finally, after more encouragement from Fowlie, he relented, 'because I think he's very good'. John 'decided to swallow his pride' and travel to India, and the result would bring lustre to the end of both of their careers.

Forster's town of 'Chandrapore' was to be recreated on the outskirts of the city of Bangalore, largely in the abandoned estate of the Maharajah of Mysore, where John would rebuild the bungalows once occupied by the English colony. While the scale of this reconstruction was reported critically at the time in a British newspaper article, it was considered essential to shield the production from local people's attention.[2] John followed his usual practice of trying to build interiors within corresponding exteriors, to

A production sketch for the courtyard and pool in front of Fielding's house in *A Passage to India* (1985), where Dr Aziz proposes the fateful expedition to the Malabar Caves.

---

1    Brownlow, *David Lean: A Biography*, Richard Cohen Books, 1996, Chapter 45, fn. 17, p. 780.
2    Ian Jack, *Sunday Times Magazine*, 8 April 1984, pp. 33ff.

Before and after:
production sketch for
the 'bridge party' (to
'bridge the gap'), held
after the English ladies
arrive in Chandrapore,
and the scene's
realisation in the film.

help the actors feel a sense of place. The hotel the unit lived in had once been a British army barracks, parts of which could be used for the façade of the Indian university where Fielding teaches. But John was also searching for 'something to fasten onto, which would convey the timelessness of India', and – not for the first time – he found this in the trees of the hotel grounds, angled in a fantastic pattern. One key scene takes place was around a pool created under these trees, making an effective contrast with the artificially 'English' lawn and park setting for the garden party that is held in a cynical attempt to 'bridge the gap' between West and East. John remembered how a small army of Indian girls 'sewed' individual leaves through a fabric backing to create the bright green grass. The club where the English maintain their rituals, and which the visiting Englishwomen Mrs Moore and Miss Quested discover is barred to Indians, was built inside the Maharajah's palace.

Railways play a vital part in the mechanics of Forster's story, and John was as delighted as Lean had been to find authentic steam locomotives in full working order that would play a vital part in setting up the stages of the story. However, there are no extraneous 'train buff' images. A noticeboard in the Bombay station evokes the exotic names of the main lines during the inter-war years, and a vintage train brings the English visitors to Chandrapore in style, with a smaller station used to represent Bangalore as it would have been. For the fateful expedition to the Malabar Caves, John repainted a steam locomotive and carriages of the Nilgiri Mountain Railway, a celebrated narrow-gauge line that runs to the hill station of Udhagamandalam in Tamil Nadu, refashioning it as the 'Malabar Express', and set the fraught early morning departure in Coonoor station.

The exact period in which the film is set is deliberately vague, with costumes and amenities that generally seem to post-date the 1920s or 1930s. Fielding's shower is an often-cited anachronism for the pre-Second World War period, although the photograph of a Great War tank that Aziz sees on his shelf suggests a date closer to 1920; and the 'Quit India' campaign, for which a placard is seen during the demonstration outside the court, only started in 1942. Lean clearly wanted Forster's view of Anglo-Indian relations not to appear too historically distant, even if the story turns on attitudes and codes of behaviour that Forster had witnessed in the 1910s and 1920s. In his recasting, the older 'colonial' characters, such as the governor Turton, the doctor and the police chief Major McBryde are fully 'in period', while the teacher Fielding and Adela Quested are distinctly modernised.

The filming was fraught with tensions: many of the younger actors found Lean remote and simplistic in his direction, while his relationship with the director of photography, Ernest Day, also became increasingly frosty, despite their previous work together. Tension arose too when Lean told his editor, Eunice Mountjoy, that he was taking screen credit as editor, for the first time in his career.[3] But the partnership between Lean and John seemed to have resumed without difficulty, and among the film's many award nominations, production design was included by both the Academy and BAFTA, although it won neither. Criticism of the film in Britain focused on Lean's alleged softening of Forster's view of British behaviour in India and his sentimentalising of the ending. His casting of Guinness as Godbole was also widely ridiculed, cited as a hangover from the era of Peter Sellers' portrayal of comic Indians. Appearing shortly after Richard Attenborough's stirring *Gandhi* (1982) and immediately before Stephen Frears's taboo-breaking *My Beautiful Laundrette* (1985), it seemed to many a film 'out of time', although the critical response in America was generally more appreciative.

---

3    Previously an editor, Lean had always been closely involved in editing his films without taking screen credit. But for what he suspected might be his last film, he not only claimed sole screenplay credit, ignoring the work done by Santha Sama Rau, who had written the first draft, based on her earlier stage version of the novel, but demoted Eunice Mountjoy to 'associate editor', to her chagrin.

## London Again

Back in London after the excitement of India, John faced a 'lull' in his career – although another project had begun to incubate, very slowly. During the making of *Passage to India*, Nick Evans had visited the unit for the *South Bank Show* special he was producing about Lean, and he and John became friends. Now Evans invited him to work on two projects that were very different from anything he had done before.

The first of these was a television film, *Murder by the Book* (1986), which mocked the conventions of the English murder mystery, while also celebrating its most famous practitioner. In Evans's script, Agatha Christie is visited by her most famous creation, Hercule Poirot, who is alarmed that she plans to kill him off by publishing an old manuscript in which he dies. The resulting battle of wits probably owed something to the example of Anthony Shaffer's *Sleuth*, another metafictional battle between a mystery writer and the threat of 'real' crime. A strong attraction for John was the cast: Peggy Ashcroft as Christie and Ian Holm, whom he had directed for the second unit on *Lawrence* twenty-five years earlier. It was in fact his first, and last, taste of designing for television and provided an insight into another level of production. The setting was a single house, which John had to dress from a total budget of £5,000. Following his established practice of concentrating on the characters and 'letting nothing get in their way', he managed to bring it in below budget and collect enthusiastic reviews.

The continuing friendship led to work on a more bizarre feature film scripted and produced by Evans, and directed by Chris Monger. *Just Like a Woman* (1992) was based on the memoir of a London landlady's relationship with a male transvestite. Co-produced by London Weekend Television and the Rank Organisation, it has the modest scale and style of television drama, and heavily caricatured roles. American Adrian Pasdar plays both Gerald as a thrusting young merchant banker, thrown out of his elegant house in Pelham Crescent by his wife when she discovers his feminine clothing, and 'Geraldine', who is encouraged by his Twickenham landlady Monica (a bemused Julie Walters) to 'come out' as a transvestite. Much of the film's action takes place in Monica's house, the exterior of which John establishes in Barnes, close to his own flat, and in Gerald's bank, for which he used the striking jagged fins of the newly completed Minster Court in Mincing Lane – producing an image of predatory capitalism as gothic as anything in the contemporary *Batman Returns* (1992). But these are incidental pleasures in a film that muddies its plea for greater understanding of sexual minorities with tepid romance and a cartoonish revenge plot.

For the modestly-budgeted *Just Like a Woman* (1992), John created a typical London house, set near his own, in Barnes, and used the new neo-gothic Minster Court in the City for the exterior of a corruptly-run merchant bank.

## Black Beauty (1994)

In 1998, Evans hit the jackpot with an international bestseller, *The Horse Whisperer*, much to John's delight. But before this, horses would loom large in his own penultimate film. At the invitation of his former agent, Robert Shapiro, who had become head of production at Warners and then an independent producer, John took on the design of Caroline Thompson's first film as a director, Anna Sewell's *Black Beauty* (1994). Thompson's screenplays included *Edward Scissorhands* (1990) and most recently *The Secret Garden* (1993), which, along with *A Little Princess* (1995) and *Black Beauty* formed part of Warners' 'family entertainment' strategy to make new versions of children's classics that were expected have a long life on video and television. Shapiro felt that John could help Thompson, herself a horse-lover, with the period drama aspects of the film, which depicts the life of a working horse in the mid-19th century.[4]

Inevitably, the budget was low, which meant finding locations within an hour's drive of Pinewood, and shooting as much as possible in the studio grounds. Much of the film naturally focuses on horses in open-air locations, beginning with Beauty's early days in an idyllic pastoral setting, lushly photographed by John's colleague from *The Keep*, Alex Thomson. The manor house for Beauty's first happy period as a working horse was Hall

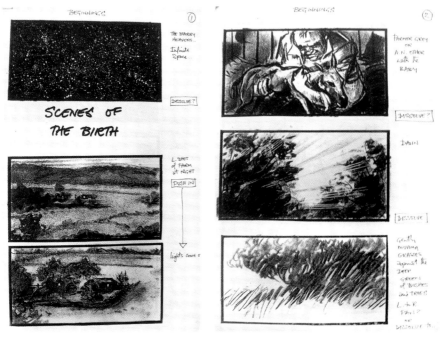

John's storyboards for the opening shots of *Black Beauty* (1994), designed for first-time director Caroline Thompson. Since both novel and film are 'first person', these images have to establish the horse-narrator as a character, entering the world and seeing it with fresh eyes.

---

4    Anna Sewell wrote her only book in 1877 as a protest against the cruelty to which many horses were subjected, but died before it was published and became a lasting success. The book is narrated in the first person by Black Beauty, and the film retains this, with Alan Cumming voicing Beauty's thoughts and feelings.

A storyboard for *Black Beauty* that explains the movement of a carriage as the camera follows it through the shot.

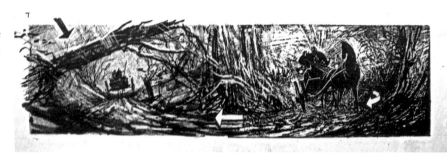

Barn in Buckinghamshire, but the scene in which he saves the groom's life when crossing a bridge in a storm was shot at Pinewood.[5] Compared with the nightmarish bridge-crossing sequence in *Sorcerer*, this was relatively simple – and cheap. Shooting at night made the scene easier, by masking any unwanted detail. 'We built the river on the lot, and could push the water in when we wanted it. The storm, lightning and sound were all easy to do in the studio.' The result, with Beauty standing firm so that the groom can be rescued from the water, is a fine example of the skills developed during a lifetime of location filming applied to a small-scale dramatic scene.

When the good squire has to sell up to take his sick wife abroad, Beauty begins to encounter the often thoughtless cruelty that Sewell hoped to expose. An aristocratic owner, Lady Wexmire (played by Eleanor Bron), insists on a fashionable bit that hurts the horses, and drives Beauty's beloved companion horse, Ginger, to revolt. In one scene, filmed in

Blenheim Palace courtyard used as an economical ready-made Victorian London, when Beauty is bought by a sympathetic cabman (David Thewlis) after harsh treatment by his aristocratic owners.

5   Details of locations used in *Black Beauty* are given in Brian Pendreigh, *On Location: The Film Fan's Guide to Britain & Ireland*, Mainstream, 1995.

an interior at Stratfield Staye House in Hampshire, Beauty serves, incongruously, as a model for Lady Wexmire to paint. Eventually, Beauty is saved from such degrading treatment when he is bought by a kindly London cabman. This posed the greatest challenge to John: how to evoke the bustling streets of Victorian London on such a modest budget? It was Caroline Thompson, he recalled, who suggested that the cobbled courtyard of Blenheim Palace, where they were looking at stables, might be dressed as London. John erected a green cabman's shelter to hide part of the existing structure and added a large sign advertising Covent Garden Opera House, and the result is a fine vignette of the turmoil of London's streets to complete his evocation of the metropolis.

After the cabby falls ill, Beauty breaks down under the strain of drawing a wagon, but is rescued when one of his earliest stable hands recognises him and provides a retirement in the same pastoral setting that he began life. A talking, moralising horse cavorting in sunlit pastures may be too much for many adult viewers, but there is no mistaking the sincerity of the film, and the light, yet idiomatic touch of its period design. And having observed many of the greatest actors of the century during his career, John was intrigued to see one of the two horses impersonating Black Beauty carefully watching the other's performance.

## *First Knight* (1995)

A film based on the Arthurian legend was a strong attraction for John, even if it was to be made by a team with no previous experience of costume drama. Jerry Zucker had made his name with a series of irreverent skits that combined comic-book humour and knowing parody, *Rock 'n' Roll High School* (1979), *Airplane!* (1980) and the *Naked Gun* series (1988–94), mostly in partnership with his brother David. He had also begun to branch out as a 'serious' director, starting with the Danny DeVito–Bette Midler comedy *Ruthless People* (1986), and scored a large and unexpected success with the supernatural romance *Ghost* (1990). Now he wanted to tackle period romantic drama, and invited John to discuss the mounting of a major Arthurian tale, backed by no less than Columbia, for whom John had worked so often in the past. However, Columbia had been acquired by the Japanese electronics company Sony and was in trouble as a studio during the mid-1990s, before John Calley took over in 1996.

None of this corporate background would have worried John as he sat down to plan his first venture into the legendary 'matter of Britain' in 1994,[6] delighted that he would

---

6   The 'matter of Britain' was first used to distinguish Arthurian legend from other groups of legends in the 12th century, before taking its best-known form in Sir Thomas Mallory's *Le Morte d'Arthur* in the 15th century. The Pre-Raphaelites revived interest in Arthurian legend in the late 19th century, giving it visual form in paintings and illustrations. Most modern dramatic versions of the 'matter' draw on Mark Twain's humorous account in *A Connecticut Yank at the Court of King Arthur* (1889) and T. H. White's reinterpretation of Camelot in *The Once and Future King* (1958), an important source for *Camelot* (play 1960, film 1967), Disney's *Sword in the Stone* (1963), John Boorman's *Excalibur* (1981) and to a lesser extent *First Knight*.

have the largest budget of his career and perhaps the greatest challenge at an age when many were retired. In this version of the Camelot love triangle, Guinevere plans to marry the much older Arthur partly out of admiration and partly to protect her domain of Lyonesse, which is being ravaged by the dissident former Knight of the Round Table, Malagant. However, when an itinerant adventurer, Lancelot, rescues her from Malagant and is invited to join the Round Table by a grateful Arthur, she is thrown into confusion by her attraction to Lancelot. When Arthur discovers their love, he puts them both on public trial, in the midst of which Malagant attacks Camelot and kills Arthur before meeting his own death, thus conveniently resolving the dilemma. The main cast was A-list, with Sean Connery as Arthur and Richard Gere as Lancelot; Julia Ormond, fresh from her success in *Legends of the Fall* (1994), was a sweet and convincing Guinevere, while Ben Cross made a villainous Malagant.

The immediate challenge for John was how to find a 'grounding' for each of the three worlds that are the emotional underpinning of this story, which he identified as 'gentleness for Guinevere, grandeur for Camelot, violence for Malagant'. Both Lyonesse and Camelot's interiors would be built at Pinewood, but both needed an exterior to set their tone. Thinking again of Wales as the most likely setting for this legend, John found an island with a causeway at Trawsfynydd in Gwynedd, where the base of Camelot could be built, and nearby a site for a windmill, whose gentle motion he felt would establish the peaceful nature of Lyonesse. For Malagant's domain, characterised by harshness and cruelty, he returned again to the slate-strewn landscape of North Wales, using various mines and slag heaps to frame studio-built interiors, as he had done in *The Keep*. But the footage that first sets the tone for Malagant's challenge to the values of Camelot was filmed on the rocky coast of Ireland, which is then married with Welsh exteriors and additional optical and digital imagery. The use of computer-generated imagery was still relatively limited at this period, largely confined to insert shots, as in films such as *Twelve Monkeys* (1995), although Zucker had already used the Hollywood digital effects company Cinesite for his *Naked Gun 33⅓* in 1994.

A windmill establishes the pastoral calm of Lyonesse in *First Knight* (1995), even before Guinevere (Julia Ormond) receives a delegation of her subjects in the cloister that John built at Pinewood.

Lyonesse is represented by two spaces – the village that is sacked by Malagant after Lancelot has left and Guinevere's court – both of which are laid out with a variety of approximately Saxon-style buildings. The village roofs are thatched, and there is a small church and a large barn, which is first seen from the outside, and then inside when the villagers take refuge from Malagant's attack. The transition from the burning village to the wind-filled sails of the mill occurs just as the final director's credit appears, and has the hallmarks of John's earlier juxtapositions for Lean. In a space ringed by grander stone buildings, Guinevere is then discovered at play in a somewhat self-conscious version of football, before news of the attack plunges her into discussion with her advisers. They move into a more formal space, defined by a cloister and two lion statues (presumably a reference to the name Lyonesse), where she receives the surviving villagers and explains to her oldest adviser, played by John Gielgud, that she intends to marry Arthur.

These two open-air sets were built at Pinewood, making use of an orchard on the lot, and John treasured a comment by Gielgud that the cloister was the most atmospheric film set he could recall. Indeed, they are perhaps the most successful of the film's sets, suggesting an ordered social life that contrasts with both the grandeur of Camelot and the desolation of Malagant's realm. At Camelot, Guinevere is met with great ceremony by Arthur: the two approach each other through an arcade formed by soldiers with flaming

Designs (top) and realisation (above): for the evil Malagant's realm, John combined the image of a rocky headland with a cave-like entrance in his beloved slate quarries of North Wales.

Guinevere's triumphal entry into Camelot was created from a constructed base, with model work and CGI enhancement, while the Round Table chamber was built at Pinewood, with much symbolic architectural detailing.

torches, and as in the later battle scene, this use of darkness is highly effective, as well as economical in terms of limiting what needs to be shown. It also prepares for the ceremonial entry into Camelot, with Arthur and Guinevere riding in a column across the causeway, the citadel illuminated as if by torchlight. More than one reviewer would comment on the over-elaboration of Camelot, and its improbably high level of lighting. Certainly, no one was aiming at any kind of 'Saxon realism' in this romantic fantasy, but John was dismayed by the extent of digital decoration that was added during post-production in Los Angeles, suggesting that Zucker was behaving like 'a child let loose in a sweet shop'.

Camelot was a substantial construction, even without digital and optical additions, and the central courtyard, with its balconies and turrets, is perhaps the design most open to accusations of 'Disneyfication'. Part of the problem is that it serves as the setting for dense set-pieces, such as the elaborate 'gauntlet' machine, with its swinging hammers and blades, where Lancelot demonstrates his prowess; and later the trial of Guinevere and Lancelot, interrupted by Malagant's attack. In these scenes, it is unashamedly functioning as a seventeenth-century arena for chivalric deeds, far removed from the modesty and sense of purpose in scenes that John had created for *A Man for All Seasons*. With the interiors of Arthur's palace, he was on firmer architectural ground, and the key set of the Round Table chamber is highly effective, with a large circular wall relief enclosing a Celtic cross that echoes the table's shape, with matching semicircular arches. St Albans Cathedral, part Norman, provides a fine church setting for Arthur and Guinevere's wedding, and some other Camelot chamber sets are superbly structured and decorated – notably the room where Arthur finally confronts Guinevere over her love for Lancelot. Sean Connery is framed by the stained-glass windows, one of which is open, giving onto a distant landscape and throwing his face into partial shadow as he wrestles with his emotions.

The most spectacular aspect of the film is unquestionably Malagant's domain, where Guinevere is taken after a daring – and somewhat implausibly hi-tech – abduction from Camelot. Using the slate of Blaenau-Ffestiniog, as he had on past occasions, for its baleful blackness, and a former slate-mine to suggest that Malagant lives in an underground

lair, complete with a dungeon overlooking a deep shaft (down which various of his followers will be dispatched when Lancelot arrives to rescue Guinevere), reached by a swinging bridge, John created a fantastic space that can stand comparison with any 'sword and sorcery' setting. It forms a perfect Gothic counterpart to the highly controlled Fascist symbolism of a similar dark set in *The Keep*. But in addition to this adventure sequence, the setting and conception of the great battle between Camelot and Malagant is noteworthy as a deliberate variation on the Agincourt battle in Olivier's *Henry V*, only staged in darkness. The same tactic is followed of luring the enemy into a trap, as Arthur pitches his camp very visibly, then waits out of sight to shower Malagant's troops with burning arrows, before counter-attacking on horseback. Darkness adds considerably to the credibility of the battle, with armour and swords creating flashing highlights and sharply reducing the pantomime quality associated with such scenes. Unfortunately for *First Knight*, however *Braveheart* appeared in the same year and provoked almost universally unfavourable comparisons.

*First Knight* represented an enormous task for John, to which was added part-responsibility for costumes. The scale of the art department's work provoked accusations of over-spending and he was summoned by the producers, who wanted to fire members of his staff, including the construction manager. He protested and blamed the production accountants for not keeping track of expenditure, but found himself dismissed instead. It was an undignified ending to a career that, as he quipped, had started by 'getting a break on *The Black Knight* and finished on the *First Knight*!' The film had cost some $75 million and initially failed to recoup this vast expenditure, although in time it would show a profit. But John had enjoyed the scale of the project, contributing a number of fine architectural sets, as well as some atmospheric 'adapted' landscapes, although he missed the sense of a coherent vision and the grit to see it through that he had found with such recent collaborators as Michael Mann and William Friedkin, and always with Lean. And he had not given up hope that Lean's last project still might be realised posthumously.

The partly Norman cathedral at St Albans provided a highly atmospheric setting for the wedding of Arthur and Guinevere. And when the marriage is threatened after Arthur (Sean Connery) discovers Guinevere with Lancelot, his jealousy is subtly underlined by an unusual framing, as he stands before a partly open window with his face in shadow.

# Close-up 8

## A Passage to India

For the arrival of the Englishwomen at Bombay in *A Passage to India* (1984), John devised an ingenious process shot that stripped the giant Gateway to India arch of its modern clutter and combined it with Indian troops filmed on parade in Delhi. These are his working pictures for the set-up.

Although most of *A Passage to India* could be filmed in and around the production's base in Bangalore, both the opening and closing sequences needed more elaborate solutions. For the arrival of the two Englishwomen in Bombay on a P&O liner, John apparently filmed an early version that did not impress Lean. They then discussed alternatives, and Lean opted for a sequence that begins with an ingenious composite shot in which the great archway known as the Gateway of India has clear sea matted in

behind it, and a large parade ground in front – neither of which surrounded it in 1983. The troops assembled to welcome the Viceroy were in fact filmed in Delhi, although the following shot, showing the Viceroy and his wife coming through the arch on a red carpet, was filmed through the real Gateway at an angle that excludes extraneous modern detail. The Viceroy then moves off in closer shots, followed by another wide overhead shot from Delhi. Mrs Moore and Miss Quested have apparently watched these scenes, looking down from the rail of the ship, which would in reality have been far from the Gateway.

John's next problem was how to get them off the liner when there was in fact no ship? This was solved by building a limited portion of the ship's side, tightly framed to suggest the melée of disembarkation, then another angled, partial view through an arch bearing the name 'Ballard Pier', with the upper part of the ship matted in. They are soon in a carriage on the way to the railway station, surrounded by the bustle of the Indian street in close and medium shot. What makes the sequence work as an evocative yet economical 'introduction to India' is: first, the contrast between the spacious grandeur of the Viceroy's welcome (with a single shot of sullen Indian women among the images of cheering English) and the crowds jostling the two Englishwomen as soon as they set foot on the quay; and second, John's careful control of colour, moving from whites and creams as the passengers wait to disembark, to a first flash of the brilliant yellow of flower garlands, followed by the sparing introduction of more vivid colour and exotic details, such as a large snake on display, as the women progress.

The result of the composite shot was a convincing 'period' view of the Gateway, through which the Governor and his wife walk, while Mrs Moore (Peggy Ashcroft) and Miss Quested (Judy Davis) appear to watch from the ship, before disembarking and leaving the dock, identified by a partially built ship superstructure. Stony-faced Indian women silently watch this complacent spectacle.

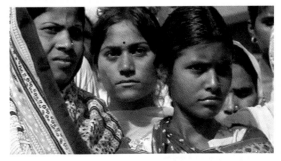

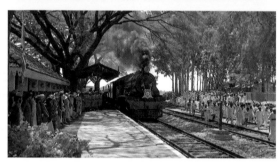

The train carrying Mrs Moore and Miss Quested in luxury to Chandrapore speeds through dream-like landscapes, partly created with models.

Controlling colour was a major part of John's design strategy, and never more so than in *A Passage to India*, with all its temptation to revel in exoticism. Shama Habibullah, sister of the British-based Indian director Waris Hussein, acted as production manager for the film and recalled what a 'privilege' it was to visit the 'incredibly organised' art department in a bungalow in Bangalore.[1] Here, John 'had one wall which was just photographs of the colours of India'. But these colours would be carefully rationed for maximum effect. Once the women are aboard the train for Chandrapore, there are just three carefully structured exterior long shots as it rushes through the Indian night. In the first, a temple dome at the left of frame stands before a glowing amber sunset; the second shows the train crossing a long river bridge; while the third is a deep purple night scene, with an exotic equestrian statue in the right foreground. The first and third are in fact studio model shots, devised to create a fairy-tale atmosphere as the Englishwomen travel to their much-anticipated destination.[2]

Opposite: Old friends reunited. John with Lean during the production of their swansong, *A Passage to India*.

The station at which they arrive was not in fact Bangalore, which John felt lacked atmosphere, but the station at Dodballapur,[3] a small town about 23 miles north, which also had monkeys clambering around its roof – a disturbing motif that would

1   Kevin Brownlow, *David Lean: A Biography*, Richard Cohen Books, 1996, pp. 664–5.
2   Distantly recalling the explicit model train shot of Joan's dream as she travels to Scotland in Powell and Pressburger's *I Know Where I'm Going* (1945).
3   See Tim Makin's s website on *A Passage to India* at: http://www.mapability.com/travel/p2i (accessed 18 January 2009).

return at the climax of Adela's discovery of the erotic temple statues. Much of the design strategy for 'Chandrapore', the fictionalised setting of the film, revolves around pointing up the contrast between the ultra-Englishness of the colonial officials' world and the 'real' India around them, which Mrs Moore and Adela long to experience. This is strongly conveyed in visual terms when the delicate tracery of a ruined mosque in the moonlight, where Mrs Moore first meets Aziz, abruptly gives way to the hearty vulgarity of the English club's revue. And in another deliberate parallel, a signpost in the town points to roads named after British military heroes, while an identical one in

Adela Quested goes in search of 'the real India' outside Chandrapore and finds more than she bargained for in the erotic statues of an overgrown temple, from which monkeys scamper promiscuously.

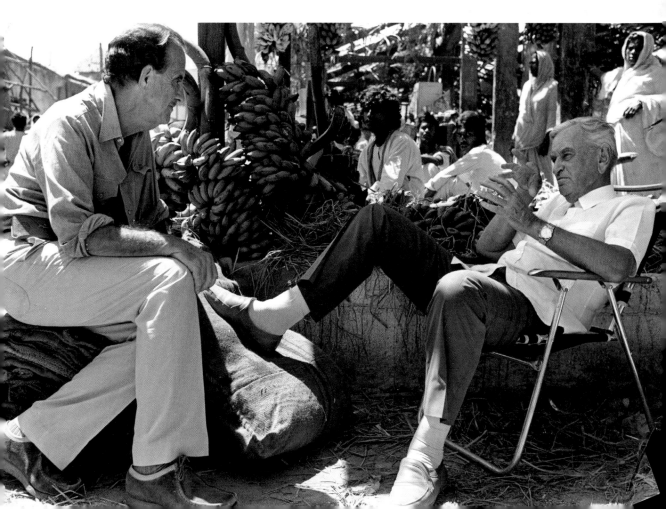

The lower and upper 'Malabar Caves', as created by John and his team, with explosives and painting – to the indignation of a British journalist.

the countryside tells Adela that she is 12 miles from Chandrapore and the propriety of the Raj, as she turns off the road towards what will be her encounter with an all too real India of uncensored sexuality.

With much of the preparation already completed by Lean and Fowlie before he arrived, John had less location finding to do than usual. But one of his major tasks was to create the caves on which the plot hinges. No actual caves existed in the hills at Savandurga near Bangalore, chosen for their picturesque quality, and it was John's responsibility to decide on their location and create them. For the lower cave, according to a recent visitor, he burrowed in some two metres, to create enough space to allow the camera to take a reverse shot of Mrs Moore outside the entrance.[4] For the upper caves, however, where Aziz and Adela go accompanied only by the guide and where the alleged assault takes place, John created a row of entrances recessed by only one metre, 'with a black backing so that they would still appear to be caves if light fell on them, and with painted 45 degree shadows, as in architectural drawings'.

Although the caves work perfectly well visually, John felt in retrospect that he should have encouraged Lean 'to show the eroticism in [Adela's] mind', possibly by quoting the erotic images she had seen earlier in the abandoned temple, 'which would have given a stab to the fact that she makes up this story about being raped by Aziz'.

Lean dropped Forster's original ending, in which Fielding and Aziz simply go their separate ways after the fiasco of the trial, and substituted his own more elaborate epilogue, set in Kashmir. This is where Professor Godbole, Fielding's colleague in Chandrapore, has gone to become Minister of Education; and in Lean's version Aziz goes to the same place, Srinagar, to open a hospital in a state where the British do not rule. Elaborating this new setting involved considerable 'magic geography', as, for example, when Fielding and his new wife visit Aziz, and see the Himalayas in ways not actually possible from the roads they take. But more important for Lean and John was the intended final image, which was to be Godbole explaining the Hindu 'wheel of life' while standing in the middle of its 4-metre span and acknowledging each spoke. Accounts differ over why Alec Guinness refused to do this, but the wheel scene was never filmed, and the film ends instead with an image of an older Adela beside a rain-streaked window in London, echoing the driving rain and umbrellas of the film's opening shot, as she visits the travel agent to book her 'passage to India'.

4    Ibid.

# Finale

## *Nostromo* and Design for the Future

It started with Spielberg. He thought the world of David [Lean], and wanted to come and see him. David asked me to be there too, and I went down to his house in Narrow Street. Steven arrived with [Robert] Zemeckis, and I rather retreated into the shadows. Steven said he owed so much to David, who had inspired him. He'd like to produce something for him. David said he was very interested in *Empire of the Sun*, and Steven said he'd get the rights. Then Maggie Unsworth, who had started with David on *In Which We Serve*, was invited to Kings College Cambridge, and in the course of lunch she was asked what David's next film would be. She said, 'why not come up with some ideas?' She called me to say they'd proposed *Nostromo*: would I read it and report? I was bored for the first 100 pages, but Maggie asked me to read further, and of course I was entranced. And the same thing happened when David started to read it. Then Spielberg called to say that he'd got the rights to make *Empire of the Sun*, but David said, 'I've changed my mind'. Spielberg said he would still produce *Nostromo*.

John's memory of how *Nostromo* became both Lean's and his last project may not agree in detail with other accounts.[1] But there is no doubt that both of them fell under the spell of Conrad's 'tale of the seaboard', which charts unsparingly the corrupting effects of silver-mining in a fictitious South American country. The central figure is an Italian immigrant, known familiarly as Nostromo, who has risen to oversee freight-handling at the port of Sulaco in Costaguana, and is widely considered incorruptible. But it is Nostromo's eventual corruption by greed that drives home Conrad's moral: the lure of

---

1   This is John Box's own account of how *Nostromo* started, and of Spielberg's involvement. Brownlow gives a different account, with Lean first being encouraged to consider the novel by Cambridge students in 1985, and taking the initiative to ask Spielberg to produce it during a transatlantic flight together on Concorde. Whatever the exact sequence of events, the substance is not in question: Lean hoped that Spielberg would be a 'good' producer, and was devastated when he criticised the script.

silver attracts everyone and fatally corrupts this microcosm of wider society. John felt the lessons of Nostromo were as relevant in the 1980s as they had been when the novel appeared in 1904.

With Spielberg's support (through his company Amblin, backed by Warners), Lean set about commissioning a script. His first choice would have been Robert Bolt, to carve a script out of Conrad's complex novel, but he had lost touch with him since *The Bounty*. Although Bolt had suffered a stroke that affected his speech, he continued to write and had recently completed *The Mission*, coincidentally also set in South America, which won the 1986 Palme d'Or at Cannes, along with other awards. In place of Bolt, Lean turned to the playwright Christopher Hampton, who began work on a script. Meanwhile, John had started to consider potential locations. The film would need mountains, dense jungle and the sea coast. Lean's age was also a consideration, as he was nearing eighty. John decided on Mexico, which he had recced for Friedkin, and settled on the Baja peninsula, close enough to Los Angeles to make logistics easy. Lean came over to look and liked what he saw: there was a good hotel to serve as a base and a small airport nearby. Back in Britain, John set up an office at Pinewood and began designing, before money began to be a problem. At this point, he put it to Lean that the film could just as well be made in their favourite stamping ground, around Carboneras in Spain, with some locations shot by a second unit in Mexico.

Hampton's script was ready by the beginning of 1987, and Lean travelled to Hollywood in February for a meeting with Spielberg. It was not a success. Despite professing admiration for what Lean and Hampton had done with Conrad's 'best and most complex novel', Spielberg offered suggestions for changes, with some embarrassment.[2] Lean was infuriated, in a way that recalled his stormy relations with previous producers, and – apparently by mutual consent – Spielberg's involvement ended. So too did Hampton's, after he helped reunite Lean with Robert Bolt in late 1987. Bolt took over reworking the script, resuming their old partnership, while the project found a new producer in the shape of the Paris-based Serge Silberman. Having produced a number of Luis Buñuel's highly successful late films and the cult hit *Diva* (1981), Silberman had followed in the footsteps of his compatriot Anatole Dauman and developed links with Japan. The fact that he had enabled the 75-year-old Akira Kurosawa to make his epic *Ran* in 1985 made him seem ideally suited to taking on Lean.

Production plans were now reworked around utilising the Victorine Studio in Nice, where the young Michael Powell had once cut his teeth with Rex Ingram, and more recently François Truffaut had made *Day for Night* (*La Nuit Americaine*, 1973). John resumed work and soon 'sets were going up in Nice and Carboneras'. After a series of illnesses, Lean went to Los Angeles in March 1990 to receive a Lifetime Achievement

---

2    Brownlow, *David Lean: A Biography*, Richard Cohen Books, 1996, pp. 717–18.

Award from the American Film Institute, where he spoke hopefully about *Nostromo* having finally received the go-ahead. However, relations with Silberman had deteriorated, and in December Lean was diagnosed with cancer of the throat. Although he kept hoping to recover enough to make the film, John had to tell him that the sets were being demolished. Lean died in April 1991 and *Nostromo* passed into limbo.

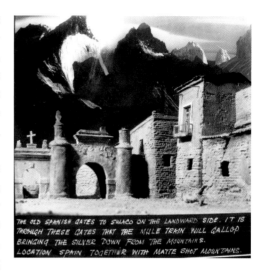

THE OLD SPANISH GATES TO SULACO ON THE LANDWARD SIDE. IT IS THROUGH THESE GATES THAT THE MULE TRAIN WILL GALLOP BRINGING THE SILVER DOWN FROM THE MOUNTAINS. LOCATION SPAIN TOGETHER WITH MATTE SHOT MOUNTAINS.

John Box was still optimistic a decade later that it might be revived and there was talk of various leading directors being interested, although Serge Silberman apparently remained a stumbling block. The visualisation that exists is evidence of the serious planning that John had done, as always, 'to get to the emotional core'. Just as scripting *Nostromo* had proved a serious challenge, so 'getting to what you put on the screen' was also difficult. John went to look at real silver mines and found them 'dull' in appearance. Since South America had been part of the Spanish empire during its formative centuries, he thought of infusing the mines with the architecture of Catholic Spain, so that the mine entrance would almost resemble a baroque church.

Mock-up design by John for an old Spanish gateway on the trail that brings silver from the mines to the port.

For the main location of the port town of Sulaco, 'a fragile thing against the mighty backdrop of the mountains', John built a large model and introduced a Spanish-style cathedral, with a large square in front. He conceived the opening scene as 'a few crosses in the foreground, and just a lone man in this intense sunlight – to take the audience into South America and introduce the central character'. When revolution breaks out and the rebels attack Sulaco to gain control of its silver, they capture Nostromo's boss, Captain Mitchell, and imprison him. John envisaged a cut from the glare of the square to an interior modelled on the sinister tangle of ropes and chains of Piranesi's *Imaginary Prisons*.[3] The figure of Mitchell would be strung up and back-lit against the window, in a mainly monochrome image.

When Lean saw this, he asked if they could introduce one element of colour, 'so I did a simplified version, with just a splash of blood on the window-sill'. This was typical of how they worked together, bouncing suggestions off each other until one had the 'bright idea' – usually David, according to John. Such telling details were vital for the style of filmmaking they practised, serving as punctuation within the larger visual structure. In this case, that structure was to be built on a contrast between the mines, buried in the

Following pages:
A watercolour sketch by John Box for the town of Sulaco in *Nostromo*, 'a fragile thing against the mighty backdrop of the mountains'. (BFI Stills Posters and Designs)

3   Giovanni Battista Piranesi (1720–78) was an engraver and antiquary, famous for his atmospheric views of Rome and for a series of engravings known as *Imaginary Prisons* (*Carceri d'invenzione*, 1750–61). These complex interiors, hung with ropes and chains and what appear to be machines of torture, appealed strongly to the Gothic and Romantic imagination.

Two versions of the hanging of Captain Mitchell, one plain and the other with a splash of blood, at Lean's suggestion.

jungle, the port where the silver becomes a valuable commodity and poisons men's values, and the sea leading to the wider world beyond. For Lean, it became a passion that lasted throughout his final illnesses, so much so that when he heard the strange noise of Canada geese flying overhead at dawn and felt it was a premonition of death, he included this in the final script (as Nostromo lies dying, he also hears geese passing overhead). John spent the best part of four years working to create and keep alive this great shared project, and remained almost as unwilling as Lean to give up hope for it right to the end of his life.

Meanwhile, the very different challenges of *Just Like a Woman* and *First Knight* still lay ahead. And there was also recognition. In 1991, John was given a BAFTA special award for his contribution to cinema. In the following year, he was appointed to the

The scene of Mitchell's imprisonment and hanging was strongly influenced by John's admiration for Piranesi's *Imaginary Prisons*, a series of fantastic, brooding interiors that have attracted writers and artists down the centuries.

Opposite top: Design by John for the entrance to a silver mine, based on Spanish Baroque church architecture rather than real silver mines, which he found 'dull'.

faculty of Royal Designers for Industry, one of the very few film designers ever recognised in this way,[4] and in 1993 he was elected a fellow of the Royal Society of Arts. In 1998, the British Film Commission encouraged him to advise on a short film by a newcomer. Jamie Payne's *The Dance of Shiva* is set during the First World War and tells the story of Indian troops 'shipped to the western front as cannon fodder' – a theme that touched John, both because of his experience in India and in war. With another veteran, Jack Cardiff, acting as cinematographer, Payne's short film attracted attention as a rare example of altruistic collaboration across the generations in British filmmaking. In the same year, John was created an OBE. With his eyesight failing, he was unable to continue offering practical help and guidance to younger filmmakers. But he remained keen to pass on the fruits of his experience, especially to student audiences.

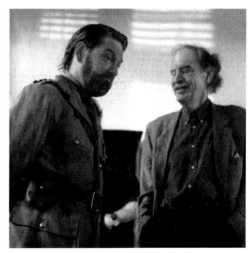

John with Kenneth Branagh during the making of Jamie Payne's *The Dance of Shiva* (1998), on which he advised.

His advice was always to start with the script, and perhaps even with its sources. Try to understand the film's theme, the ideas within the script, and to find images for these, whether in locations, in sets to be constructed or in characters. Then engage in

4   The Royal Designers for Industry was established in 1936 by the Royal Society of Arts to recognise
    distinction in all branches of British design, and only 200 designers may hold the title at any one time.

John surrounded by fellow award-winning art department colleagues in the mid-1980s. Among those pictured are: Ken Adam (left rear), Robert Laing (left), Carmen Dillon (seated at left), Roy Walker (behind John left), Terence Marsh (behind John right), Stuart Craig (second right rear), Norman Reynolds (front right). Photo by Cornel Lucas.

Opposite page: John photographed by David Lean in Venice: giving scale and balance to a typically confident composition.

close dialogue with the director, to grasp his or her conception of the film. He stressed the need to understand each director as an individual, 'how they work, what they need to realise their vision, even if it's not yours'. John's early experience had given him the confidence to take responsibility for his solutions to design and logistical problems, which are often intertwined. Working with Lean, and with Spiegel, gave him the confidence to argue his interpretation and to propose bold, apparently counterintuitive solutions. But he also believed firmly that respecting the director's vision is vital for the coherence of a film.

But if the director has ultimate responsibility, John also believed passionately in co-operating with the other members of the film production team, even beyond the 'craft' departments of camera, sound, costume and editing. He would work with actors whenever possible, understanding their vulnerability and the difficulty they face creating a role in what are often highly artificial settings. While preparing *First Knight*, he recalled being asked to take Julia Ormond, a relative newcomer among experienced actors, to Wales in order to get a feel for the locations. 'I found her sitting by the lake gently picking flowers and I knew she'd be an excellent Guinevere.' Establishing Guinevere's domain of Lyonesse as an island of tranquillity in a violent landscape was a priority, and John's solution was to build a windmill to establish its serenity visually, accompanied by the sound of a woman's laughter.

Working closely with the wardrobe and costume department was also an article of faith for John. Phyllis Dalton remembers his support in situations where wardrobe would routinely be kept in the margins, and his belief in the need to see costume choices in the context of the overall scene. All three of their major films together – *Lawrence*, *Zhivago* and *Oliver!* – involved costuming large numbers of extras, with unavoidable simplifications of what might have been great historical complexity. But according to Dalton,

> John always believed in putting things in their context. And if you were going to show things to David [Lean], John would be there. Because sometimes directors need reminding that there's a reason why they've got this or that.

John would have described this as 'directing the director': making sure they stayed true to the original conception worked out together, amid all the pressures and compromises of actual production.

All of this was part of John's 'vocabulary of life': bringing his wide experience to bear on the actual problems and choices faced in any production. Above all, asking the question: what does this production need artistically and logistically? Coming from the studio tradition, his instinct was to build no more than was strictly necessary from the camera perspective, while bearing in mind what would help actors feel in period and in character. His preferred tools were a notebook, 'mostly to scribble in'; still photographs, 'mostly in black and white, not as works of art but for reference'; and above all three-dimensional models. Unlike some designers, he did not produce large numbers of elegantly finished sketches, but used sketch artists as the art department equivalent of secretaries. Lean never wanted to use sketch artists, convinced that this interfered with his own visualisation, but John insisted on their value to the production as a whole, enabling other departments to plan around their work.

For all his practicality, John insisted that making a film was 'living in another world'. He would speak of 'getting images and having to act on them'. Some of his best ideas had been born of necessity – having to find a way of setting a scene when time or money had run out – or by chance, as when he came across the postage stamp that inspired the ice palace for *Zhivago*. But the ability to recognise these solutions came from a lifelong habit of observation – 'watching people, on the Tube and on buses, making up stories about them, trying to understand their lives'.

# Appendix

## On the History and Theory of Film Design

In deference to John Box's own essentially pragmatic approach, this account of his career and work has not invoked any wider historical or theoretical framework for understanding production design. It may therefore be helpful to sketch the context in which the profession and its significance within film production have belatedly received due attention.

Until art direction and production design were included in the recent vogue for books offering practical guidance for would-be filmmakers, literature on film design was sparse.[1] Three books more or less defined the field. Edward Carrick's *Designing for Moving Pictures* appeared in 1941, as part of a practical 'How to Do It' series on art and craft techniques.[2] Based on his own experience as an art director in British studios and as head of a pioneering film school, Carrick's lavishly illustrated book began with a four-page survey of 'The Growth of a New Art', before explaining the departmental structure and procedures of a 1940s studio, and ending with an appendix of 'old workshop recipes' for achieving effects. Like Carrick, Leon Barsacq was primarily a practitioner, working in French studios from the 1930s to the 60s, before writing *Le Décor du film* in 1970. Expanded by Elliott Stein, with a somewhat misleading new main title, *Caligari's Cabinet and Other Grand Illusions*, this appeared in English translation in 1976 as *A History of Film*

---

1 Recent books on film design include: Jane Barnwell, *Production Design: Architects of the Screen*, Wallflower, 2003; Vincent LoBrutto, *The Filmmaker's Guide to Production Design*, Allworth Press, 2002; Michael Rizzo, *The Art Direction Handbook for Film*, Focal Press, 2005.

2 Edward Carrick (a pseudonym for Edward Craig, son of the famous stage designer, Gordon Craig) published his *Designing for Moving Pictures* in a wide-ranging series on art and craft techniques, issued by Studio Publications, in 1941, and republished as *Designing for Films* in 1948.

*The Assassination of the Duc de Guise* (France, 1908) launched the *film d'art* movement, striving for authentic décor and costume.

*Design*. Although offering a more detailed and international account of design landmarks and styles than Carrick, it follows basically the same pattern, and ends with a summary of studio construction techniques. However, Stein's fifty-page appendix established the first wide-ranging reference list of art directors and production designers, providing a valuable basis for further research.[3]

A rather different approach to screen design appeared with Donald Albrecht's *Designing Dreams: Modern Architecture in the Movies* (1986). An architectural historian, Albrecht traced how modernist design reached a mass audience through its use as decor in a range of popular films from the 1920s to the 1940s, culminating in the portrayal of an architect-hero based on Frank Lloyd-Wright in King Vidor's *The Fountainhead* (1949). Albrecht's influential book opened up a dialogue between architectural and design historians and cinema that has continued to this day, promoting a more informed discussion of the visual influences on and of cinema than had hitherto existed.[4] It did not, however, deal with non-modernist film design or attempt any theorisation of the role of design in film's overall communication with the viewer.

Before these developments, design had been traditionally viewed with suspicion by theorists of the new medium , its 'theatrical' artificiality routinely cited in contrast with an ideal of film portraying 'reality'. The origins of this attitude can be traced back to the 1908 *film d'art* production *The Assassination of the Duc de Guise*, which established a new standard for accurate historical setting and costume that would have a lasting effect on international production – but which later fell foul of cinema's first theorists and historians. Likewise, the most famous 'designed' film of the silent era, *The Cabinet of Dr. Caligari* (1919), was hailed by Paul Rotha in 1930 as evidence of how every aspect of a film's design could be 'pointed to the one purpose'.[5] But four years later, the distinguished art historian Erwin Panofsky took *Caligari* as an example of precisely what cinema should *not* do:

The expressionist settings of *The Cabinet of Dr. Caligari* could be no more than an exciting experiment … To prestylize reality prior to tackling it amounts to dodging the

3   Surprisingly, John Box does not appear in this list, despite the major awards he had already won. Stein notes that his list makes no claim to completeness.

4   Among books that have continued this exploration are: Dietrich Lohmann, *Film Architecture: From Metropolis to Blade Runner*, Prestel, 1996; François Penz and Maureen Thomas, eds., *Cinema and Architecture: Méliès, Mallet-Stevens, Multimedia*, BFI Publishing, 1997; James Sanders: *Celluloid Skyline: New York and the Movies*, Knopf, 2001.

5   In the first influential survey of world cinema after the pioneer period: Paul Rotha, *The Film Till Now*, Jonathan Cape, 1930, p. 47.

problem. The problem is to manipulate and shoot unstylized reality is such a way that it has style.[6]

Two decades later, the influential French critic André Bazin would promote an aesthetic of realism that was influenced equally by the location shooting of Italian neo-realist filmmakers and by the elaborate 1940s Hollywood studio sets of Orson Welles and William Wyler. But as location-based filming became popular again in the 1960s, realism became identified with 'reality', and interest in the studio tradition dwindled, except in the case of fantasy genre films, where extravagant design was an acknowledged part of the spectacle.[7]

Perhaps paradoxically, it was the arrival of a more self-consciously theorised approach to cinema in the 1970s that drew serious attention to the visual aspect of cinema. Semiotic theorists recognised the importance of the 'pro-filmic' in the overall process of filmic narration:

> The pro-filmic concerns the elements placed in front of the camera to be filmed: actors, lighting, set design, etc. These elements, rather than being seen simply as raw material, can be understood as narrative discourse by the fact that they have been chosen and selected to communicate narrative meanings.[8]

Theorising the narrative significance of set design was undertaken by Charles and Mirella Affron in their major study of 'art direction and film narrative', *Sets in Motion*.[9] Noting the near-total absence of comment on art direction in the popular literature of cinema during the 1930s and 1940s, the Affrons proposed a theoretical model that recognised five levels of set 'intensity', graduated from 'transparency' to 'opacity':

> From denotation, in which the set functions as a conventional signpost of genre, ambience, and character; to punctuation, where the set has a specially emphatic narrative function;

*The Cabinet of Dr. Caligari* (Germany, 1919) had a profound impact around the world, suggesting that film could portray disturbed mental states by means of distorted décor.

6   Panofsky's paper 'Style and Medium in the Motion Picture', first given as a talk at Princeton University, to help raise interest in the proposed film department of the Museum of Modern Art in New York and published in Princeton's *Bulletin of the Department of Art and Archaeology* in 1934. A revised version appeared in *Critique*, vol. 1, no. 3, 1947, but its wider influence was due to inclusion in the pioneering collection edited by Daniel Talbot, ed., *Film: An Anthology*, University of California Press, 1966, p. 32.

7   Significantly, the only British production designer to be celebrated at book length is Ken Adam, designer of the early Bond films and of Kubrick's *Dr Strangelove* (1964), among many other works. See Christopher Frayling, *Ken Adam and the Art of Production Design*, Faber, 2005; and Frayling, *Ken Adam Designs the Movies: Bond and Beyond*, Thames and Hudson, 2007.

8   Robert Stam, Robert Burgoyne and Sandy Flitterman-Lewis, *New Vocabularies in Film Semiotics*, Routledge, 1992, p. 142.

9   Charles Affron and Mirella Jona Affron, *Sets in Motion: Art Direction and Film Narrative*, Rutgers University Press, 1995.

Set as narrative in Hitchcock's *Rear Window* (1954), where the immobile central character's world is defined by the apartment building around him.

to embellishment, where the verisimilitudinous set calls attention to itself within the narrative; to artifice, where the set is a fantastic or theatrical image that commands the centre of narrative attention.[10]

The fifth level in this scheme is termed 'set as narrative', which is explained by reference to a relatively small number of films where 'the field of reading is composed of a single locale' (p. 39), as in, for example, Hitchcock's *Rope* (1948) and *Rear Window* (1954), but also the village street of *How Green Was My Valley* (1941).

The Affrons' typology or hierarchy is useful as a means of distinguishing different functions of design, even if it may be too schematic to apply in close analysis. Paying attention to the statements of designers, we might want to recast it in terms of narrative economy or *efficiency*, where denotation and narrative function are paramount, with varying degrees of punctuation and embellishment, according to the demands of genre and directorial vision.

While the theorisation of film design was taking its first tentative steps, there was also evidence of a renewed interest in its history in Britain. Much of this concerned the influence of foreign-born designers who worked here: notably Alfred Junge, Vincent Korda and Hein Heckroth.[11] Junge and Korda brought with them badly needed international experience to British studios at the beginning of the 1930s, and both stayed long enough to train their native pupils and successors. Each believed implicitly in the professional principle that art direction should be 'invisible' – despite designing a number of highly spectacular films – and both contributed to the rising prestige of the designer that would lead their successors to exert an increasing influence over the creation of a distinctive stylisation for British films, in a creative intertextual relationship with the literary works that are often their premise.[12] John Box was clearly a beneficiary of this tradition, par-

---

10  Ibid., pp. 36n7.

11  These are three of the four European art directors (along with Lazare Meerson) discussed in Catherine A. Surowiec's pioneering *Accent on Design*, a booklet published by the British Film Institute in 1992. My own books on Powell and Pressburger also stressed the role of art direction, especially Christie, *Arrows of Desire: The Films of Michael Powell and Emeric Pressburger*, Waterstone, 1985/Faber, 1994; *A Matter of Life and Death*, BFI Films Classics, 2000. Building on this earlier work, see also: Tim Bergfelder, Sue Harris and Sarah Street, *Film Architecture and the Transnational Imagination: Set Design in 1930s European Cinema*, Amsterdam University Press, 2007.

12  Developing Bakhtin's concept of 'intertextuality', whereby various texts are seen in shifting relations to each other, without a presumed hierarchy of chronology or status, may be a firmer basis than 'adaptation' for considering the translation from verbal to audiovisual text. On specifically filmic applications of intertextuality, see Mikhail Iampolski, *The Memory of Tiresias: Intertextuality and Film*, University of California Press, 1998.

ticularly in his approach to such London subjects as *A Man for All Seasons* and *Oliver!*. And these relationships and traditions have continued. Most recently, Stuart Craig has emerged from the Bryan–Box succession to design very different versions of Victorian London for *The Elephant Man* (David Lynch, 1980) and *Chaplin* (Richard Attenborough, 1992), before creating a paradigmatic version of contemporary London in *Notting Hill* (Roger Michell, 1999) and then embarking on the hugely popular Harry Potter series, rooted in the tradition of English juvenile fantasy fiction and combining British studio practice with the new graphic resources of CGI.[13]

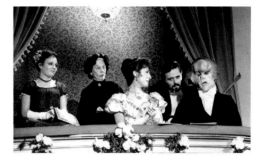

*The Elephant Man* (1980), designed by Stuart Craig, brought a new sense of period detail, using black and white, to the portrayal of Victorian London.

Among the many books that now provide closely illustrated interviews with leading practitioners and practical advice on production design, it may still be useful to take a longer view of the role of picturing narrative. Grahame Smith has shown how 'visualisation' played a vital part in Dickens's imaginative life and novels, and notes that his evocative power was readily compared with the new photographic media of the 19th century by his contemporaries.[14] Indeed, the work of contemporary production designers may more closely resemble that of graphic artists in earlier times, given the digital media now at their disposal. And in the endless debate between authenticity and stylisation, they are subject to much greater pressures than those faced by earlier scenic artists, and surely deserve at least the same level of scholarly attention.

---

13  Computer-generated images (CGI) have come to play a significant part in many films during the last ten years, replacing what was once achieved by 'glass' or matte shots, whereby painted imagery was introduced into the photographic image. However, many contemporary films use a combination of built structures and CGI, to create a more substantial effect.

14  Grahame Smith, *Dickens and the Dream of Cinema*, Manchester University Press, 2003.

# Filmography

Listed here are all the films that John Box is known to have worked on in the order in which they were released in the UK. The abbreviated credits mostly give only heads of department, except for the art department, and the main cast. All films qualified as UK productions at the time of making, other than those listed as 'USA'.

Abbreviations used are as follows: *d* – director; *p.c* – production company; *p* – producer; *sc* – screenplay; *ph* – cinematographer; *ed* – editor; *art dir* – art director/later *p. des* – production designer; *art dept* – members of the art department, often uncredited, including draughtsmen, property masters; *set dec* – set decoration; *cost* – costume; *vis effects* – visual effects; *m* – composer; *sd* – sound recordists and editors. Filming locations are indicated where known, together with main awards.

## Escape (1948)

*d* – Joseph Mankiewicz. Twentieth Century-Fox. *p* – William Perlberg. *sc* – Philip Dunne, from a play by John Galsworthy. *ph* – F. A. Young. *ed* – Kenneth Heeley-Ray, Alan Jaggs. *art dir* – Alex Vetchinsky. *asst art dir* – Brian Herbert. *sets* – John Box. *m* – William Alwyn. *sd* – Kenneth Heeley-Ray, W. H. Lindop, Gordon K. McCallum.

*Main cast*: Rex Harrison (*Matt Denant*), Peggy Cummins (*Dora Winton*), William Hartnell (*Insp. Harris*), Norman Wooland (*Minister*), Jill Esmond (*Grace Winton*).

Filmed in Dartmoor, London and at Denham Studios.

78 mins. *UK rel* – March

## The Weaker Sex (1948)

*d* – Roy Ward Baker. *p.c* – Paul Soskin Productions/Two Cities. *p* – Paul Soskin. *sc* – Paul Soskin, Esther McCracken, from her play *No Medals*. *ph* – Erwin Hillier. *ed* – Michael Chorlton, Joseph Sterling. *art dir* – Alex Vetchinsky. *art dept* – John Box, Brian Herbert, Arthur Taksen. *m* – Arthur Wilkinson. *sd* – John Cook, Desmond Dew, Dennis Gurney, Kenneth Heeley-Ray.

*Main cast*: Ursula Jeans (*Martha Dacre*), Cecil Parker (*Geoffrey Radcliffe*), Joan Hopkins (*Helen Dacre Winan*), Derek Bond (*Lt. Cmdr. Nigel Winan*), Thora Hird (*Mrs Gaye*).

Filmed in Margate and at Denham Studios.

84 mins. *UK rel* – September

## Adam and Evelyne (1949)

*d* – Harold French. *p.c* – Two Cities. *p* – Harold French. *sc* – Noel Langley, Lesley Storm. *ph* – Guy Green. *ed* – John D. Guthridge. *art dir* – Paul Sheriff. *art dept* – John Box, Brian Herbert. *m* – Mischa Spoliansky. *sd* – Desmond Dew, W. Lindop.

*Main cast*: Stewart Granger (*Adam Black*), Jean Simmons (*Evelyne Wallace*), Edwin Styles (*Bill Murray*), Raymond Young (*Roddy Black*), Helen Cherry (*Moira*), Beatrice Varley (*Mrs Parker*).

Filmed at Denham Studios.

92 mins. *UK rel* – May

## Madness of the Heart (1949)

*d* – Charles Bennett. *p.c* – Two Cities. *p* – Richard Wainwright. *sc* – Charles Bennett, Flora Sandstrom, from her novel. *ph* – Desmond Dickinson. *ed* – Helga Cranston. *art dir* – Alex Vetchinsky. *cost* – Rahvis. *art dept* – William Bowden, John Box, Arthur Taksen. *m* – Allan Gray. *sd* – Desmond Dew, Dudley Messenger.

*Main cast*: Margaret Lockwood (*Lydia Garth*), Paul Dupuis (*Paul de Vandiere*), Kathleen Byron (*Verite Faimont*), Maxwell Reed (*Joseph Rondolet*), Thora Hird (*Rosa*), Raymond Lovell (*Comte de Vandiere*).

105 mins. *UK rel* – July

## Treasure Island (UK/USA) (1950)

*d* – Byron Haskin. *p.c* – Walt Disney Productions. *p* – Perce Pearce. *sc* – Lawrence Edward Watkin, from the novel by R. L. Stevenson. *ph* – Freddie Young. *ed* – Alan Jaggs. *p. des* – Thomas Morahan. *asst art dir* – John Box. *cost* – Sheila Graham. *m* – Clifton Parker.

*Main cast*: Bobby Driscoll (*Jim Hawkins*), Robert Newton (*Long John Silver*), Basil Sydney (*Capt. Smollett*), Walter Fitzgerald (*Squire Trelawney*), Denis O'Dea (*Dr Livesey*), Finlay Currie (*Capt. Billy Bones*).

Filmed at Pinewood and Denham Studios, Iver Heath, Buckinghamshire, and in Cornwall.

96 mins. *UK rel* – July

## The Woman in Question (1950)

*d* – Anthony Asquith. *p.c* – Javelin Films/Vic Productions/Rank. *p* – Teddy Baird, Joseph Janni. *sc* – John Cresswell. *ph* – Desmond Dickinson. *ed* – John D. Gutheridge. *art dir* – Carmen Dillon. *art dept* – John Box, Peter Lamont, Bert Gaiters. *m* – John Wooldridge. *sd* – John Dennis, Gordon McCallum, Ken Rawkins, Kenneth Heeley-Ray.

*Main cast*: Jean Kent (*Agnes/Mme Astra/Parrot*), Dirk Bogarde (*Bob Baker*), John McCallum (*Michael Murray*), Susan Shaw (*Catherine Taylor*), Hermione Baddeley (*Mrs Finch*).

Filmed at Pinewood Studios.

88 mins. *UK rel* – October

## The Browning Version (1951)

*d* – Anthony Asquith. *p.c* – Javelin Films. *p* – Teddy Baird. *sc* – Terence Rattigan, from his own play. *ph* – Desmond Dickinson (bw). *ed* – John D. Guthridge. *art dir* – Carmen Dillon. *asst art dir* – John Box. *cost* – Yvonne Caffin.

*Main cast*: Michael Redgrave (*Andrew Crocker-Harris*), Jean Kent (*Millie Crocker-Harris*), Nigel Patrick (*Frank Hunter*), Wilfred Hyde-White (*Frobisher*), Brian Smith (*Taplow*), Bill Travers (*Fletcher*).

90 mins. *UK rel* – April

### Hotel Sahara (1951)

*d* – Ken Annakin. *p.c* – Tower. *p* – George Brown, Steven Pallos. *sc* – George Brown, Patrick Kirwan. *ph* – David Harcourt, Jack Hildyard. *ed* – Alfred Roome. *art dir* – Ralph Brinton. *set dec* – Betty Pierce. *cost* – Julie Harris. *art dept* – John Box, Geoffrey Drake, Peter Lamont, Bert Gaiters. *m* – Benjamin Frankel. *sd* – Gordon K. McCallum, John Mitchell, Bob Wilson.

*Main cast*: Yvonne De Carlo (*Yasmin Pallas*), Peter Ustinov (*Emad*), David Tomlinson (*Capt. Puffin Cheyne*), Roland Culver (*Maj. Bill Randall*), Albert Lieven (*Lt. Gunther von Heilicke*), Bill Owen (*Pte. Binns*).

Filmed at Pinewood Studios.

96 mins. *UK rel* – July

### The Importance of Being Ernest (1952)

*d* – Anthony Asquith. *p.c* – British Film-makers/Javelin. *p* – Teddy Baird. *sc* – Asquith, based on the play by Oscar Wilde. *ph* – Desmond Dickinson (Technicolor). *ed* – John D. Gutheridge. *art dir* – Carmen Dillon. *asst art dir* – John Box. *cost* – Beatrice Dawson. *m* – Benjamin Frankel.

*Main cast*: Michael Redgrave (*Jack Worthing*), Richard Wattis (*Seton*), Michael Dennison (*Algernon Moncrieff*), Walter Hudd (*Lane*), Edith Evans (*Lady Augusta Bracknell*), Joan Greenwood (*Gwendolen Fairfax*).

Filmed at Pinewood Studios.

95 mins. *UK rel* – 2 June

### The Story of Robin Hood and His Merrie Men (USA/UK) (1952)

*d* – Ken Annakin. *p.c* – Disney/RKO Radio. *p* – Perce Pearce, Walt Disney. *sc* – Lawrence Watkin. *ph* – Guy Green (Technicolor). *ed* – Gordon Pilkington. *art dirs* – Carmen Dillon, Arthur Lawson. *cost* – Michael Whittaker, Yvonne Caffin. *art dept* – Ernest Archer, Ivor Beddoes, John Box, Roy Dorman, Peter Lamont, Don Picton. *vis effects* – Peter Ellenshaw. *m* – Clifton Parker. *sd* – Winston Ryder, Peter Davies, C. C. Stevens.

*Main cast*: Richard Todd (*Robin Hood*), Joan Rice (*Maid Marian*), Peter Finch (*Sheriff of Nottingham*), James Hayter (*Friar Tuck*), James Robertson Justice (*Friar Tuck*), Martita Hunt (*Queen Eleanor*), Hubert Gregg (*Prince John*).

Filmed in Buckinghamshire, and at Pinewood and Denham Studios.

84 mins. *UK rel* – March

### It Started in Paradise (1952)

*d* – Compton Bennett. *p.c* – British Film-makers. *p* – Sergei Nolbandov, Leslie Parkyn. *sc* – Marghanita Lasky. *ph* – Jack Cardiff (Technicolor). *ed* – Alan Osbiston. *art dir* – Edward Carrick. *cost* – Sheila Graham. *art dept* – Ernest Archer, John Box, Brian Herbert. *m* – Malcolm Arnold. *sd* – Gordon K. McCallum, Jack Slade, C. C. Stevens.

*Main cast*: Jane Hylton (*Martha Watkins*), Ian Hunter (*Arthur Turner*), Terence Morgan (*Comte Edouard*), Muriel Pavlow (*Alison*), Martita Hunt (*Mme. Alice*), Kay Kendall (*Lady Caroline*).

94mins. *UK rel* – October

### Malta Story (1953)

*d* – Brian Desmond Hurst. *p.c* – Rank Organisation/Theta/British Film-makers. *p* – Peter de Sarigny. *sc* – Nigel Balchin, William Fairchild. *ph* – Robert Krasker (bw). *art dir*

– John Howell. *draughtsman/asst* – John Box. *cost* – Dorothy Edwards, Robert Rayner. *m* – William Alwyn. *sd* – Gordon K. McCallum, Eric Wood.

*Main cast*: Alec Guinness (*Flight Lt. Peter Ross*), Jack Hawkins (*Air Comm. Frank*), Anthony Steel (*Wing Cmdr. Bartlett*), Muriel Pavlow (*Maria Gonzar*), Renée Asherson (*Joan Rivers*), Hugh Burden (*Eden*).

103 mins. *UK rel* – June

### The Sword and the Rose (USA/UK) (1953)

*d* – Ken Annakin. *p.c* – Disney. *p* – Perce Pearce, Walt Disney. *sc* – Lawrence Watkin, from the novel by Charles Major, *When Knighthood Was in Flower*. *ph* – Geoffrey Unsworth (Technicolor). *ed* – Gerald Thomas. *art dir* – Carmen Dillon. *cost* – Valles. *vis effects* – Peter Ellenshaw, Albert Whitlock. *art dept* – Ernest Archer, John Box, Ted Clements, Vernon Dixon, Geoffrey Drake, Roy Walker. *m* – Clifton Parker. *sd* – Gordon McCallum, Bill Daniels, E. G. Daniels.

*Main cast*: Glynis Johns (*Princess Mary Tudor*), Richard Todd (*Charles Brandon*), James Robertson Justice (*King Henry VIII*), Michael Gough (*Duke of Buckingham*), Jane Barrett (*Lady Margaret*), Rosalie Crutchley (*Queen Katherine*), D. A. Clarke-Smith (*Cardinal Wolsey*).

91 mins. *UK rel* – August

### Personal Affair (1953)

*d* – Anthony Pelissier. *p.c* – Two Cities. *p* – Antony Darnborough. *sc* – Lesley Storm, from her play *A Day's Mischief*. *ph* – Reginald Wyer. *ed* – Frederick Wilson. *art dir* – Cedric Dawe. *cost* – Joan Ellacott. [*art dept* – John Box, Robert Cartwright, Lionel Couch]. *sd* – Gordon K. McCallum, Harry Miller.

*Main cast*: Gene Tierney (*Kay Barlow*), Leo Genn (*Stephen Barlow*), Glynis Johns (*Barbara Vining*), Walter Fitzgerald (*Henry Vining*), Pamela Brown (*Evelyn*), Nanette Newman (*Sally*).

83 mins. *UK rel* – October

### The Million Pound Note (1954)

*d* – Ronald Neame. *p.c* – Group Film Productions/ Rank Organisation. *p* – John Bryan. *sc* – Jill Craigie, based on a story by Mark Twain. *ph* – Geoffrey Unsworth (Technicolor). *art dirs* – John Box, Jack Maxted. *cost* – Margaret Furse. *ed* – Clive Donner. *sd* – Gordon K. McCallum, Winston Ryder.

Gregory Peck (*Henry Adams*), Ronald Squire (*Oliver Montpelier*), Joyce Grenfell (*Duchess of Cromarty*), A. E. Matthews (*Duke of Frognell*), Maurice Denham (*Mr Reid*), Reginald Beckwith (*Rock*).

90 mins. *UK rel* – January

### The Black Knight (1954)

*d* – Tay Garnett. *p.c* – Warwick. *p* – Irving Allen, Albert Broccoli. *sc* – Alec Koppel, Dennis O'Keefe, Bryan Forbes. *ph* – John Wilcox. *art dir* – Vetchinsky. *cost* – Beatrice Dawson. *ed* – Gordon Pilkington. *m* – John Addison. *asst. art dir* – John Box. *sd* – Charles Knott, J. B. Smith.

*Main cast*: Alan Ladd (*John*), Patricia Medina (*Linet*), André Morell (*Sir Ontzlake*), Harry Andrews (*Earl of Yeoville*), Peter Cushing (*Sir Palamides*), Anthony Bushell (*King Arthur*), Patrick Troughton (*King Mark*).

85 mins. *UK rel* – August

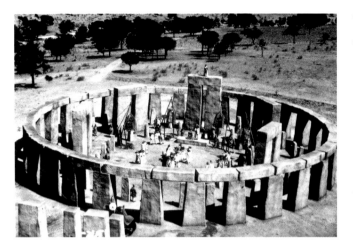

For *The Black Knight*, John had to create a plausible Stonehenge on the outskirts of Madrid, a foretaste of many later improvisations in Spain.

## The Young Lovers (1954)

*d* – Anthony Asquith. *p.c* – Group Film Productions. *p* – Anthony Havelock-Allan. *sc* – Robin Estridge, George Tabori. *ph* – Jack Asher (bw). *ed* – Frederick Wilson. *art dir* – John Box. *cost* – Yvonne Caffin. *m* – Benjamin Frankel. *sd* – Roger Cherrill.

*Main cast*: Odile Versois (*Anna Szobek*), David Knight (*Ted Hutchens*), Joseph Tomely (*Moffatt*), Theodore Bikel (*Joseph*).

96 mins. *UK rel* – 24 August

## A Prize of Gold (1955)

*d* – Mark Robson. *p.c* – Warwick. *p* – Irving Allen, Albert Broccoli, Phil C. Samuel. *sc* – Robert Buckner, from a novel by Max Catto. *ph* – Ted Moore (Technicolor). *ed* – Bill Lewthwaite. *art dir* – John Box. *m* – Malcolm Arnold. *sd* – Gerald Anderson.

*Main cast*: Richard Widmark (*Sgt. Joe Lawrence*), Mai Zetterling (*Maria*), Nigel Patrick (*Brian Hammell*), George Cole (*Sgt. Morris*), Donald Wolfit (*Stratton*), Joseph Tomelty (*Uncle Dan*).

98 mins. *UK rel* – February

## The Cockleshell Heroes (1955)

*d* – José Ferrer. *p.c* – Warwick. *p* – Irving Allen, Albert Broccoli, Phil C. Samuel. *sc* – Bryan Forbes, Richard Maibaum, from a story by George Kent. *ph* – Ted Moore, John Wilcox (Technicolor, CinemaScope). *ed* – Alan Obistan. *art dir* – John Box. *asst art dir* – Syd Cain. *cost* – Elsa Fennell. *m* – John Addison. *sd* – Chris Greenham, Bert Ross.

*Main cast*: José Ferrer (*Maj. Stringer*), Trevor Howard (*Capt. Thompson*), Dora Bryan (*Myrtie*), Victor Maddern (*Sgt. Craig*), Anthony Newley (*Clark*), David Lodge (*Ruddock*), John Van Eyssen (*Bradley*).

110 mins. *UK rel* – 16 November

## Zarak (1956)

*d* – Terence Young. *p.c* – Warwick. *p* – Irving Allen, Albert Broccoli, Phil C. Samuel. *sc* – Richard Maibaum. *ph* – Ted Moore, John Wilcox, Cyril Knowles (Technicolor, CinemaScope). *ed* – Alan Obistan, Bert Rule. *art dir* – John Box. *cost* – Phyllis Dalton. *m* – William Alwyn. *sd* – Peter Davies.

*Main cast*: Victor Mature (*Zarak Khan*), Michael Wilding (*Maj. Ingram*), Anita Ekberg (*Salma*), Bonar Colleano (*Biri*), Eunice Gayson (*Cathy Ingram*), Finlay Currie (*Mullah*).

99 mins. *UK rel* – December.

## The Gamma People (1956)

*d* – John Gilling. *p.c* – Warwick. *p* – Irving Allen, Albert Broccoli, John Gossage. *sc* – Gossage, Gilling from a story by Robert Aldrich. *ph* – Ted Moore. *ed* – Jack Slade. *p. des* – John Box. *asst art dir* – Syd Cain. *cost* – Olga Lehmann. *m* – George Melachrino.

*sd* – Peter Davies, Frank Goulding.

*Main cast*: Paul Douglas (*Mike Wilson*),
Eva Bartok (*Paula Wendt*), Leslie Phillips
(*Howard Meade*), Walter Rilla (*Boronski*),
Philip Leaver (*Koerner*).

79 mins. *UK rel* – January

## High Flight (1956)

*d* – John Gilling. *p.c* – Warwick. *p* – Irving
Allen, Albert Broccoli, Phil C. Samuel.
*sc* – Ken Hughes, Joseph Landon, from
a story by Jack Davies. *ph* – Ted Moore
(Technicolor). *ed* – Jack Slade. *art dir* – John
Box. *cost* – John McCorry. *m* – Douglas
Gamley, Kenneth Jones. *sd* – Bert Ross.

*Main cast*: Ray Milland (*Wing Cmdr. Rudge*),
Bernard Lee (*Flight Sgt. Harris*), Kenneth
Haigh (*Tony Winchester*), Anthony Newley
(*Roger Endicott*), Kenneth Fortescue (*John
Fletcher*), Sean Kelly (*Day*).

86 mins. *UK rel* – December

## Fire Down Below (1957)

*d* – Robert Parrish. *p.c* – Warwick. *p* – Irving
Allen, Albert Broccoli, Ronald Kinnoch.
*sc* – Irwin Shaw, from a novel by Max Catto.
*ph* – Desmond Dickinson (Technicolor,
CinemaScope). *ed* – Jack Slade. *set des*
– John Box. *asst art dir* – Syd Cain. *cost*
– Pierre Balmain. *m* – Arthur Benjamin,
Douglas Gamley, Kenneth Jones. *sd* – Peter
Davies, Gordon K. McCallum.

*Main cast*: Rita Hayworth (*Irena*), Robert
Mitchum (*Felix Bowers*), Jack Lemmon
(*Tony*), Herbert Lom (*Harbour Master*),
Bonar Colleano (*Lt. Sellars*), Bernard Lee
(*Dr Blake*).

116 mins. *UK rel* – May

## No Time to Die (1958)

*d* – Terence Young. *p.c* – Warwick. *p* – Irving
Allen, Albert Broccoli, Phil C. Samuel.
*sc* – Richard Maibaum, Terence Young. *ph*
– Ted Moore (Technicolor, CinemaScope).
*ed* – Bert Rule. *art dir* – John Box. *asst art
dir* – Syd Cain. *cost* – John McCorry. *m* –
Kenneth Jones. *sd* – Alan Pattillo, Bert Ross.

*Main cast*: Victor Mature (*Sgt. David Thatcher*),
Leo Genn (*Sgt. Kendall*), Bonar Colleano
(*Polish POW*), Anthony Newley (*Pte.
Noakes*), Alfred Burke (*Capt. Ritter*).

79 mins. *UK rel* – April

## How to Murder a Rich Uncle (1957)

*d* – Nigel Patrick. *p.c* – Warwick. *p* – John Paxton,
Irving Allen, Albert Broccoli. *sc* – John Paxton,
from the play by Didier Daix, *Il Faut tuer
Julie*. *ph* – Ted Moore (CinemaScope, bw). *ed*
– Bert Rule. *art dir* – John Box. *m* – Kenneth
V. Jones. *sd* – Peter Davies, Bert Ross.

*Main cast*: Nigel Patrick (*Henry*), Charles
Coburn (*Uncle George*), Wendy Hiller (*Edith
Clitterburn*), Katie Johnson (*Alice*), Anthony
Newley (*Edward*), Athene Seyler (*Grannie*).

79 mins. *UK rel* – June

## The Inn of the Sixth Happiness (USA) (1958)

*d* – Mark Robson. *p.c* – Twentieth Century-
Fox. *p* – Buddy Adler. *sc* – Isobel Lennart,
based on a book by Alan Burgess. *ph* – F. A.
[Freddie] Young (col, CinemaScope). *ed* –
Ernest Walker. *art dirs* – John Box, Geoffrey
Drake. *cost* – Margaret Furse. *sd* – J. B.
Smith, Gerry Turner.

*Main cast*: Ingrid Bergman (*Gladys Aylward*),
Curt Jurgens (*Capt. Lin Nan*), Robert
Donat (*Mandarin*), Michael David (*Hok-A*),

Athene Seyler (*Jeannie Lawson*), Ronald Squire (*Sir Francis Jamison*).
Filmed in Wales and London.
158 mins. *UK rel* – December

## Left, Right and Centre (1959)

*d* – Sidney Gilliat. *p.c* – Vale Film Productions, for British Lion. *p* – Gilliat, Frank Launder. *sc* – Sidney Gilliat. *ph* – Gerald Gibbs. *ed* – Gerry Hambling. *art dir* – John Box. *cost* – Anthony Mendleson. *m* – Humphrey Searle. *sd* – Pater Handford, Red Law, Alastair McIntyre.
*Main cast*: Ian Carmichael (*Robert Wilcot*), Alastair Sim (*Lord Wilcot*), Patricia Bredin (*Stella Stoker*), Richard Wattis (*Harding-Pratt*), Eric Barker (*Bert Glimmer*), Moyra Fraser (*Annabel*).
Filmed at Ham House, Richmond and at Shepperton Studios.
96 mins. *UK rel* – June

## Our Man in Havana (1960)

*d* – Carol Reed. *p.c* – Kingsmead Productions/ Columbia Pictures. *p* – Reed, Raymond Anzarut. *sc* – Graham Greene, from his own novel. *ph* – Oswald Morris (CinemaScope, bw). *ed* – Bert Bates. *art dir* – John Box. *asst art dir* – Syd Cain. *cost* – Phyllis Dalton. *m* – Laurence and Frank Deniz. *sd* – John Cox, Red Law, Ted Mason.
*Main cast*: Alec Guinness (*Jim Wormold*), Burl Ives (*Dr Hasselbacher*), Maureen O'Hara (*Beatrice Severn*), Ernie Kovacs (*Capt. Segura*), Noël Coward (*Hawthorn*), Ralph Richardson ('*C*'), Jo Morrow (*Milly Wormold*).
Filmed in Havana, Cuba and at Shepperton Studios.
111mins. *UK rel* – January

## Two Way Stretch (1960)

*d* – Robert Day. *p.c* – Vale Productions/ Shepperton Productions/Tudor Productions. *p* – M. Smedley-Aston. *sc* – Vivian Cox, Len Heath, John Warren. *ph* – Geoffrey Faithfull. *ed* – Bert Rule. *art dir* – John Box. *asst art dir* – Ray Rossotti. *m* – Ken Jones. *sd* – Maurice Askew, Paddy Cunningham, Teddy Mason.
*Main cast*: Peter Sellers (*Dodger Lane*), David Lodge (*Jelly Knight*), Bernard Cribbins (*Lennie Price*), Wilfred Hyde-White (*Soapy Stevens*), Maurice Denham (*The Governor*).
Filmed at Shepperton Studios.
87 mins. *UK rel* – January

## The World of Suzie Wong (1960)

*d* – Richard Quine. *p.c* – World Enterprises/ Paramount. *p* – Hugh Perceval, Ray Stark. *sc* – Paul Osborne, John Patrick, from a novel by Richard Mason. *ph* – Geoffrey Unsworth (Technicolor). *ed* – Bert Bates. *art dir* – John Box. *asst art dir* – Syd Cain. *cost* – Phyllis Dalton. *m* – George Duning. *sd* – Roy Baker, Gerry Turner.
*Main cast*: William Holden (*Robert Lomax*), Nancy Kwan (*Suzie Wong* [*Mee Ling Wong*]), Sylvia Sims (*Kay O'Neill*), Laurence Naismith (*O'Neill*), Michael Wilding (*Ben Marlowe*), Jacqui Chan (*Gwennie Lee*).
Filmed in Hong Kong and at Shepperton Studios.
126 mins. *UK rel* – December

## Lawrence of Arabia (1962)

*d* – David Lean. *p.c* – Horizon pictures/ Columbia Pictures. *p* – Sam Spiegel. *sc* – Robert Bolt, Michael Wilson, from writings by T. E. Lawrence. *ph* – F. A. Young (Super Panavision 70, col), *ed* – Anne V. Coates.

*p. des* – John Box. *art dirs* – John Stoll, Anthony Masters. *set dec* – Dario Simoni. *asst art dirs* – Terence Marsh, George Richardson, Tony Rimmington, Roy Rosotti. *prop. master* – Eddie Fowlie. *constr. manager* – Peter Dukelow. *cost* – Phyllis Dalton. *m* – Maurice Jarre. *sd* – John Cox, Paddy Cunningham, Winston Ryder.

*Main cast*: Peter O'Toole (*T. E. Lawrence*), Alec Guinness (*Prince Feisal*), Anthony Quinn (*Auda*), Jack Hawkins (*Gen. Allenby*), Omar Sharif (*Sherif Ali*), José Ferrer (*Turkish Bey*), Anthony Quayle (*Col. Brighton*), Claude Rains (*Dryden*).

Filmed in Jordan, Spain, Morocco, Wales, Surrey and London.

210 mins (228 mins director's cut reissue). *UK rel* – December. Won seven Academy Awards in 1963, including Best Art Direction/Set Decoration in Color for JB, John Stoll and Dario Simoni.

## The Wild Affair (1963)

*d* – John Krish. *p.c* – Seven Arts Productions. *p* – Richard L. Patterson, William Kirby. *sc* – Krish, William Sanson, from his novel *The Last Hours of Sandra Lee*. *ph* – Arthur Ibbotson (bw). *eds* – Russell Lloyd, Norman Savage. *p. des* – John Box. *art dirs* – Terence Marsh, Wallis Smith. *constr. manager* –Peter Dukelow. *cost* – David Ffolkes. *m* – Martin Slavin. *sd* – George Adams, Bill Blunden, Stephen Dalby.

*Main cast*: Nancy Kwan (*Marjorie Lee*), Gladys Morgan (*Mrs Tovey*), Betty Marsden (*Mavis Cook*), Victor Spinetti (*Quentin*), Jimmy Logan (*Craig*), Joyce Blair (*Monica*).

Filmed at Twickenham Studios.

88 mins. *UK rel* – December

## Of Human Bondage (1964)

*d* – Ken Hughes (Bryan Forbes, Henry Hathaway). *p.c* – Seven Arts Productions/ MGM British. *p* – James Woolf (Ray Stark). *sc* – Bryan Forbes, based on the novel by Somerset Maugham. *ph* – Owald Morris (bw). *ed* – Russell Lloyd. *p. des* – John Box. *cost* – Beatrice Dawson. *asst art dir* – Terence Marsh. *m* – Ron Goodwin. *sd* – Norman Bolland, Bob Jones.

*Main cast*: Kim Novak (*Mildred Rogers*), Laurence Harvey (*Philip Carey*), Robert Morley (*Dr Jacobs*), Siobhan McKenna (*Nora Nesbitt*), Roger Livesey (*Thorpe Altheny*), Jack Hedley (*Griffiths*).

100 mins. *UK rel* – April

## Doctor Zhivago (1965)

*d* – David Lean. *p.c* – Sostar SA/MGM. *p* – Carlo Ponti. *sc* – Robert Bolt, from the novel by Boris Pasternak. *ph* – Freddie Young (Panavision, col). *ed* – Norman Savage. *p. des* – John Box. *cost* – Phyllis Dalton. *art dirs* – Terence Marsh, Gil Parrondo. *set dec* – Dario Simoni. *asst art dirs* – Ernest Archer, Bill Hutchinson, Roy Walker. *special effects* – Eddie Fowlie. *m* – Maurice Jarre. *sd* – Paddy Cunningham, Winston Ryder.

*Main cast*: Omar Sharif (*Yuri Zhivago*), Julie Christie (*Lara*), Geraldine Chaplin (*Tonya*), Rod Steiger (*Komarovsky*), Tom Courtenay (*Pasha*), Alec Guinness (*Gen. Evgraf Zhivago*), Siobhan McKenna (*Anna*), Ralph Richardson (*Alexander*), Rita Tushington (*Girl*).

Filmed in Canada, Finland and Spain.

193 mins. *UK rel* – April. Won five Academy Awards, including Best Art Direction/Set Decoration in Color for JB, Terence Marsh and Dario Simoni.

## A Man for All Seasons (1966)

*d* – Fred Zinnemann. *p.c* – Highland Films, for Columbia Pictures. *p* – Zinnemann, William Graf. *sc* – Robert Bolt, from his own play. *ph* – Ted Moore (Technicolor). *ed* – Ralph Kemplen. *p. des* – John Box. *art dir* – Terence Marsh. *cost* – Elizabeth Haffenden, Joan Bridge. *constr. manager* – Peter Dukelow. *asst art dir* – Roy Walker. *m* – Georges Delerue. *sd* – Buster Ambler, Bob Jones.

*Main cast*: Paul Scofield (*Sir Thomas More*), Wendy Hiller (*Alice More*), Robert Shaw (*King Henry VIII*), Leo McKern (*Thomas Cromwell*), Orson Welles (*Cardinal Wolsey*), Susannah York (*Margaret More*), Nigel Davenport (*Duke of Norfolk*), John Hurt (*Richard Rich*).

Filmed in Hampshire, Oxfordshire and at Shepperton Studios.

120 mins. *UK rel* – December. Won six Academy Awards and seven BAFTAs, including Best British Art Direction (Colour) for JB.

## Oliver! (1968)

*d* – Carol Reed. *p.c* – Romulus/Warwick, for Columbia Pictures. *p* – John Woolf. *sc* – Vernon Harris, based on Lionel Bart's musical, 'freely adapted' from Charles Dickens's novel. *ph* – Oswald Morris (col). *ed* – Ralph Kemplen. *p. des* – John Box. *art dir* – Terence Marsh. *cost* – Phyllis Dalton. *constr. manager* – Peter Dukelow. *m* – Lionel Bart. *mus sup* – John Green. *choreo* – Onna White. *sd* – Buster Ambler, Bob Jones, John Cox, Jim Groom.

*Main cast*: Ron Moody (*Fagin*), Shani Wallis (*Nancy*), Oliver Reed (*Bill Sikes*), Mark Lester (*Oliver*), Jack Wild (*Artful Dodger*), Harry Secombe (*Mr Bumble*).

Filmed at Shepperton Studios.

153 mins. *UK rel* – September. Won five Academy Awards, including Best Art Direction/Set Decoration for JB, Terence Marsh and colleagues.

## The Looking Glass War (1969)

*d* – Frank Pierson. *p.c* – Frankovich Productions, for Columbia Pictures. *p* – John Box, Mike Frankovich, William Kirby. *sc* – Pierson, from the novel by John Le Carré. *ph* – Austin Dempster (Panavision, col). *ed* – Willy Kemplen. *art dir* – Terence Marsh. *cost* – Dinah Greet. *asst art dir* – Roy Walker. *m* – Wally Stott. *sd* – Buster Ambler, John Cox.

*Main cast*: Christopher Jones (*Leiser*), Pia Degermark (*German girl*), Anthony Hopkins (*John Avery*), Ralph Richardson (*LeClerc*), Paul Rogers (*Haldane*), Susan George (*Susan*).

110 mins. *UK rel* – September

## Nicholas and Alexandra (1971)

*d* – Franklin Schaffner. *p.c* – Horizon Pictures, for Columbia Pictures. *p* – Sam Spiegel, Andrew Donally. *sc* – James Goldman, Edward Bond, based on a book by Robert K. Massie. *ph* – Freddie Young (Panavision, col.). *ed* – Ernest Walker. *p. des and 2nd unit dir* – John Box. *art dirs* – Ernest Archer, Jack Maxted, Gil Parrondo. *cost* – Yvonne Blake, Antonio Castillo. *prop. master and special effects* – Eddie Fowlie. *asst art dirs* – Benjamin Fernandez, Robert Laing, Alan Roderick-Jones. *m* – Richard Rodney Bennett. *sd* – Gerry Humphreys, Winston Ryder.

*Main cast*: Michael Jayston (*Tsar Nicholas II*), Janet Suzman (*Tsarina Alexandra*), Tom Baker (*Rasputin*), Roderic Noble (*Tsarevich Alexei*), Lynne Frederick (*Tatiana*), Fiona Fullerton (*Anastasia*), Harry Andrews (*Grand Duke Nicholas*), Irene Worth (*Dowager Empress*).

Filmed in Spain and Yugoslavia.

189 mins. *UK rel* – November. Won two Academy Awards, including Best Art Direction/Set Decoration for JB and colleagues.

## Travels with My Aunt (USA) (1971)

*d* – George Cukor. *p.c* – MGM. *p* – Robert Fryer, James Cresson. *sc* – Jay Presson Allen, Hugh Wheeler, based on the novel by Graham Greene. *ph* – Douglas Slocombe (Panavision, col). *ed* – John Bloom. *p. des and 2nd unit dir* – John Box. *cost* – Anthony Powell. *art dirs* – Robert Laing, Gil Parrondo. *asst art dir* – Benjamin Fernandez. *sd* – Derek Ball, Harry W. Tetrick.

*Main cast*: Maggie Smith (*Aunt Augusta*), Alec McCowen (*Henry*), Lou Gossett (*Zachary*), Robert Stephens (*Ercole Visconti*), Cindy Williams (*Tooley*), Robert Flemyng (*Crowder*), José López Vázquez (*Achille Dambreuse*).

Filmed in London, Paris, Monaco, Italy, Spain, Turkey and Yugoslavia.

109 mins.

## The Great Gatsby (USA) (1974)

d – Jack Clayton. *p.c* – Newdon Productions/ Paramount Pictures. *p* – David Merrick, Hank Moonjean. *sc* – Francis Ford Coppola, from the novel by F. Scott Fitzgerald. *ph* – Douglas Slocombe. *ed* – Tom Priestley.

*p. des* – John Box. *art dirs* – Robert Laing, Gene Rudolf. *cost* – Theoni V. Aldredge. *m* – Nelson Riddle. *sd* – Ken Barker, Terry Rawlings, Brian Simmons.

*Main cast*: Robert Redford (*Jay Gatsby*), Mia Farrow (*Daisy Buchanan*), Sam Waterston (*Nick Carraway*), Bruce Dern (*Tom Buchanan*), Karen Black (*Myrtle Wilson*), Scott Wilson (*George Wilson*), Lois Chiles (*Jordan Baker*).

Filmed in New York, Rhode Island and at Pinewood Studios.

144 mins. Won one Academy Award and three BAFTAs in 1975, including Best Art Direction for JB.

## Rollerball (1975)

*d* – Norman Jewison. *p.c* – Algonquin, for United Artists. *p* – Jewison, Patrick Palmer. *sc* – William Harrison, from his own story, 'Roller Ball Murder'. *ph* – Douglas Slocombe. *ed* – Antony Gibbs. *p. des* – John Box. *art dir* – Robert Laing. *cost* – Julie Harris. *m* – Albinoni, J. S. Bach, Shostakovich. *cond* – André Previn. *sd* – Derek Ball, Archie Ludski, Gordon K. McCallum.

*Main cast*: James Caan (*Jonathan E*), John Houseman (*Bartholomew*), Maud Adams (*Ella*), John Beck (*Moonpie*), Moses Gunn (*Cletus*), Ralph Richardson (*Librarian*).

Filmed in Bavaria and at Pinewood Studios.

125 mins. *UK rel* – September. Won a BAFTA for Best Art Direction for JB.

## Sorcerer/Wages of Fear (USA) (1975)

*d* – William Friedkin. *p.c* – Film Properties International NV/Paramount Pictures/ Universal Pictures. *p* – Friedkin, Bud Smith.

*sc* – Walon Green, from the novel by Georges Arnaud, *Le Salaire de la peur*. *ph* – Dick Bush, John M. Stephens. *eds* – Bud Smith, Robert K. Lambert. *p. des* – John Box. *art dir* – Roy Walker. *set dec* – Robert Laing. *m* – Tangerine Dream. *sd* – Charles Campbell, Larry Carow, Jean-Louis Ducarme.

*Main cast*: Roy Scheider (*Jackie Scanlon*), Bruno Cremer (*Victor Manzon*), Francisco Rabal (*Nilo*), Amidou (*Kassem*), Raymond Bien (*Charles Corlette*), Peter Capell (*Lartigue*).

121 mins.

### The Keep (USA) (1983)

*d* – Michael Mann. *p.c* – Associated Capital. *p* – Gene Kirkwood, Howard Koch, Jr. *sc* – Michael Mann, from a novel by F. Paul Wilson. *ph* – Alex Thomson (J-D-C Scope, col). *eds* – Dov Hoenig, Chris Kelly. *p. des* – John Box. *art dirs* – Alan Tomkins, Herbert Westbrook. *set dec* – Michael Seirton. *cost* – Anthony Mendleson. *vis. effects* – Wally Veevers, Robin Browne. *m* – Tangerine Dream. *sd* – Bob Jones, Bill Trent.

*Main cast*: Scott Glenn (*Glaeken Trismegestus*), Alberta Watson (*Eva Cuza*), Ian McKellen (*Dr Theodore Cuza*), Jürgen Prochnow (*Capt. Klaus Woermann*), Gabriel Byrne (*Maj. Kaempffer*), Robert Prosky (*Fr. Mihail Fonescu*).

Filmed in North Wales and at Shepperton Studios.

96 mins. *UK rel* – December

### A Passage to India (USA/UK) 1984

*d* – David Lean. *p.c* – EMI Films/HBO. *p* – John Brabourne, Richard Goodwin. *sc* – David Lean, Santha Rama Rau, from the novel by E. M. Forster. *ph* – Ernest Day. *ed* – David Lean. *p. des* – John Box.

*cost* – Judy Moorcroft. *props* – Eddie Fowlie. *art dirs* – Clifford Robinson, Leslie Tomkins, Herbert Westerbrook, Ram Yedekar. *m* – Maurice Jarre. *sd* – Michael Carter, Graham Hartstone, Lionel Strutt, Winston Ryder.

*Main cast*: Judy Davis (*Adela Quested*), Peggy Ashcroft (*Mrs Moore*), James Fox (*Richard Fielding*), Victor Bannerjee (*Dr Aziz Ahmed*), Alec Guinness (*Prof. Godbole*), Nigel Havers (*Ronny Heaslop*).

Filmed in India and at Shepperton Studios.

163 mins. *UK rel* – March 1985

### Murder by the Book (UK/Canada) (1986)

*d* – Lawrence Gordon Clark. *p.c* – TVS Ent./ Benbow Evans Productions (for television). *p* – Dickie Bamber, Nick Evans. *sc* – Nick Evans. *ph* – Peter Gessop. *ed* – John Price. *p. des* – John Box. *m* – Howard Goodall.

*Main cast*: Peggy Ashcroft (*Agatha Christie*), Ian Holm (*Hercule Poirot*), Richard Wilson (*Sir Max Mallowan*), Michael Aldridge (*Edmond Cork*), John Atkinson (*Gardener*).

45 mins.

### Just Like a Woman (1992)

*d* – Christopher Monger. *p.c* – Zenith/Rank/ LWT Productions/British Screen. *p* – Nick Evans, Nick Elliott, Archie Tait. *sc* – Nick Evans, from the book by Monica Jay, *Geraldine: For the Love of a Transvestite*. *ph* – Alan Hume. *ed* – Nicolas Gaster. *p. des* – John Box. *cost* – Suzy Peters. *m* – Michael Storey. *sd* – Neil Kingsbury, John Poyner.

*Main cast*: Julie Walters (*Monica*), Adrian Pasdar (*Gerald Tilson/Geraldine*), Paul Freeman (*Miles Millichamp*), Susan Wooldridge (*Louisa*), Gordon Kennedy (*CJ*).

105 mins. *UK rel* – September

## Black Beauty (USA/UK) (1994)

*d* – Caroline Thompson. *p.c* – Warner Bros. *p* – Peter Macgregor-Scott, Robert Shapiro. *sc* – Caroline Thompson, from the novel by Anna Sewell. *ph* – Alex Thomson (Technicolor). *ed* – Claire Simpson. *p. des* – John Box. *art dirs* – Kevin Phipps, Leslie Tomkins. *cost* – Jenny Beavan. *sd* – Robert Bradshaw, Joe Dorn, Gordon Ecker.

*Main cast*: Sean Bean (*Farmer Grey*), David Thewlis (*Jerry Barker*), Jim Carter (*John Manly*), Peter Davison (*Squire Gordon*), Alun Armstrong (*Reuben Smith*), John McEnery (*Mr York*), Eleanor Bron (*Lady Wexmire*).

88 mins. *UK rel* – February 1995

## First Knight (USA) (1995)

*d* – Jerry Zucker. *p.c* – First Knight Productions/Columbia Pictures. *p* – Hunt Lowry, Jerry Zucker, Gil Netter, Eric Rattray, Janet Zucker. *sc* – William Nicholson, from a story by Lorne Cameron, David Hoselton. *ph* – Adam Greenberg. *ed* – Walter Murch. *p. des* – John Box. *cost* – Nanà Cecchi. *art dirs* – Bob Laing, Michael White, Giles Masters, Stephen Scott. *vis effects sup* – Denis Lowe. *m* – Jerry Goldsmith. *sd* – Colin Charles, Gary Gegan, John Morris, Walter Murch.

*Main cast*: Sean Connery (*King Arthur*), Richard Gere (*Lancelot*), Julia Ormond (*Guinevere*), Ben Cross (*Prince Malagant*), Liam Cunningham (*Agravaine*), John Gielgud (*Oswald*).

Filmed in Wales, Buckinghamshire, Hertfordshire, Hampshire, Mexico and at Pinewood Studios.

134 mins. *UK rel* – July

## The Dance of Shiva (1998)

*d* – Jamie Payne. *p.c* – Epiphany Productions. *p* – Jamie Payne, Thomas Delfs, Stephanie Sindaire. *sc* – Joseph Miller. *ph* – Jack Cardiff. *ed* – Peter Beeston. *p. des* – Luke Smith. *des. consultant* – John Box. *art dirs* – Paul Finch, Hauke Richter. *m* – Nitin Sawhney.

*Main cast*: Sanjeev Bhaskar (*Sgt. Bakshi*), Kenneth Branagh (*Col. Evans*), Julian Glover (*Gen. Willis*), Paul McGann (*Capt. Greville*), Samuel West (*Lt. Davis*).

Filmed in Sussex, Hertfordshire and at Pinewood Studios.

26 mins. *UK rel* – November

# Bibliography

## Books referring directly to John Box

Brownlow, Kevin, *David Lean: A Biography*, Richard Cohen Books, 1996.

Clagett, Thomas D., *William Friedkin: Films of Aberration, Obsession and Reality*, Jefferson, 2003.

Evans, P. W., *Carol Reed*, Manchester University Press, 2008.

Feeney, F. X. and Duncan, Paul, *Michael Mann*, Taschen, 2006.

Fraser-Cavassoni, Natasha, *Sam Spiegel*, Little, Brown, 2003.

Jackson, Kevin, *Lawrence of Arabia*, BFI, 2007.

Sinyard, Neil, *Jack Clayton*, Manchester University Press, 2000.

Sorenson, Colin, *London on Film*, Museum of London, 1996.

Turner, Adrian, *The Making of David Lean's Lawrence of Arabia*, Dragon's World, 1994.

Wapshott, Nicholas, *The Man Between: A Biography of Carol Reed*, Chatto and Windus, 1990.

Young, Freddie, *Seventy Light Years: A Life in the Movies*, Faber, 1999.

Zinnemann, Fred, *An Autobiography*, Bloomsbury, 1992.

Major sets for *Oliver!* under construction at Shepperton Studios.

## Articles

Ellis, Samantha, 'Lionel Bart's *Oliver*, June 1960', *Guardian*, 18 June 2003.

Houston, Penelope, 'Gatsby', *Sight and Sound*, vol. 43, no. 2, Spring 1974.

Panofsky, Erwin, 'Style and Medium in the Motion Picture', *Critique*, vol. 1, no. 3, 1947 (reprinted in Talbot, Daniel, ed., *Film: An Anthology*, University of California Press, 1966).

Surowiec, Catherine A., 'John Box: "Magician" of Film Production Design', *The Independent*, 17 March 2005.

Tuson, Elizabeth-Marie, 'Interview with John Box', *Journal of British Cinema and Television*, vol. 2, May 2005.

Ware, John, 'Production-Wise' [on *The Looking Glass War*], *The Daily Cinema*, 30 October 1968.

## Film source works (selected)

Conrad, Joseph, *Nostromo: A Tale of the Seaboard* (1904).

Dickens, Charles, *Oliver Twist* (1838).

Fitzgerald, F. Scott, *The Great Gatsby* (1926), Penguin Books, 1994.

Forster, E. M., *A Passage to India* (1924).

Massie, Robert K., *Nicholas and Alexandra: An Intimate Account of the Last of the Romanovs and the Fall of Imperial Russia*, Atheneum, 1967.

Lawrence, T. E., *Seven Pillars of Wisdom: A Triumph* (1926).

Pasternak, Boris, trans. Max Hayward and Manya Harari, *Doctor Zhivago*, Collins and Harvill Press, 1958.

Sewell, Anna, *Black Beauty* (1877).

## Reference and context

Adam, Ken and Frayling, Christopher, *Ken Adam Designs the Movies: Bond and Beyond*, Thames and Hudson, 2007.

Affron, Charles and Affron, Mirella Jona, *Sets in Motion: Art Direction and Film Narrative*, Rutgers University Press, 1995.

Albrecht, Donald, *Designing Dreams: Modern Architecture in the Movies*, HarperCollins, 1986.

Barnwell, Jane, *Production Design: Architects of the Screen*, Wallflower, 2003.

Barsacq, Leon, *Caligari's Cabinet and Other Grand Illusions: A History of Film Design*, New American Library, 1976.

Bergfelder, Tim, Harris, Sue and Street, Sarah, *Film Architecture and the Transnational Imagination: Set Design in 1930s European Cinema*, Amsterdam University Press, 2007.

Bright, Morris, *Shepperton Studios: A Visual Celebration*, Southbank Publishing, 2005.

Carrick, Edward, *Designing for Moving Pictures*, Studio Publications, 1941.

Carrick, Edward, *Art and Design in the British Film*, Dennis Dobson, 1948.

Carrick, Edward, *Designing for Film*, Studio Publications, 1949.

Christie, Ian, *Arrows of Desire: The Films of Michael Powell and Emeric Pressburger*, Waterstone, 1985/Faber, 1994.

Christie, Ian, *A Matter of Life and Death*, BFI Film Classics, 2000.

Christie, Ian and Moor, Andrew, eds, *The Cinema of Michael Powell: International Perspectives on an English Filmmaker*, BFI Publishing, 2005.

Coppel, Stephen, *The American Scene: Prints from Hopper to Pollock*, British Museum Press, 2008.

Doré, Gustave and Jerrold, Blanchard, *London, A Pilgrimage* (1872). Dover edition *Doré's London: All 180 Illustrations*, Dover Pictorial Archives, 2004.

Draper, Peter, ed., *Reassessing Nikolaus Pevsner*, Ashgate, 2004.

Ettedgui, Peter, *Production Design and Art Direction*, RotoVision, 1999.

Frayling, Christopher, *Ken Adam and the Art of Production Design*, Faber, 2005.

Iampolski, Mikhail, *The Memory of Tiresias: Intertextuality and Film*, University of California Press, 1998.

LoBrutto, Vincent, *The Filmmaker's Guide to Production Design*, Allworth Press, 2002.

Lohmann, Dietrich, *Film Architecture: From Metropolis to Blade Runner*, Prestel, 1996.

Mizener, Arthur, *The Far Side of Paradise: A Biography of F. Scott Fitzgerald* (1959), Heinemann, 1969.

Pendreigh, Brian, *On Location: The Film Fan's Guide to Britain & Ireland*, Mainstream, 1995.

Penz, François and Thomas, Maureen, eds, *Cinema and Architecture: Méliès, Mallet-Stevens, Multimedia*, BFI Publishing, 1997.

Pevsner, Nikolaus, *Pioneers of Modern Design*, Penguin, 1960.

Rizzo, Michael, *The Art Direction Handbook for Film*, Focal Press, 2005.

Rotha, Paul, *The Film Till Now*, Jonathan Cape, 1930.

Sanders, James, *Celluloid Skyline: New York and the Movies*, Knopf, 2001.

Smith, Grahame, *Dickens and the Dream of Cinema*, Manchester University Press, 2003.

Stam, Robert, Burgoyne, Robert and Flitterman-Lewis, Sandy, eds, *New Vocabularies in Film Semiotics*, Routledge, 1992.

Stern, Milton, *The Golden Moment: The Novels of F. Scott Fitzgerald*, University of Illinois Press, 1970.

Surowiec, Catherine A., *Accent on Design: Four European Art Directors*, BFI Publishing,1992.

## Internet sources

Baxter, Brian, 'Alex Vetchinsky', in *Film Reference*, at: www.filmreference.com/ Writers-and-Production-Artists-Ta-Vi/ Vetchinsky-Alex.html

Bonfardion, Odile, Eyewitness account of the aftermath of the Battle for Caen at: www. pbase.com/bonfas/dday

Internet Movie Database (IMDb) at www. imdb.com

Makin, Tim, Website on *A Passage to India* at: www.mapability.com/travel/p2i/index. html.

Walton, Tony, 'Variety Is the Spice', The Old Radleian online (2001) at: www.radley.org. uk/or/OldRadleian/2001/variety.html.

# Index

Page numbers in *italic* denote illustrations/captions, those in **bold** indicate the subject is the main topic of the section in question.

## Illustration acknowledgements

The majority of illustrations in this book come from John Box's personal collection, much of which is now preserved in BFI Stills Posters and Designs, from his family, or are frame stills taken from the films he designed to illustrate specific aspects of his work. The copyright of these films remains with the relevant producers and current rights holders, whose ownership is acknowledged. BFI Stills also kindly supplied the portrait of Vetchinsky (p. 18), for which special thanks are due to Nigel Arthur. Additional stills and publicity images courtesy of the Kobal Collection (pp. 24, 25, 28, 29, 76 (both), 107, 108 &142)'. Portraits of Anthony Asquith (p. 21) and of a group of art directors (p. 160) are by Cornel Lucas. The photograph of Bedouin extras on p. 50 was kindly supplied by Phyllis Dalton. Photograph of John Box on the set of *Just like a Woman* by Geoff Langan. *Portrait of Sir Thomas More* (p. 79) by Hans Holbein the Younger belongs to the The Frick Collection, New York; *East River* (p. 115) by Maurice Kish belongs to the Museum of the City of New York; and *Gas* (p. 115) by Edward Hopper belongs to the Museum of Modern Art, New York. The photo of Temple of the Tooth (p. 8) originally posted on Flickr is by McKay Savage, and the photograph of Albert Speer's Zeppelinstribune at Nuremberg (p. 129) is from Wikipedia, both are used under the Creative Commons Attribution 2.0 Licence. Photographs and drawings from *The Keep* (pp. 131–5) reproduced from Feeney and Duncan, *Michael Mann*. The photo of the Cromwell tank (p. 12) is from www.1rtr.net/historypotes.2.html. All other illustrations are from the collection of the author.